Painted Ladies

Painted Ladies

Models Of The Great Artists

by Muriel Segal

STEIN AND DAY / Publishers / New York

First published in 1972
Copyright © 1972 by Muriel Segal as *Dolly on the Dais*
Library of Congress Catalog Card No. 73-187312
All rights reserved
Printed in the United States of America
Stein and Day/*Publishers*/7 East 48 Street, New York, N.Y. 10017
ISBN 0-8128-1472-X

With gratitude to Iris Furlong who,
with much labour and a lot of laughter,
helped me to write this book

Contents

Acknowledgements

The Author wishes to thank the authors and publishers of the following works for permission to reprint copyright material: *Lives of the Painters*; Vasari; translated by Philip Lee Warner: The Medici Society. *Civilization of the Renaissance in Italy*; Jacob Burkhardt: Phaidon Press. Paris Soir Strip Cartoon. *Camille*; C. P. Weeks: Sidgwick and Jackson. *Life of Cellini*; John Addington Symonds: Macmillan. *Autobiography of Benvenuto Cellini*; translated by George Bull: Penguin Books Ltd. *Memoirs of Benvenuto Cellini*; Anne McDonnell: J. M. Dent & Sons, Ltd. *The Bare Truth*; Kurtenbaum: Walheim and Krochem A.G. The Connoisseur Magazine. *Autobiography of Alice B. Toklas*; Gertrude Stein: Grey Arrow. Clive Holland; Seeley Services Ltd. *Picasso and his Friends*; Fernande Olivier: Librairie Stock, Delamain et Boutelleau.

The author wishes to thank the sources listed below
for their kind permission to reproduce the illustrations
in this book.

Venus; Praxiteles: Mansell Collection
Virgin and Child; Jehan Fouquet:
 Mansell Collection
Madonna adoring the Child; Filippino Lippi:
 Mansell Collection
Mars and Venus; Botticelli: National Gallery
The Birth of Venus; Botticelli: Mansell Collection
Sistine Madonna; Raphael: Mansell Collection
La Fornarina; Raphael: Mansell Collection
Madonna del Arpe; Andrea del Sarto:
 Mansell Collection
Mona Lisa; Leonardo da Vinci: Mansell Collection
Virgin, Infant Jesus and St. Anne; Leonardo da
Vinci: Mansell Collection
Fête Champêtre; Giorgione: Mansell Collection
La Flora; Titian: Mansell Collection
Venus of Urbino; Titian: Mansell Collection
Salt cellar made for Francis I; Cellini:
 Mansell Collection
Rape of the Daughters of Leucippus; Rubens:
 Mansell Collection
Helena Fourment; Rubens: Mansell Collection
A Woman Bathing; Rembrandt: Mansell Collection
Polyphile au Bain des Nymphes; Lesueur:
 Remy of Dijon
Venus and Mars surprised by Vulcan; Boucher:
 The Trustees of the Wallace Collection
Reclining Maiden; Boucher: Mansell Collection
Drawings of Lady Hamilton (Various):
 Mansell Collection
Lady Hamilton as Diana; Romney: Mansell Collection
Duchess of Alba; Goya: Mansell Collection
Naked Maja; Goya: Mansell Collection
Ophelia; Millais: Mansell Collection

Painted Ladies

1. PHRYNE
Too sexy for
a deity

The first professional model we know anything about was Phryne, who lived in Athens in the fourth century B.C. Those were the days when the model was considered as important as the artist, and Phryne, who posed for what is acknowledged to be the most beautiful Venus in the history of art, shared credit with the great Praxiteles who created it. Because of her beauty, writers have inclined to white-wash Phryne, who was obviously out for the money as much as the glory. Hence her name, 'Phryne', meaning a 'sieve'. The nickname was given to her because of the speed with which she ran through the fortunes of her rich lovers. Being a courtesan, she automatically became a second-class citizen, deprived of the right to use her own name and so given a pseudonym; but by any name, Phryne would have become famous and ever since her sensational career two thousand years ago the word 'phryne' has become the accepted term for a girl who earns her living by posing for artists. To this day painters and sculptors refer to a 'phryne', and whether in Renaissance Florence or around the studios of Montmartre, one might hear among artists: 'Hasn't your phryne arrived yet?' or—only too often—'I owe my phryne for the last five sittings.' And many a pretty model called Jeanne or Marie would adopt the name of Phryne in the hope of acquiring some of the magic of the original.

We can see by the original statue of Phryne in the Vatican Museum that she had the looks that were currently in fashion, the small breasts, big hips and strong ankles so much admired in ancient Greece. Her life is fairly well documented because of the famous law-suit of 'Phryne versus the State' and also because of her associations with the great sculptor Praxiteles and the artist Appeles. We learn that she was brought up by her mother on a small chicken farm near Thebes (her father is

thought to have been an army officer, billeted overnight and then seen no more). When she was fifteen she was kidnapped by an uncle who took her to Athens to sell her to the Hetairai. Not an unusual event, one gathers, and it is probable that the abducted girl would put up little opposition, for the Hetairai were the only women in the country to be educated. As one of these 'female companions' Phryne would lead a comparatively gay and luxurious life. She would also be reasonably emancipated, for she could mix with men, instead of being kept in purdah, imprisoned in her own quarters, like the wives, sisters and mothers of respectable Athenians. The Hetairai lived in villas on the slopes of the Acropolis; the higher they climbed in their profession, the higher up the mountainside they moved. Phryne, as a very young beginner, was practically on the flat. In order to get promotion she needed more publicity. The equivalent of getting her picture in the paper or glossy magazines or on television was to be painted by Appeles, the foremost artist of the day. Any girl he chose as a model was well launched on the road to fame and riches. But how to get to his notice?

There are two versions of how she did it. One is that she went bathing with nothing on, perhaps the first girl to get publicity by what was to become a much-overworked ploy. She chose the day of the Neptune Beach Fête, when the whole male population assembled on the sands. She stripped, and walked into the sea in a sort of baptismal ritual. We are told that the crowd broke into crashing applause 'at sight of her divine form', and Appeles, up in the official vantage point, a type of press gallery from where he was painting the scene, decided instantly that she must pose for his *Aphrodite Coming Out of the Sea*.

The second version shows her in a less spectacular light. Her bathroom plumbing went wrong and the drain in her bath clogged up, so she had to go to the public baths as part of her beauty treatment was two baths a day. On that particular morning Appeles was also at the public baths in search of a new model to inspire him for his contemplated picture of *Aphrodite* and thus he found Phryne. But whichever is the the true story, the result was proclaimed as 'the greatest painting of antiquity'. A poet of the day wrote that he could now believe, after seeing the picture, that 'when Aphrodite was wafted on to shore, the flowers blossomed and the birds sang'.

Sadly, that lovely picture has been lost and only the legend of its beauty remains; this most gorgeous girl as Aphrodite portrayed by the genius of Appeles. But Phryne was destined to inspire even greater work. Praxiteles, successful, handsome, and probably the foremost of all

sculptors, saw the painting of her and wrote: 'If Venus came back to earth she would have the body of Phryne.' Forthwith he lured her away to work exclusively for him.

Posing for Praxiteles could hardly be described as 'gainful employment', for he seems to have considered that the love he developed for his new model should cancel out any question of a model's fee. In the awful verses he liked to write he describes how:

> 'Praxiteles here has seated to entrap
> the contours of the love he felt, and
> deep dredged in himself to find that
> perfect form. I gave myself to Phryne
> for her wages, and now I use no charms,
> no arrows now, nothing but a deep gazing
> at my love.'

But mere 'deep gazing' did not suit the avaricious Phryne, so she now bargained for a piece of sculpture in lieu of hard cash. In order to be certain of the most profitable choice, she woke Praxiteles up in the middle of the night, telling him his studio was on fire. 'We must save the Cupid,' he cried, which decided Phryne that it was the Cupid she must have, and which she later sold for a large sum to Caius Caesar who took it back to Rome.

Soon a great honour came along—Praxiteles was commissioned by the city of Cos to sculpture a Venus. Of course Phryne was chosen to be the model. For the early sessions she was draped discreetly in the accepted convention of goddesses intended for public worship, because goddesses were modest and never sexy; the idea being that they were to be venerated from a distance without passion. But as he finished this statue Praxiteles thought that it did not do justice to the lush 'contours of his love'. He felt driven to portray the splendid body of his eighteen-year-old beauty.

So he made a replica, this time of Phryne nude. And by contrast the original draped version appeared an out-dated, run-of-the-mill sort of goddess. Ultimately he sent both interpretations to the committee who had ordered it for the city of Cos, and thus started the tremendous controversy over the *Venus Draped* versus the *Venus Undraped*. Some of the critics were shattered at the mere idea of a nude deity, much as Royal Academy judges might be if Henry Moore sent in a sculpture of a Royal Personage in a bikini. As was expected, the timid city elders chose the one wearing at least a semblance of clothing and discarded the

nude. The more progressive city of Cnidus immediately snapped up the nude and held on to it, refusing all offers, even when a neighbouring king offered to pay off their national debt in exchange for it. Wisely they kept their treasure, which became the immortal Cnidian Venus, one of the greatest examples of art in our civilization and one that has always overshadowed the modestly draped statue. No one now ever mentions the Cos Venus.

It must be remembered that these sculptured figures were nothing like the cold white marble statues we see today. The originals were in colour; the dimpled shoulders and shadowed bosom of Parian marble were flesh-tinted, the hair gilded and dusted over with gold, the eyes set with turquoise, the belt and sandals bejewelled, the toes and lips stained with carmine, the blue gown laced with silver cord. One can well imagine that this life-sized replica of the radiant young Phryne did something to the virile if unsophisticated citizens and countrymen alike, who treated each new statue as though it were Marilyn Monroe in the flesh. They crowded round it to fondle the arms and reached up to caress the face; they swore with frustration when the marble folds of the tunic would not pull up; they bruised their fingers trying to pinch the stony buttocks.

A senator, incensed at such scenes of mob hysteria among the worshippers at his local temple, wrote that 'the Cnidian Venus looks as if she is about to step into a ritual bath. Men are heard to speak of her exactly as if she were a living woman of overwhelming beauty and they tip the guide to let them into the shrine to admire more closely this embodiment of physical desire. Indeed, one youth, carried away by excitement, leapt on to the pedestal and threw his arms round the neck of the statue.'

Phryne-worship seemed to be getting out of hand and suddenly, instead of being praised and fêted, Phryne was suspected of the dreadful sin of impiety, which for Greeks was a capital crime punishable by death. To back up the imputations against her were the mischief-making stories circulated by the jealous boys who loved the huge, bearded he-man Praxiteles. The young male models were already stamping with fury that Phryne had impinged on their preserve. Praxiteles had always taken the greatest care to keep them happy and well fed so that they would not lose weight during the months of waiting between posing for a tessellated pavement or a Doric pediment. To date their only worry had been the hermaphrodites monopolizing the best places on the Temple friezes, but now if they had to cope with female models too . . . And they could quote the accepted code of Athenian

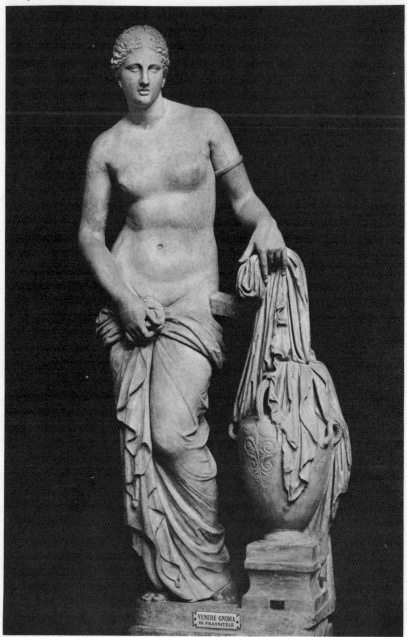

VENERE GNIDIA
DI PRASSITELE

sex-behaviour: 'Men for companionship, boys for pleasure, women for child-bearing.'

So the studio boys, plump and peevish, hinted that Phryne had mocked the secret religious cult of the Athenian women, who took their Eleusinian rites very seriously. Respected matrons romped over the hills during the midnight ceremonies, returning at dawn exhausted, with bruises, scratches and bite marks. Moreover Phryne had been heard to make fun of their goings-on.

On May 10th, 318 B.C., the gossip culminated in Phryne being summoned to Court. The case of 'Phryne versus the State' opened and she found herself accused of impiety and on trial for her life before the highest court in Greece, the Court of the Aeropagus at the foot of the Acropolis. One of the charges brought against her concerned the group by Praxiteles, *The Weeping Wife and the Laughing Harlot*. The harlot was obviously Phryne and she was shown to be exulting in her victory over the forsaken wife. There was no doubt, they said, that the artist was expressing what was going on in his own heart, the triumph of lust over virtue. Pliny maintained that nothing would be further from Praxiteles' character; he was not the sort of man to tell the world about his emotions. It was more likely, says Pliny, that the group had been ordered for decorating a theatre where the theme of tearful wife and cockahoop whore was often chosen as a 'weepie' show.

The courts took place at night, dramatically lit by the flames of scores of torches, with five hundred and one respected citizens of Athens acting as jury. Probably several of them had seen Phryne before in more intimate circumstances and Euthais, prosecutor for the State, was one of her rejected suitors. His fiery accusation is still preserved as a textbook example of legal rhetoric. His opponent was the only lawyer who could be found to take her case, the young and inexperienced Hyperide. He had long been in love with Phryne but knew he was too poor and unknown to get far with her. Now was his chance to prove himself. But when he rose to speak for her defence he must have felt the scandalised antagonism of his fellow citizens was too strong for any speechifying. This, he judged, was a time for action not words so he pushed Phryne before the judges, swept off her tunic with the exhortation, 'You who worship Venus, take a look at her whom the Goddess of Love could claim as a sister. Send her to her death if you dare!' According to reports of the case, 'there was a general cry of admiration at the sight of her beautiful body unveiled and she was unanimously acquitted'.

This piece of high drama in its theatrical setting, depicting the naked artist's model being saved from death by her lover's action, has served

as a theme for countless uninspiring neo-classic paintings. One of the dreariest of these is that by Gérôme in the Louvre, with the coy and prissy figure of Phryne giving no idea of the tempestuous young prostitute who stripped for her life. Since then, other women have tried the same trick to escape the death sentence. Mata Hari was one. She planned to flummox the firing squad by displaying herself completely nude the instant before the command to fire, but something went wrong and when they took off her stained raincoat, she was found to be wearing nothing beneath it but a rather soiled corset with two broken suspenders.

Phryne's story, however, is less sad. She ignored her saviour, the lawyer Hyperide, and went on her way to become very rich. In later years she seems to have developed a distinct power complex. She tried to buy the immortality for which she had always yearned by having a portrait of herself in gold placed in the temple between the busts of the kings. She even offered to rebuild the walls of Thebes after they had been razed by the Macedonian troops on condition that a plaque should be fixed to the gates on which would be inscribed 'Destroyed by Alexander but rebuilt by Phryne'. Her offer was refused and she never recovered from the rebuff. However, she managed to keep her love life going until she was almost seventy, still beautiful and courted. When she died, her statue was placed in the temple at Delphes with the dedication: 'To Phryne who inspired all artists and lovers.'

Just over a hundred years ago the battered head of a Greek goddess arrived at the British Museum from the Cnidian site in Turkey. It was stored in the basement until 1970, when Miss Iris Love from Long Island, U.S.A., happened to be crawling around on the cellar floor and found it. Thus started the second big art rumpus over Phryne, the nude Aphrodite. The Press splashed headlines—'Love Goddess Found in Museum Cellar' and 'Aphrodite Meets her Public'. In an interview, archaeologist Iris Love described her discovery: 'I was in the cellar on my hands and knees looking for items that I'd marked in the catalogue when I noticed a head (labelled No. 1,314) covered with a cloth and the dust of ages. I pulled it out, looked at it and screamed: "It's here! It's here!"'

The British Museum took a poor view of this dramatic account, especially to the version in which she added, 'It was dark and dank and deep gloom.' The official explained that the basement is always open to scholars and, piqued by the suggestion that they had been sitting on the long-lost masterpiece for a century, they issued scholarly views discounting Miss Love's claim.

C. Blinkenberg, in his *Knidia*, maintained that the head could not be considered the true replica of the Cnidian Aphrodite, 'but came from a contemporary high-relief inspired by the masterpiece', while E. Schwarzenberg wrote in *Bonner Jahrbucker* that, although it was undeniably fourth century B.C., it was the head from a statue of Persephone and not Aphrodite. But Miss Love remained adamant and drew attention to the incredible quality of the surface, 'a slight burnishing of the marble that makes the stone look like skin', and she continued measuring the other eight Aphrodite heads, four in the Louvre and four in the Vatican.

Near where Phryne's head was found was also a block of marble on which the word 'Prax' is followed by 'nude' and 'aph'. Miss Love says that this stone was set up by the city of Cnidus as a signpost to the tourists who flocked from distant parts of the ancient world to see the celebrated nude. However, there remained two questions which rather floored Iris. Firstly, the fact that the head was flattened at the back as though it has had a veil or head-dress to fit on from behind . . . and would a nude wear a head-dress? And secondly, why was the head found half a mile away from the spot where Phryne stood? It could hardly have rolled there because it was up an incline. But the fact that after two thousand years she was on show at the British Museum and causing all that admiration and concern amongst the highbrows of Bloomsbury must have been just what she would have wished for.

2. LA BELLE AGNES
The model who shocked the English troops

The Romans, who took over almost everything from the Greeks, also adopted their cult of the nude but they coarsened and ruined the purity of the Greek conception and they used the love affairs of the Olympians merely as an excuse for painting crowds of naked women in erotic poses. Describing the interior décor of one of the fashionable villas of Pompeii, Bulwer-Lytton said, 'The amorous intrigues of the gods are the most popular motifs.' He counted twelve *Daphnes pursued by Apollos*, thirty-one *Venuses*, fifteen in the arms of Mars and sixteen in the arms of Adonis, and sixteen *Jupiters*, three of them seducing Danaë, ten with Leda and three raping Europa.

The collapse of the classical world put an end to sexy women in art, and for centuries no one took the slightest notice of the beauty of a woman's body. In the wake of the Celts, who preferred spirals, and the Goths and Visigoths, who preferred demons, painting, like all other forms of learning, was kept alive in the monasteries from Lindisfarne to Istanbul, but when the artists are monks and the studio is a celibate's cell, there is no room for a nude in art. The Dark Ages were dark indeed for the artist's model.

During these pious centuries people became accustomed to two-dimensional saints and martyrs with no sex appeal, but who had interesting deaths which translated well into stained-glass windows.

Consequently Cimabue caused a medieval sensation in thirteenth-century Florence when he gave his Madonna the body and the face of a young girl, a sweet-faced youngster in gilded robes whose figure was nebulous enough to lend credence to the myth of the Immaculate Conception. The story goes that people crowded around the altar-piece trying to touch the panel to see if she was real. She was the fore-runner of the long line of madonnas who influenced the thinking of their time. The fact that two of the most 'venerated Virgins' were painted by dubious priests is symptomatic of the church-ruled age.

It often happened, however, that when a model established herself as a beautiful Madonna, she was invested with a halo of goodness and wisdom. Thus, in France, in the middle of the fifteenth century, romantic Agnes Sorel was being painted by the priest-cum-court painter Jehan Fouquet as well as by most of the other French artists while, at the same time, distracting the King's mind from State affairs, such as the trial of Jeanne d'Arc. Indeed, it has been stated that if Charles VII had not stayed in bed with Agnes all day, the Maid might never have been burned.

Agnes Sorel, who is more often called 'La Dame de Beauté', is best known to us by the *Antwerp Madonna* and *Melun Madonna* by Fouquet. The illegitimate son of a priest and an unnamed woman, Fouquet was tutored by his father for Holy Orders, but spent most of his time trying to get himself legitimized, which he succeeded in doing at the age of thirty only after many costly expeditions to Rome. One wonders how this passion for respectability and his horror of bastardy ties up with his tolerant attitude towards painting Agnes as a Virgin though she was the unmarried mother of several children. In the *Melun Madonna* she is nursing her bastard son by the King. History tells us that Charles gave her three other children, which is odd in view of Voltaire's statement that 'the King never touched her below the chin'.

The only other famous painting in which the Virgin and Child are posed by a king's mistress holding their baby is Lely's picture of Nell Gwynn nursing her son by the Merry Monarch, but Agnes Sorel carried on her affair in a more lofty manner than did Sweet Nell two centuries later. La Belle Agnes could do no wrong; idealized as pious, wise and gentle, she established the canons of beauty of her time. Jehan Fouquet gave out that he had never hoped to find such a lovely model. 'Smooth skin, unpitted by smallpox scars, none of her teeth has turned black or dropped out as after-effects of the plague, and she has no bald patches on her scalp through the prevalent scurvy.'

She led fashion with 'La Fronte Superbe', the high, round forehead

which was considered the last word in elegance and which entailed plucking the hair back from the brow and shaving the temples to give an egghead effect. Agnes could boast that her forehead was higher-domed and shinier than that of any other Court lady. She had the pot belly and narrow shoulders then in vogue, but she was most proud of her breasts, 'small, very high, white and round'. She launched a new fashion, a one-sided plunge neckline that left one breast entirely bare, for which she

Agnes

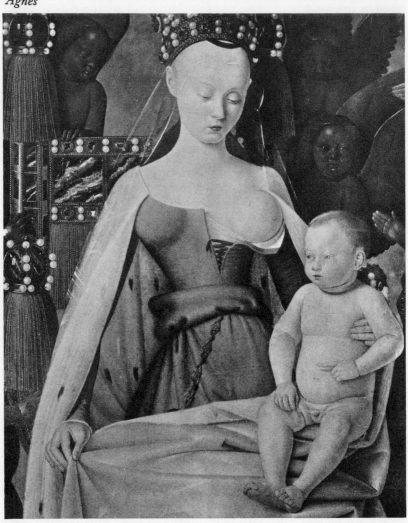

became known as Madame Sein-à-l'air. She was painted like this by Fouquet and subsequently every artist in France seems to have become inspired by her figure. She appears on the pages of illuminated manuscripts such as the treasured half-length *Virgin Annunciation* by Jean Colombe all glittering in gold paint and she posed for the Etienne Chevalier *Book of Hours*, entwined in the gilded capital letters, languidly embracing an 'F' or bending backward in a Gothic curve as a capital 'S'. She posed for a tapestry, stately and gay, riding side-saddle on a white palfrey and wearing a white wimple in a hawking scene, or for a stained-glass window, romantically waving a blue scarf from a high turret tower.

Apart from this, she was the soldiers' sweetheart. The historian, Maurice Champion, believed that the bawdy barrack-room ballads about her which were circulating through the camp almost caused another crisis between the French and the occupying British troops. The English generals sent memos around (in triplicate, no doubt) setting out the verses to be censored. To placate them the French troops were forbidden to sing 'Agnes' ballads outside their own camp 'as the English are easily shocked'. One of the more innocuous ditties started off with a verse considered sufficiently decorous even for 'les Anglais', describing her meeting with the King and relating how, although His Majesty was already married with a family, his Lady Mother, feeling he was in need of extra-marital stimulation, invited Agnes, the seventeen-year-old sister of one of her courtiers, to a ball.

> 'In the Spring of his youth, the good King Charles
> Went to a Ball, for the King liked dancing.
> Here he found (and how lucky for France)
> A beautiful girl called Agnes Sorel.
> The breast is so white, it shames alabaster,
> The wide apart nipples, the colour of roses,
> Circle around, advance, retreat,
> Surrounded by love.'

The second verse is marked '*Défendu*'.

The King's mother certainly succeeded in cheering her son up, says one writer of the period. 'Charles VII seemed old at thirty but under the influence of his mistress he has suddenly become young at forty.'

The King had never been a heart-throb, being 'so ill-shaped he wore his state robe on every possible occasion to disguise his misshapen limbs', but he seems to have suffered from no inferiority complex. After

the second meeting he could hardly bear to leave Agnes even for the
necessary visit home to his weeping wife, Marie d'Anjou, whom,
somehow or other, he managed to keep perpetually 'enceinte', as she
had a baby or miscarriage every nine months throughout her married
life. King Charles had a rule that each time a wife or mistress bore him
a child he presented the mother with a château, and he kept the local
builders busy with the Château Roquecessiers for the little Marie-Claire
or the Château de Bois Trouneau for Jean-Pierre, or the Château
Vernon for Louis. Consequently Agnes had plenty of châteaux, but the
last was the most elegant. The poet Eustache Deschamps describes it
as 'overlooking lush pastures with windmills turning, waterfalls tinkling
and nightingales singing', and Agnes called the place 'Beauté', a name
which fitted well, as she was already known as La Belle Agnes, and was
thereafter known as La Belle Agnes, Dame de Beauté.

This château, surrounded by the parkland where Agnes would walk
with Robin, her precious dog, is still to be seen as one of the gems of the
Loire Valley. In the walled medieval town of Loches one can find the
beautiful *Madonna of Loches*, which is said to be part of a funeral effigy
and suggests that an altar was given to the church in honour of La Belle
Agnes, Dame de Beauté.

3. LUCREZIA AND SPINETTA BUTI
The runaway nuns who became best-selling virgins

With a similar name, but a very different story, was the fifteen-year-old Lucrezia Buti, who inspired the defrocked friar, Filippo Lippi, to paint the sweetest Virgins ever known. At this time teenagers were creating a problem in Medici Florence and Signor Buti, a rich, respectable trader who strongly disapproved of the permissive society, was determined to put a stop to the irresponsible behaviour of his two pretty daughters. But after futile efforts to enforce some discipline he packed both of them off to the Convent of Santa Margharita at Prato. There Lucrezia and Spinetta Buti might have spent their lives embroidering altar-cloths and practising the lute, had not the Abbess engaged as the new chaplain Fra Filippo Lippi, a fifty-year-old unfrocked friar who had been in trouble for forgery.

Someone suggested that the dubious monk seemed hardly ideal for the appointment since he was 'in disgrace, gay, pleasure-loving, idle, dissolute and always penniless', but the Abbess had heard that he was a fine artist and she was anxious to redecorate the chapel used by the

nuns. She had no qualms until she learned that the friar had arranged an audition of the local prostitutes to select a model for the Virgin. The Abbess insisted that one of her own nuns would be more suitable and she forthwith produced a batch of pale and pasty novices, none of whom impressed Fra Filippo, who prided himself on being Italy's premier connoisseur of virgins. Eventually the two Buti sisters were brought in, sixteen-year-old Lucrezia, 'beautiful and graceful', and Spinetta, who was a year older, 'slender and shy' and 'so alike in face and features, they could be two daisies flowering side by side'. Filippo could not make up his mind which was the more paintable so he decided to use them both.

Now any elderly artist is apt to lose his head when his model happens to be a very young and pretty novice, so what could be expected of an unfrocked friar with two equally youthful and attractive girls trying to please him? The next thing we hear, therefore, is that on the eve of the Festival of the Holy Girdle, while everyone was at prayer, Fra Filippo wrapped Lucrezia in a roll of canvas and smuggled her out of the convent and back to his own studio, where they were soon joined by her sister Spinetta.

The news that his two daughters had gone off to live in sin with the same man shocked Signor Buti into an apoplectic attack. To quote Vasari, 'He was so grievously affected that he never more recovered his cheerfulness.'

The gay friar, on the contrary, became even gayer than before, for now he had the use of two almost identical models working in shifts day and night. Moreover, in 1457 Lucrezia had a son (or was it Spinetta?) so now the friar had resident models, not only for the Virgin, but also for the Babe, hence he could paint ad lib. Madonnas-and-infant-St. Johns, Madonnas-and-children-with-pomegranates, Madonnas-and-children-with-saints. So what did he care that the whole of Florence was chuckling over the story of the Friar fathering a family? Giovanni di Medici wrote to a friend, 'I laughed heartily when I heard of Fra Filippo's escapade.'

But the two little nuns did not find life particularly amusing; posing as a Madonna day after day, holding a naked, fat and heavy child on your knee, or balancing it, bawling, on your arm was hardly preferable to the monotony of the Convent, where at least one had enough living room. In Filippo's cramped and littered studio there were not only themselves, the babies, the artist and his pupils, but also various relatives, including the friar's six sickly nieces. As Vasari describes the situation, 'Six orphan nieces, sickly and incapable girls of marriageable age, who turned up whenever they were ill.' Towards Christmas 1459,

with six feverish Signorinas Lippi to look after, as well as the children
to tend at the end of long hours of posing, both girls decided they had
had enough. The night before Christmas Eve, when the Bishop was due
to visit Santa Margharita, the two pretty penitents returned to the
Convent to confess and renew their vows before His Holiness. They
wrote to their father assuring him of their happiness in being back in a
quiet and godly atmosphere.

But within a few weeks, reports Vasari, they smuggled out a letter to
Filippo Lippi telling him that 'the spiteful Sister Angelica has hinted to
the Mother Superior that "the Buti sisters have little vocation for the
cloisters" ' (which by now could hardly have been news to the Mother
Superior). But the girls were missing the bawdy jokes and lusty love-
making of the unconventional friar and once again waited until the nuns
were at prayer to make their escape. This time, however, only Lucrezia
got away; Spinetta was never allowed to join her sister to resume their
ménage-à-trois. When news of the escape reached him, Signor Buti
rallied from his now chronic depressive state sufficiently to make one
last effort to save his problem daughter. By pulling strings and greasing
palms, and with the help of the rich Medici family, he succeeded in
obtaining a dispensation for Lucrezia, releasing her from her religious
vows with freedom to marry. There was little he could do about the
unfrocked monk except to make sure no obstacle stood in the way of a
wedding. But all these efforts were wasted. To everyone's amazement
Lucrezia Buti refused to marry Filippo Lippi. To this day no one
knows why.

By now her son Filippino, grown too big to sit for the Babe, was
learning to paint alongside his father's pupils and apprentices and
colour-boys. This group included many names that were to become
illustrious, such as Botticelli and Lorenzo Costa. They were all busy
completing the frescoes in Spoleto Cathedral, the last work of the ageing
Filippo.

When Lippi died Filippino took over and by the time he was twelve
he was executing commissions. Like his father, he painted his mother
Lucrezia into every female figure and she devoted herself to the work of
her son as she had dedicated herself to the Friar. Though he is judged
as a lesser painter than his father Filippo, the young Filippino portrayed
her more tenderly. Says a critic of the day: 'He made her look even
more gentle, a mild virgin face.' Still under thirty, she was described by
one of the Medici family as a 'sweet young religious'.

The last of her jobs was, curiously, to pose for the fresco commenced
years before by Filippi and now to be finished by Filippino. It was in

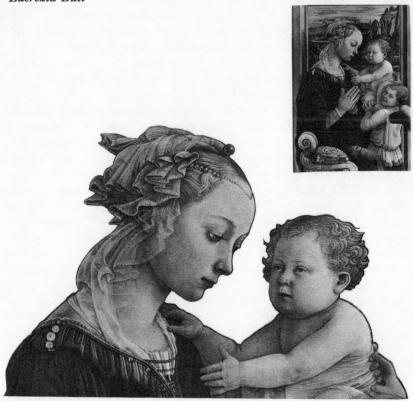

the corner of the market-place in Prato next to the Santa Margharita
Convent where she had once been so unwilling a novice and where her
sister was still confined. Perhaps Spinetta caught a glimpse from her cell
of the picture of Lucrezia looking so mild and holy in that familiar pose,
and perhaps it reminded her of the noisy studio and the merry friar,
who must have been a lovable old rogue despite everything.

Then young Filippino went off to work in Rome, but before going he
made sure his mother was well provided for. He drew up a will leaving
her his house in Florence and bequeathing his estate to the Hospital of
Santa Maria Nuova on condition that 'a liberal provision of corn, wine,
meat, wood, oil and salt should be given yearly to my beloved mother
Lucrezia Buti'.

4. LA BELLE SIMONETTA
Botticelli's golden dream girl

Filippino returned to Florence accompanied by his fellow painter Botticelli, a neurotic young genius several years older than himself. Although almost fanatically religious Botticelli had been accused of homosexuality, a charge which, being commonplace at that time, did not mean very much. His nickname, meaning 'little barrow', was inherited from his brothers. It was obviously ill-suited to the slender silent introvert who made it famous. But had Botticelli been more normal and had Simonetta not radiated an unworldly innocence we may never have had such works as the famous *Primavera* or the *Birth of Venus*. Simonetta was Botticelli's dream woman. She is one of the most extraordinary myths in all art history.

Most biographies of Botticelli stress his delight when he first saw Simonetta all decked out in her outfit of gold. To us the effect might seem a bit tatty but to him she appeared as the ideal of feminine beauty for which he had searched all his life—'a combination of chastity and sensuality, physical beauty and ethereal radiance'.

One gathers that they had a purely spiritual affair, carried out on a high plane, never touching a physical level. The artist who painted most of the beautiful women of Florence knew no romance in his life other than Simonetta, his model and his inspiration. Simonetta's beauty and innocence links up with the attraction of the nymphet, a word of medieval origin which we now apply to the sexy teenager. Vladimir Nabokov, author of *Lolita*, makes his peculiar anti-hero, Humbert, recognize the affinity between his nymphet Lolita and Simonetta. 'I

definitely realized, so hopelessly late in the day, how much she looked, had always looked, like Botticelli's russet Venus, the same soft nose, the same blurred beauty.'

The Simonetta story tells of a golden-haired dream girl too good to live, the ideal of purity and gentleness, a girl who married at sixteen and died at barely twenty, and was to be the only artist's model in history to be painted more often after her death than during her lifetime. One Simonetta Christmas card sold by the National Gallery gives the information that she was born in 1459 at Genoa of English-Italian parents. But the more generally accepted story woven around her birth places it in Port Venere (Port of Venus), where legend says Venus was washed up when she emerged from the depths of the Mediterranean and, standing on her shell like a surf-rider, was blown by the wind to the Italian coast. No modern-day publicist could have concocted a better background for a girl who was to be painted in this pose in one of the greatest pictures of the Renaissance.

As the sixteen-year-old wife of Marco Vespucci, Simonetta Catteneo was the pet of the intellectuals, poets, scientists, navigators, explorers and artists who surrounded the great Vespucci family. She must have been unusually sweet and gentle, for we read that she was praised by the people of Florence for her goodness and beauty, but she seems to have been a passive type. Poets wrote odes to her, artists painted her, nobles loved her and knights jousted for her, but as far as we know she never *did* anything or *said* anything or *went* anywhere worth noting. The mighty Lorenzo the Magnificent, on returning to Florence from one of his private wars, demanded to meet this much-talked-of bride and confessed himself 'entranced by her gentle silence'. One of the Duke's young kinsmen, Giuliano Medici, fell in love with her and it is with this Giuliano that her name is usually linked, though always in the most highly respectable context, for the romantic trend of the age of chivalry made it possible and quite permissible to carry on an idyll without causing the slightest scandal. Bed was never considered by a devoted swain and his lady, and an old troubadour song tells of the knight who slept with his inamorata night after night without going any further than stroking her hair spread out on her pillow.

Consequently, when Giuliano chose Simonetta as the lady he would champion at the Courts of Love, her husband, Marco Vespucci, felt no resentment at all. Indeed, it was his idea to commission Botticelli, already famous as a 'painter of flowers and beautiful women', as the most suitable artist in Florence to paint the standard for Giuliano to carry out to the lists.

The annual event, known as the Courts of Love, could be regarded as a combination of the *Cup Final* and the *Miss World Competition*. The whole population turned out and excitement ran high as each knight entered the arena carrying a banner on which was painted the portrait of his beloved. The winner of the joust established his lady as the Beauty Queen of Florence for a year. The gown they chose for Simonetta to wear for her banner picture was a long gold tissue tunic which, with her shining blonde hair, gave the effect of gold from head to toe. In Botticelli's study of her for the standard she appears as Pallas, the Goddess of War, a symphony in gold. He painted her in her golden gown against a blazing sun, the sun's rays fusing with her flowing fair hair. But this radiant composition has been lost, probably thrown away as worthless after the tournament, as we might destroy a poster or a programme. Who knows what happened to it after the excitement on January 25th, 1475, when Giuliano won his jousting event at the Courts of Love, thereby establishing Simonetta as the most beautiful woman in Florence? That day Botticelli made scores of sketches of her and Giuliano which he used as notes ten years later when both of them were dead. We can see them in *Mars and Venus* in London's National

Simonetta

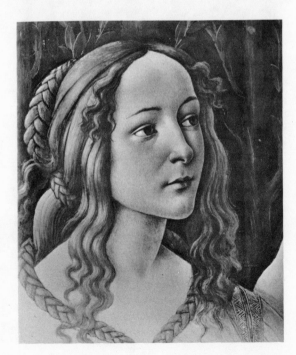

Gallery; Giuliano is Mars sleeping exhausted after his battle, Simonetta is Venus. She is draped in a tunic, one of the rare paintings in which the Goddess of Love wears any clothes. Botticelli only once painted Simonetta nude and that was from imagination when, ten years after her death, he painted the famous *Birth of Venus* with Simonetta, Goddess of

Botticelli's golden dream girl

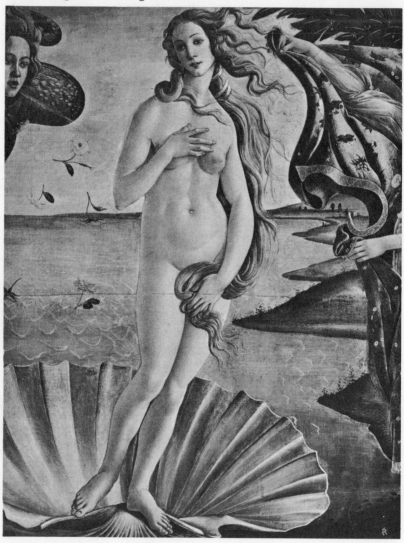

Love, balancing unsteadily on her shell. At the time critics excused the
shaky anatomy by saying that he drew from memory but our modern
experts see Simonetta as a floating figure.

Simonetta typifies the Age of Chivalry and her remote pre-Raphaelite
appeal had a tremendous revival in Victorian England. The Japanese
authority on the period, Yashiro, wrote of Simonetta's 'unawakened
sensuality', an idea which inspired pages of sentimental prose enjoyed
by fin-de-siècle ladies. Even the highly reputable *Connoisseur* fell for
the Simonetta cult and as late as 1904, looking back four hundred and
fifty years or so, published a saccharin account of an imaginary *Day in the
Life of Simonetta*. She is being dressed to receive her devoted swain
Giuliano.

'When Simonetta woke in the morning she looked round her
room and saw pale roses, a present from Giuliano, a little casket
containing verses from some other; a lute lay on the floor. And
when her handmaiden opened two cedar chests containing her
raiment, a faint scent of lavender floated throughout the room,
and from the hanging cupboard stole the perfume of oriental iris.

'Her teeth were cleansed with powdered pearls or whitest coral
crushed, and scented water, delicately warmed, bathed her fair
limbs; then the silk under the robes were donned, the dressing
jacket of fine Eastern embroidery came next, and after that the
framework is fastened on her head and her hair is perfumed and
sprinkled with fine gold dust; off comes the framework and now
her dress is put over her head and fastened. Now comes the busi-
ness of her hair, the ropes of pearls and fine gold thread are plaited
into it, the sides are waved and carefully drawn back, the forehead
freed from superfluous curls, and after all the little chain of silver,
from which depends the jewel for her forehead, is clasped behind.

'Beside her, on a silver tray, the gift of one of the love-sick swains,
are sweets of marzipan, almonds, pistachios and burnt sugar. Here
also a thin-stemmed glass with some light, watered wine. Whilst on
another dish oranges and grapes are laid. And for something sub-
stantial to break her fast, a jelly of the breasts of capons on a gilded
plate. While she eats, one of her maids reads verse after verse of
languishing poetry sent by her many admirers. She has already
been to Mass.'

Before she died, many other artists, great and less great, were painting
Simonetta, including Piero di Cosimo and Ghirlandaio. It has been
claimed that she sat for Leonardo da Vinci, but his was such a protracted
genius that probably he had no time to finish even his preliminary

studies before her early death. Had she lived to give him the countless sittings he required, the results, some suggest, would have been the greatest portrait ever painted. Before her year as Beauty Queen ended Simonetta literally faded out. No illness, no accident, no pregnancy is mentioned, at twenty she just died.

Hollywood never afforded a film star a more lavish send-off. An account of it written by Lorenzo de Medici was found among his private papers. It describes how, dressed in her wedding gown and lying on an open bier, she was carried through the streets of Florence; how the crowds of wailing mourners packed thick along the route of the funeral cortège, the hundreds of young people throwing flowers and singing their songs of adieu to the beautiful Simonetta. Lorenzo himself wrote a poem in memory of her; the last stanza, used as her epitaph, runs thus:

'How lovely is youth's Springtime day
Which flies on every side away;
Who would be glad, let him be
Of tomorrow there's no certainty'

and this verse was set to music to become a sort of Simonetta theme song to be sung at the opening of the memorial festivities constantly held in her honour.

A great Simonetta fan-club came into being, banding together hundreds of devotees who met to extol her beauty, compose poems about her, sing ballads in her praise . . . and to think about her. Artists painted her from memory and some, who had never seen her, had to imagine her. Botticelli resorted to the few sketches he had saved of her as reference for the continual flow of Simonetta pictures which he turned out.

The Simonetta cult changed with the times; from publicizing her as the Goddess of Love, as she had always been painted, her fans now turned to picturing her as a Madonna. Yashiro explains: 'The fifteenth century saw Madonna in Venus. As the tide turned into the sixteenth century they saw Venus in Madonna.' She proved even more popular as a Madonna after her death than she had been as a love goddess during her lifetime. Rich aristocrats liked the idea of a Madonna with the face of a Vespucci to hang in their private chapels, or to give as presents to the fashionable cathedrals. Monks hung her in their halls and nuns gave her pride of place on their convent wall. In 1480, three years after Simonetta's death, we hear that Botticelli is 'running a large shop for the production of the gentle and devout Madonnas. Teams of

employees are turning them out en masse copied from his original drawings of Simonetta'. Even so, the supply could not keep pace with the demand, and awkward questions started being asked in high places— were the people worshipping the golden-haired girl with her chaste sensuality rather than the image of the Virgin? Followers of Savonarola condemned all such emotional attitudes, along with everything that might be called feminine or non-austere.

Botticelli, long inclined to be something of a zealot, now developed religious mania. He got caught up in the Savonarola hysteria, joining in the frenzy of repentance that ended in the Burning of the Vanities. On that Sunday afternoon in the Piazza della Signoria, Botticelli tossed all his beautiful Simonetta pictures onto the bonfire, heaped them up along with cosmetic boxes, fancy combs, beaded slippers, satin gloves, bangles and naughty books, which Savonarola condemned as sinful vanities. Botticelli, now convinced that Simonetta, his erstwhile ideal of sweetness and light, was a wicked temptress, piled masterpiece after masterpiece into the blaze. The psychologists explain that this was his way of trying to free himself of her memory, to wipe her image from his mind, but true or not it didn't work out, for his last paintings were illustrations to Dante's *Inferno* and in Beatrice we see a striking likeness to Simonetta.

Before he died, Botticelli, old and slightly crazed, lived to see his unrealistic dreams fade from public favour and become unfashionable. Nevertheless, his Simonetta went on selling for centuries and she is still one of the most popular of all religious portraits.

5. LA FORNARINA
Raphael's favourite model who preferred black cats to babies

Simonetta as a religious symbol is only outstripped by Raphael's *Sistine Madonna* which for nearly five centuries has topped the best-sellers. Every Christmas she appears on thousands of Christmas cards and on scores of calendars. Missionaries, in the heyday of their zeal, distributed to the heathen more tracts of this lovely painting than of any other; little did they know that the comely Fornarina who posed for it was reputed to have been mixed up in witchcraft.

Fornarina was Raphael's model and his love. Even her name, 'La Fornarina'—the Baker's Daughter—was sinister, for in those days, to be called a 'baker's daughter' did not signify that your father made bread. In the old dictionaries it is given as the term for 'a cannibal owl-goddess who ate her own husband and her own son'. Shakespeare's Ophelia says: 'They say the owl was a baker's daughter. We know what we are but know not what we may.' And there are references elsewhere that this special category of 'baker's daughter' spent most nights as an owl. Fortunately for Fornarina, witchcraft was fairly well accepted in cinquecento Rome and magicians were not discriminated against as a

minority. Jacob Burkhardt in *The Civilization of the Renaissance in Italy* says: 'The Italian witch practised a trade which was to provide for other people's pleasure. By far the most important field for her activities was in love affairs and included the stirring up of love and of hatred. If she was credited with the power of assuming different shapes, or of transporting herself suddenly to distant places, she was so far content to accept this reputation, as her influence was thereby increased.'

Fornarina certainly cannot be accused of any evil witchcraft but neither is she anything like anyone's guardian angel: she is spoken of as having a 'magic attraction' and as possessing a 'magnetic quality'. There was nothing pale or ethereal about the buxom Fornarina. Indeed it may well have been her stalwart limbs and forceful character that most attracted Raphael, for he loathed the pale wraiths of the Botticelli dream-world, wafting about with tiny feet that never touched the ground. The late Bernard Berenson, commenting on the switch over to healthy-looking models, says: 'Despite the many efforts made in our time to make the ailing woman popular, the type of woman to which our eyes and our desires still return is Raphael's.'

Hence it was the solid Fornarina who established the ideal of beauty for the next four hundred years; everything about her is ample, from her full lips and plump arms, to her broad hips, big bosom and large hands and feet. But, as a contemporary critic wrote of her: 'Yet, large as these parts are, they moved with grace.' However, there was one quality she lacked. She appears to have possessed none of the tender

La Fornarina

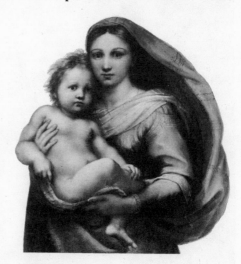

maternal instincts which one associates with holy pictures. It is intriguing to find that the world's most famous mother figure obviously preferred black cats to babies. She seems to scare the child held in her arms; he

The Baker's Daughter

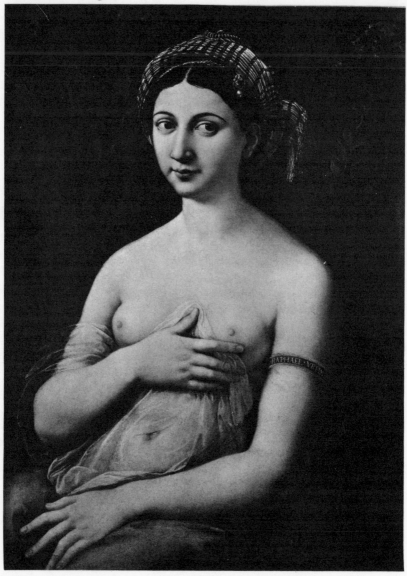

squirms away and she only just manages to keep him captive. The learned Mr. Wolff in his *Classical Art* notes that 'Raphael's Roman madonnas are quite different from those of his earlier period', and he remarks on the lack of motherly love and tenderness.

Nor did the prospect of being a wife appeal to Fornarina though there is no known reason why a witch may not be a bride. It is hard to understand why she persistently refused to marry Raphael, who must have been the most eligible bachelor in Rome and himself mentioned the efforts of the matchmakers to lure him into wedlock with an heiress or high-born lady. He was certainly a spectacular figure, a splendid young man known as the 'Prince of Painters', dressed in flamboyant clothes and leading his entourage, consisting of fifty assistants, colour-boys and liveried lackeys, through the city to his studio; still in his twenties he was already acknowledged as the equal of Michelangelo and Leonardo da Vinci. But did all this impress Fornarina? Not at all! She would not even accept a betrothal bracelet, the gold band which in those days an engaged girl wore high above the elbow instead of an engagement ring and on which both names were inscribed. On one occasion, when he was painting the portrait of her which is now the most treasured in the Barberini Palace collection, he proposed to her again and with no better success. So he painted the bangle on her arm in the picture and that elusive hint of mockery we see in her smile may well have accompanied her umpteenth refusal to wear the bangle in real life.

Continuing deeply in love and frustrated by the hopeless situation, Raphael let his work suffer and began to neglect his important clients. Instead of painting, he spent his days writing bad love sonnets to Fornarina which were found long after on the back of sketches for the Sistine Chapel walls. Soon he was hardly working at all; it took him fifteen months to complete one picture, orders were left unfinished, jobs for the Pope not even started, resulting in rows in the Papal Palace. Eventually the Pope himself became anxious and decided to investigate. He reached the conclusion that his favourite painter-cum-art-consultant-cum-decorator was only temporarily infatuated with the girl and young enough to recover as soon as she could be got out of the way. So she must be removed. In consultation with Raphael's close friend and patron, the banker Agostino Chigi, it was decided to smuggle Fornarina out of the studio and to keep her in custody where the painter would not be distracted by her until he had finished the important assignments that were long overdue. They tried to abduct her several times. Once they sent one of Raphael's assistants to get her on the pretext that she was wanted to choose some cloth for a background drapery, but the

assistant returned pale and full of some cock-and-bull story that, when he entered the studio, it was dark and empty and a black bat (or owl) kept flying across his face. Another time a howling gale seemed to be blowing through the studio although it was noon on a hot summer's day and the easel and palette fell to the floor as something flew out of the open window. Both these incidents are reported in Uide Grimm's *Leben Raphaels*, published in Berlin, 1872.

Finally the wise Pope Leo and the crafty Chigi, who had no time for such nonsense, thought up something new and foolproof. They offered Fornarina a very large sum of money, which she immediately accepted. But the Pope and the banker had misjudged the artist, who was too upset by Fornarina's disappearance to do anything but fret and fume. He soon sought out his friend Chigi to beseech his help. Chigi, chuckling at the idea that 'Raphael confides his loss to the very ravisher himself', promised to use his influence to discover the lady's hiding place and to bring news of her on condition that Raphael would meantime concentrate on his work.

Then Raphael did work, driving himself on and on, kept afire by hope until, realizing that she might never come, he again 'relapsed into a state of gloom, apathy and despair'. Eventually Chigi brought a letter from Fornarina. It was faked, of course, but Raphael believed every word of it. It stated that her captors would allow her to return to him as soon as he had completed the décor for the first floor of Chigi's new palace.

So now Raphael worked as he never had before, goading on everyone in the studio to rush through the orders and finish the assignments. Sometimes they worked with genius, sometimes without—but they got them finished. Over and over he painted the face of Fornarina from memory, and almost every woman seen in his pictures can be recognized as an idealized version of the Baker's Daughter. When it was clear that he had reached breaking point and could go no further, Chigi appeared to delight him with the news that, in the face of great danger, he had rescued the girl and would bring her back to the studio. But to make sure of keeping them on the premises to finish the painting under way, Chigi warned that both artist and model must stay in night and day, for should Fornarina so much as show her face outside she risked being recaptured. Raphael assured his friend that he personally would be responsible for seeing that Fornarina never left the studio couch. So he finished *The Transfiguration* and he finished *The Marriage of Psyche* and he finished *The Galatea*. And he made ardent love to Fornarina. And then he died. From overwork or from love or from a germ picked up

while excavating Roman ruins for the Pope. He left Fornarina a small legacy with which she did an extraordinary thing. She bought herself a place in the Convent for Repentant Women where she stayed and repented for the rest of her life, though for what, no one can be sure.

6. LUCREZIA DEL FEDE
The madonna suspected of murder

The next of our famous models married her artist. She was probably a murderess. As the Renaissance reached its height the art industry flourished in Florence as it had in Fornarina's Rome. If there were no new churches or palaces to decorate, there was always an ambitious Prior who wanted a new altarpiece to bring the décor of his old church up to date. Since there was no abstract art and little in the way of landscape or still-life, painting was synonymous with figure painting, so artists had to have models. There were not enough to go round and a good model seems to have been as hard to find as a reliable secretary is today.

Andrea del Sarto, called 'the faultless painter', was considered the most important artist working in Florence when Michelangelo and Raphael were making history in Rome. Raphael, as we know, had his Fornarina to inspire him, and the great Michelangelo had no need of girls as he used boys to whom he added or subtracted anatomy as required. Indeed, one of Michelangelo's male wrestler models, irritated at being painted in falsies as a Sibyl, criticized the Master for always choosing unsuitable models. 'Why use that goosegirl for the St. Peter's Madonna?' The great Michelangelo answered: 'Chaste women keep fresh far longer than the unchaste. Only a simple goosegirl can look as pure as a Virgin who hasn't had a lascivious thought.' The more conventional del Sarto, needing a saintly madonna type, called in at a friend's studio to see a new model he had spotted in a back-street tavern. As soon as Andrea saw Lucrezia del Fede, to use his own words,

he 'stood transfixed and memorizing every curve of that heavenly face'. He vowed then and there that for the rest of his life he would never paint any other woman's features. And he never did.

Lucrezia's face was to become a symbol of devotion and purity, 'the most saintly face ever put on canvas', though the soft lips and dewy eyes belonged to a mean-tempered young vixen with a bad reputation, strongly suspected of having poisoned her husband. But del Sarto never saw her that way. He let her move into his studio and she collected her husband, sisters, father and cousins from hovels on the wrong side of the Arno, to hire out as models to del Sarto for his big religious paintings. From the beginning, her husband was too ill to be anything but a palsy case being cured, or a starving beggar receiving alms. According to the chronicles, on the afternoon of September 16th, 1516, he was posing as a leper, and by the next night he was dead, 'seized by a sudden and grievous illness and died thereof'. Nothing was ever proved against Lucrezia; cases of poisoning as favoured by the Borgias were a common occurrence, but her guilt was no secret. Andrea painted his angelic Lucrezia, utterly ignoring the apprentices' pointed questions about the missing gallipot of white lead paint. He merely continued to marvel at her beautifully accentuated horizontals, such marvellously coherent planes. He gazed entranced at the bone structure of her jaw, that sweet skull, the swell of the rounded belly and the delightful mauve shadow at the armpits. So he married her.

We have first-hand information as to what happened next because amongst del Sarto's young apprentices was a boy called Georgio Vasari, who was to become the well-known art gossip writer, author of the chatty best-seller of the century, *Lives of the Painters*. He tells how she took over; how, between long sessions of posing for the pictures which would immortalize her pious smile and devout serenity, she made a hell of what until then had been a happy, carefree household. 'None could escape her blows' he writes, and that he never knew when she would jump from the model throne, cuff him across the ears, hop back again and, straightening her halo, resume her meek smile and saintly pose, while Andrea, engrossed at his easel, never noticed that she had moved. But Vasari did not forgive her and in those days, as now, it was not a good idea for a model to hit a gossip writer.

Despite his prejudice, however, Vasari admits, 'although she comes from a stinking slum house in the Via del S. Gallo and her father is a poor and vicious villain, she carries herself with pride and haughtiness and has no difficulty in entrapping every man she meets with her beauty and fascination'.

Lucrezia del Fede

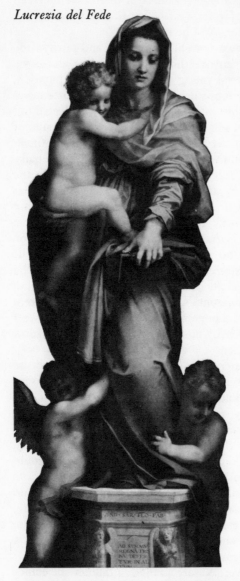

In the portrait of her as the *Madonna del Arpe* with a child on one arm, the other supporting a book balanced on the hip, the critics extol her as 'the most aristocratic Madonna in Europe'. No one mentioned that she had thrown the brassbound volume across the studio, and

Andrea could only praise her for 'looking queenly'. Next she turned both del Sarto's old parents out of the house, announcing her intention to install her own father and sisters in their place, but, to quote from Vasari's account of this incident, 'he only continued his enraptured gazing and decided that in his next *Disputa* he would paint her face into all the six saints as well as the Madonna'.

Soon Lucrezia set about separating Andrea from his comrades, with whom she considered he spent too much time when he could have been earning money. Vasari tells how, when they came to collect him for dinner at the Saucepan Club she slammed the door in their faces. Every other wife cooked a handsome dish for the husband to take with him to banquets—such as Vasari describes one offering: 'A temple with sausages for the columns and cheese making the capitals and the choir-desk of veal and pasta. Six baked thrushes with their mouths open represented six choirboys wearing surplices made from pigs' cauls.'

But Lucrezia raged and swore that she would never cook any such dishes, and one of the club members noted: 'Andrea lives in the midst of that torment and yet he accounts it a high pleasure!' He renounced the parties and the entertainments and the spectacles he loved to design, which were so important a part of the life of the artist in Renaissance Florence. He was not among the guests dressed up as gods of the under-world when they banqueted in a room strewn with bleeding limbs, with Mars and Venus acting their part naked on a bed. 'All having been conceived by del Sarto who stayed at home to paint in order to keep Lucrezia and all her relatives happy.' Goodness knows how long this dreary state of affairs would have continued had not Andrea del Sarto's agent, a certain G. B. della Falla, arranged for him to accept a plum job at the Court of France. Lucrezia was eventually bribed into agreeing by promises of a grand new house she could buy out of the proceeds.

Before he left for France, Andrea had the bright idea of asking her to start preparing the studio in order that it might be all ready for him to commence work the minute he arrived home, so giving her hopes that he might return at any moment. This appeasement did not last long; soon she started to panic that he might never return and she would be left alone, saddled with all her family to support. Receipt of his first letter only added to her fears, since he sounded full of enthusiasm for the luxurious life and amusing company at the French Court, boasting how much all these grand people liked him, especially the ladies, though he was careful to assure her that 'he always put something of his dear wife's features into every portrait, for were not her lineaments engraven on his heart?'

Furious, fuming, she replied: 'I am alone and never stop weeping and in perpetual affliction at your absence. . . . I can hardly eke out the money you left, and have to deny my father and sisters their little luxuries. If you don't come home immediately, you will find me dead when you get back.' Blackmail by suicide threats was no new weapon even in those days. Besides, as Vasari comments, she was 'more anxious to profit by his gains than to see him again', but del Sarto's letters to her clearly show his agitated state of mind. 'Though I watch for your letters, I dread to read them for they are so full of your fury that my spirits are depressed for days though this I must disguise for if there is a thing the French cannot tolerate, it is a long face.'

Lucrezia won. After nearly a year, he wrote that he was coming home 'as he had got leave for two months and longed to show her all his new French clothes'. She may not have been particularly interested and anxious to see his new French clothes, but she was very much interested in the postscript to this letter—a great deal of money had been entrusted to him to buy pictures and statues for the King. On his return they had a second honeymoon, for Lucrezia was amiable while enjoying her new wealth. She paid all the larger outstanding bills out of the King's cash-box (including the price of the new house behind the Munziata) despite Andrea's objection to her spending so much of His Majesty's money on new bedroom furniture. She had her reasons. She knew that once the King's money with which he had been entrusted was spent, Andrea could never return and face the authorities in France. There would be no other future open to him but vistas of Madonnas, each an idealized Lucrezia, selling at higher and higher prices.

Shackled once more, he may have had second thoughts on the warning given by those wily French courtiers that 'he was returning to resume his chains and was choosing a life of wretchedness with her, in preference to the ease and all the glory which his art would have secured in France'. And so it turned out. The money spent, del Sarto was forced to work at top pressure to keep the household going, driven by the dread that he would never catch up. His fellow painters now publicly opined that his wife was ruining him artistically. Lucrezia posed for picture after picture, always pure and patient, and as each was finished and shipped off to the insatiable buyers in Spain or Holland, another was started. Even when the plague came, Lucrezia insisted that they worked on to fulfil the waiting orders, locked up in the house while all around people nursed the sick and took food to the hungry. Once when a neighbour called urgently for help, Lucrezia refused to open the door —she was too busy posing for *Charity*, the lovely picture that shows her

as a selfless religieuse, going about her task of helping. The neighbour died.

When the worst of the plague had passed, del Sarto suddenly went down. There is nothing like overwork, a nagging wife and an extravagant household to kill a man in early middle age, whether he be a twentieth-century advertising executive or a Renaissance artist . . . and at fifty-five del Sarto collapsed. Lucrezia refused to go near him in case it might be the plague. She put his paints and canvas by his bed and kept out of the way. It seems to be an artist's not uncommon deathbed wish to paint a beloved face for the last time. Yet how different the circumstances when in 1827 William Blake died at the age of seventy-one! Seeing his wife in tears, he begged her, 'Stay, Kate. Keep just as you are. I will draw your portrait for the last time for you have ever been an angel to me.' Poor del Sarto, before he died in 1531, had an urge to paint Lucrezia once again and called out to her to come and sit for him while he yet had strength to hold his brush. She did not even answer so he took a mirror and painted himself.

7. MONA LISA
Her trials and tribulations in Leonardo's studio

Goodness knows what the rich merchant Signor Francesco Gioconda, who fancied himself as an art patron, would have had to say at the very suggestion that his wife, the Mona Lisa Gioconda, should be classed as an artist's dolly. But how could the woman who sat for 'the finest portrait ever painted' and at least nineteen other works by da Vinci, 'the greatest genius of our civilization', rank as any but the First Lady of the Muses?

Said to be the best-known woman in painting, she remains the most famous enigma of all time. We do not know what was her relationship with Leonardo despite the varying stories that have been told. Described as tall, strong and 'marvellously handsome', Leonardo is reputed to have had no use for women and is quoted as saying of the man–woman relationship: 'I think it so disgusting that the human race would soon die out if it were not such an old-established custom and if there were not so many pretty faces and sensuous dispositions to keep it going.' Leonardo's best customer, the well-off but elderly Sgn. Gioconda, therefore had no qualms when he commissioned a portrait of his young and beautiful wife to hang in their dining-room. The first appointment for a sitting was made for the evening of November 1st, 1503, or in the afternoon if it happened to be wet or cloudy for, as everyone knew, the Master disliked working in daylight, preferring the sombre mysterious shadows of flickering candles, or winter mornings when low clouds blurred the view of the rolling Tuscany hills from the studio windows.

Mona Lisa

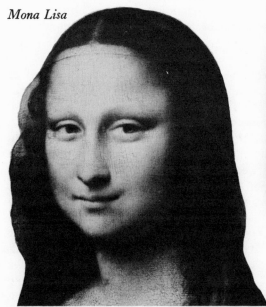
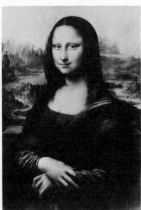

From the moment she arrived on that first dark evening, Lisa lived in a wondrous world of science fiction in an Italian Renaissance setting. One can imagine that she never forgot her first impression as she sat on the dais and looked across the enormous da Vinci workshop, like a huge film studio where sets for a dozen films were ready for shooting. At one end were great kite-shaped frames with flapping wings, the mock-ups of the primitive aircraft da Vinci planned for men to fly to the moon; over in the opposite corner, periscopes pointed up through an opening in the glass-domed studio roof to range the night skies; below them were long benches fitted with microscopes and magnifying glasses, set out for the intricate study of plants and insects. Along the far end were bigger benches with larger equipment used obviously for the dissection of human corpses, for a half-opened head with the tongue pulled out lay beside a sketch-book.

Leonardo, taller than any and beautifully dressed in coloured silks and velvets (he gave up sculpting since he hated grit and dust getting into his clothes), strode from one set to the other. Background music played non-stop, giving rise to the oft-repeated assertion that the smile of the Gioconda was in appreciation of the music and singing and jokes put on for her entertainment while posing. Everyone knows that

Leonardo is supposed to have told the financier: 'We shall want a dozen violin players to keep the sitter in a bright humour. If you like, we will add some singers and a few buffoons, so as to vary the monotony of the instruments.' But it is likely that he made the request tongue in cheek, with plenty of ideas of his own for keeping Lisa in 'bright humour'. She probably found infinite entertainment watching the scene enacted on the studio floor from where she sat in her high-backed chair up on the dais, as though she were in a box at the ballet. She could observe the tricks of the students. Cesare de Sesto who was jealous of Boltraffio; Francesco Melzi who made Andrea Saliano fetch and carry for him, but they all ganged up against the handsome graceful Biezzi, nicknamed Sodoma, the boy whom Leonardo made his heir and who was the most stupid and spiteful of the lot. One of Leonardo's critics wrote: 'None of them was much good at painting, but oh, they had long eye-lashes.'

Judging by Leonardo's notes, his models spent tedious hours waiting around while he stopped his painting in order to do a bit of research. If, for instance, he had trouble in finding the exact turn of the wrist, he would call to Cesare or Francesco to bring him an arm from the big cupboard where they stored the odd limbs, and Lisa could watch when they cut through to show just how the tendons pulled the muscles. Similarly, Lisa may or may not have enjoyed the experience of being the first person whose portrait was painted with that haunting glance that seems to follow you from wherever you look at the picture. For this was no slick gimmick. It entailed going through a dozen heads of corpses, Leonardo and the boys yanking the eyeballs out of their sockets, turning them this way and that to catch the reflection of light that gave the illusion of shifting focus. But he never, so far as we know, exacted realism from La Gioconda in the way he did from his other models, as in one case, for instance, when he tied a girl's hands behind her back and twisted the ropes from time to time, as the quickest way to get a sufficiently tortured expression on her face for a martyr.

Leonardo, with his customary slowness and notorious habit of not finishing most of the projects he started, kept Mona Lisa posing all of the four years between 1503 and 1507. In the beginning, we hear, Gioconda himself accompanied Lisa to the studio, but he was not the type to enjoy the trials of art. There is one incident on record when he escorted her to find Leonardo working on the anatomy of a sheep. Leonardo held the close-coiled intestines in the hollow of his hand—'See how miraculously compact'—and then hung them in the corner of the studio, took a blacksmith's bellows and blew them up and up until

they became so inflated they spread out into the room. Enthralled, the wide-eyed boys and the rather stout merchant and his quietly smiling wife crowded into a corner, as bigger and bigger swelled the horrifying tubes. Leonardo was elated to have demonstrated one of nature's marvellous workings, which always exalted and delighted him. Gioconda hated it and wondered at Lisa's interest; perhaps he wished that she would take that 'inscrutable grin' off her face once in a while.

She made it known that the research intrigued her, as did the mechanics of the many experiments being carried on by the machine-age-minded Leonardo. She watched it all with that detached expression which delighted him. Numerous theories have been passed down the years since the Smile first cast its spell. Conti wrote: 'A woman's life, reserve and seduction, devoted tenderness and demanding sensuality, good and evil, cruelty and compassion, graceful and catlike . . . she laughs.' Our contemporary novelist Laurence Durrell is less reverential, a character in *Justine* comments that 'the Mona Lisa looks as though she has just finished a meal of her husband and is licking her lips'. Leonardo himself thought that Lisa's smile was too magical to be merely female, and would be more appropriate to a tantalizing boy figure; thus her mysterious expression and peculiar glance are seen on every face he

too big for Mother's knee

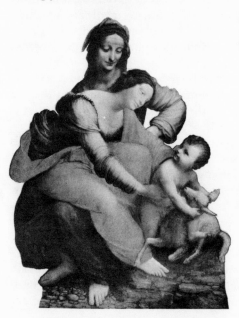

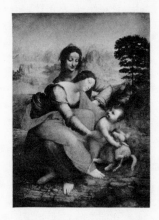

painted or drew after their meeting. This fusion of male and female beauty can be recognized in John the Baptist in the Louvre and in both the female figures, Mary and St. Anne in Leonardo's famous cartoon (being rather larger than the model posing as St. Anne she is slipping off her 'Mother's' knee).

Lisa's own sex seems to have become confused in this sexless sphere. Long after it was too late to prove otherwise, writers hinted that the model who sat for the Mona Lisa was a man and not a woman at all. Anyway, it is usually assumed that some unfeminine streak in the woman attracted Leonardo, who had once been arrested on charges of homosexuality involving a particularly dubious type of male prostitute. Psychologists have given much time to analysing the smile that plays around the lips of Leonardo's 'pretty boys with feminine tendencies and girlish limbs'. Freud explains why Leonardo put the same head on men and women, the elongated neck and sensuous lips known as Leonardesque. These youths 'do not cast down their eyes but gaze mysteriously triumphant as if they knew of a great happy issue concerning which one must remain quiet, the familiar fascinating smile leads us to infer that it is a love secret'. Again Freud tackles the Leonardo complexes in a simple little booklet entitled: *Jarbuch fur psychoanalustische und psychopathologische Forschangen* or *Phobias of a Five Year Old Boy* dealing with the theme of the dream Leonardo is said to have related to Mona Lisa during the countless sittings. 'I was lying in my cradle and a vulture swooped down on me. He kept pushing his tail into my mouth.' Freud may find therein a clear sign of passive homosexuality, but the peasants of the Renaissance would have told you that there were only female vultures. Males were not necessary in their sex life; the wind did it. 'At certain times the vultures stop in the midst of a flight and let the wind blow into the vagina to impregnate them', and this is the story that is supposed to have made the Mona Lisa smile.

Another belief concerning the complicated sex make-up of this famous couple is that both wrote 'looking glass' handwriting, reading from right to left, which was supposed to signify unusual sex development, the fusion of male and female in a left-handed physical beauty. It is perhaps relevant that he left only one drawing of female anatomy and this 'of woman's internal genitals, the position of a child in the womb and such'.

Meanwhile, years went by and the space on the wall in the Gioconda's dining hall was still empty, waiting for the great da Vinci portrait. There was always something afoot to hold up its completion; she must pose for a choirboy (which made jealous young Francesco cry) and she

had that tricky pose as St. Anne, not to mention Mary, and the male saints.

Then on November 3rd, 1507, when work on the portrait was resumed for the first time in months, all the candles were lit and the mysterious gloom established and the magic excitement of studio life had reached full height, Mona Lisa Gioconda got the toothache.

She had come rushing out as the gathering clouds (and Leonardo's recently invented weather forecaster) had signalled that welcome mists and fog and rain would soon take over from the long spell of tiresome sunshine. Anxious not to lose a moment of this precious dark weather, she had flung on a cloak and arrived soaking wet at the studio (Leonardo had not completed his new formula for making fabric waterproof). Whether it was the chill or sitting by that open window with the draught sweeping in from the dim and windy landscape outside, or whether it was just her age, the result was two nights and two shattering days of pain. In the end, she was only too thankful to have three teeth, two front ones and an eye-tooth, pulled out.

When she had recovered sufficiently from the shock and bleeding to return to the studio, she took up her pose with her hands folded on the table before her, rolled her eyes to get that distant look and smiled her famous Mona Lisa mystery smile. And Leonardo saw that the curiously alluring line of the lips was now destroyed. The flickering candlelight, however soft, couldn't hide the sunken cheek and the lost contour of the lower jaw line.

Leonardo got to work on an idea that had often crossed through his mind—a plate. He hauled some of his dead bodies out of the corner, found a couple of beggars he'd bought fresh that Monday and started to yank out the teeth to replace those missing in Lisa's mouth. Now a model will do a lot; many have suffered amazingly for Art's sake, but the refined Florentine lady was not at all happy to have those unsavoury teeth in her mouth. Also, they would not stay firmly on the wide copper bands that Leonardo forged, however carefully he worked out the balance. Lisa's gums became sore and sensitive; the teeth, even when filed down, still bulged. It seemed that the then unknown science of cosmetic dentistry must remain unmastered, even by the greatest man of his day.

Soon Leonardo went off to Paris, taking the unfinished portrait with him. Lisa's husband having refused to pay for it, Leonardo got the best price he could from the French King, for he couldn't bear to be reminded of that unfathomably mysterious charm that he had caught just in time. . . .

Mona Lisa need not have repined. She had won her share of immortality. For four hundred and fifty years her face has 'caused every man to lose his head who has paused to gaze'—except perhaps a few; in October '71, Mr. Brezhnev, Secretary of the Soviet Communist Party, commented as he passed the picture, 'a plain, sensible-looking woman'.

8. VIOLANTE, CECILIA, LAURA and the DUCHESS OF URBINO
The girls with titian-red hair

Venice in the early part of the sixteenth century was more Hollywood than Hollywood in its heyday, complete with all its show-biz characteristics, with the mighty Titian playing the part of producer of the big scene and promoter of glamorous girls and voluptuous women.

The artist's model developed traits of the show girl as we know her today. Fashions were sensational—the women clopped about in shoes with high platform soles, enforced by jealous husbands to make it difficult for a wife to scurry from one bedroom to another. The painters now turned out pictures for collectors to hang on their walls rather than for churches, and the girls who posed for them were no longer expected to wear holy expressions and push their hair back under a coif in the conventional style decreed for religious purposes. Taste switched towards vivid, colourful girls and Titian went the whole way with his passion for bright auburn redheads, the hair colour known since that day as Titian Red. Only happy when painting solid Venetian types with their plump arms and big bottoms, Titian persistently refused assignments offered by noblemen in other parts of Europe who invited him to their courts to paint their women. He replied to one and all 'I could not think

of leaving Venice where I have the best possible convenience of models.'

Violante was the first girl to be featured in Titian's pictures. He was working at that time with Giorgione (the ill-fated young genius of whom little is known) and Palma Vecchio, who was then making his name as a painter of the particularly splendid type of rich blonde which Violante typified. She posed for the three of them, separately and to-gether. We know that Giorgione was seriously in love with her and Titian was attracted to her in some way as he writes that he 'loved her like a lover', whatever that may mean. There is one reference to her being the daughter of Palma Vecchio by a Gypsy model and using his name, calling herself Palma Violante, but as Palma Vecchio was at the time in his twenties he could hardly have had a nineteen-year-old daughter.

In Giorgione's most famous painting of her she is holding bunches of violets, though in character Violante bore no resemblance to a shrinking violet, for apparently she organized her three employers with scant respect for the illustrious places they were fated to fill in the art world of the future. The rustic-scene picture was just coming into fashion and artists were trying out backgrounds of extensive panoramas and working on vast vistas like aerial views. There was a demand for country settings. Customers were buying Holy Family pictures if the characters were sitting in a field, or a nude if there were trees and clouds about; hence Violante shepherded her artists off on their perpetual picnics, Titian looking beautiful in his velvet cap with a feather flopping in front and voluminous silk sleeves beneath his jerkin, Palma Vecchio with his flute, Giorgione carrying the wine and Violante laden with most of the painting gear as well as the food. Fortunately at the end of the trek she could strip off and sit still. The three artists made scores of sketches of her nude on the grass playing the recorder in various versions of the *Concert Champêtre* theme, relaxing with the others after their picnic. Each of the three would draw the other two men with Violante, she stark naked but both her male escorts fully dressed as in the *Concert Champêtre*, which shocked no one at that time, although a couple of centuries later when Manet cribbed it for his *Déjeuner sur l'Herbe*, it caused a furore and was thrown out of the French Academy. It has been said that the 'almost brutal directness of Titian's nudes has an un-aphrodisiac effect' which can be equalled in this present day of over-exposure.

Palma Vecchio, being more religiously inclined than the others, used the same pastoral settings for his Holy Family studies. Violante took time off to become *Madonna of the Cherries*. With one of the men and a

Violante

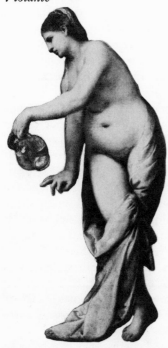

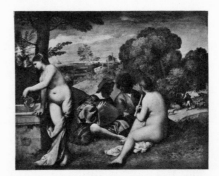

babe borrowed from a peasant, she posed for the *Holy Family in the Meadow* and *Holy Family in the Field.* But the most famous picture from this picnicking epoch centred around a picturesque well. In the now famous picture variously entitled *Sacred and Profane Love, Artless and Sated Love, Two Maidens at a Fountain,* Violante posed first as one and then as another for all the girls who are seen moving around the well. She was happy and glowing in the admiration of her escorts. 'She is an adored nude,' Blake says. 'She had the lineaments of gratified desire.' And Kenneth Clark says, 'She is generous, natural and calm.'

This same favourite spot was used as background for other pictures which remained unfinished, for a reason we now know. 'The well smelled most foul.' After the last visit, when they returned to the studio Violante was so ill that the Nursing Sisters had to be called to fetch her away. 'Plague,' they said. She begged for Titian to come to her bedside; but though he again proclaimed 'he had all the affection for her of a lover', he declined, being unusually health-conscious. Indeed, he was to live to be nearly a hundred. The devoted Giorgione went alone; took Violante in his arms and kissed her—a fatal kiss, for although Violante

recovered, the brilliant but always delicate artist caught the plague and died, not yet thirty-two.

He would never paint Violante again, but neither would Titian nor anyone else, for the plague left her ravaged; her rich bronze hair fell out and her limbs withered. Sadly Palma Vecchio told her that he would have to find another model to take up to the fields for his *Madonna of the Harvest*.

Thus Cecilia appeared on the scene, a splendid girl who later became Titian's favourite model and his love. But at the time he rejected her because of her mouse-coloured hair. Cecilia's father was a hairdresser, who was experimenting in 'tinting'. He mixed his special chemicals into a paste which he spread all over her hair and then took her up to the flat roof and sat her down in all the heat of the midday sun. Her hair bleached all right, but her face and shoulders blistered and she got sunstroke. Undiscouraged, they tried again. This time Cecilia wore a wide-brimmed hat with the crown cut out; her hair, spread all over the brim, bleached while her face and neck were shaded. The result was a great success, a glowing redhead effect which was much publicized by the hairdresser as 'Titian Red'. It became a new craze among the Venetian smart set. One writer describes the sight of the ladies of fashion undergoing this latest beauty treatment as looking like 'a mass of burning mushrooms shooting up on the rooftops'.

Now Titian was delighted with Cecilia and she had her first baby by the following Christmas, followed by four more children in five years, for Titian preferred his models to be pregnant. 'Paint women only when they are ripe and ready to conceive' was his advice to pupils.

Eventually Cecilia started to feel the strain of non-stop child-bearing for the sake of an art that entailed hours of cramped poses with aching back and swollen ankles. She demanded at least the security of wedlock, for she suspected that Titian's interest in her was on the wane—and what would happen to her and their children should she lose her job? Determined that they must be legitimized, she played upon Titian's love for his many sons and daughters to persuade him to marry her for their sakes. By this time he was well under her thumb for, as she had settled into being first lady in Titian's opulent and lavish household, she had developed the bossy and avaricious attitudes which, unfortunately, sometimes show themselves in such circumstances.

A writer of the last century writes in a chapter headed *Henpecked* thus: 'Cecilia, the wife of the great painter Titian, is known to have been a domineering, dictatorial woman who insisted that her husband should render an account to her of every item of his expenditure. The painter

was very wealthy but the poor man was often put to the sorest straits to buy a glass of wine without letting his wife know anything about the transaction.'

The wedding was unnecessary, as it turned out, for almost immediately afterward (one source gives it as two weeks, others up to three years) Cecilia died in childbirth. At her funeral Titian received the news that he was to be made a Knight of the Golden Spur, an honour which carried with it the privilege of legitimizing any baby 'born of a father below the rank of Prince, Count or Baron', so he could have legitimized his children himself without marrying poor Cecilia. She left her eldest daughter Lavinia to step into her shoes; a big strapping girl, she is best known as the Venus and Salome, though she figures in many of Titian's finest nudes.

Now as an important citizen, having taken over from Giorgione as 'Painter to the Republic' and with his additional new honours, Titian took his whole family to live in his sister's house in Beri, a suburb of Venice, where the garden sloped down to the canal, making a perfect setting for water fêtes and gondola scenes. Titian must have been the first artist to employ a publicity manager and the burly, flamboyant Pietro Aretino was possibly the first artist's publicity agent to take on the job of steering an art celebrity. He worked in much the same way as his modern counterpart, surrounding his client with gorgeous girls and big names. The crowds packed the opposite banks to watch the showily dressed Venetian beauties and their escorts arriving in their private gondolas, eager to see any 'happening' staged by Aretino to draw attention to the new model of a forthcoming picture.

The flashiest courtesans of the town vied to be chosen for a Titian painting, and invariably their rich protectors bought the finished picture. One of the loveliest of these was the lithe and sinuous Laura Dianti, a girl of humble origin and poor reputation, who had the Duke of Fararra paying her bills. She is seen in her first picture wearing a skimpy fur around her neck and otherwise nude. This painting, pointedly entitled *Girl with a Fur*, was doubtless intended by Laura as a gesture of gratitude to the Duke for this little necktie, and to encourage him to think in bigger terms—perhaps a sable cape—for the colder weather. Next came the now famous *Flora* by which name Laura was hereafter usually known and which earned her the reputation of 'the most gracious strumpet in art'. Here she is holding a full-blown rose, Aretino's idea of a telling visual image, to put over his idea that roses were much more suited to her character than violets. 'Not the maiden, but the woman with the roses she has plucked,' he explained.

Laura

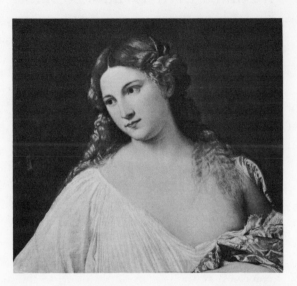

After this, things between artist and model seem to have got a bit out of hand, though Laura was clever enough to hoodwink the Duke while openly tangling with Titian. She posed for the well-known series of paintings, all of which are labelled *Titian and His Mistress*. One of these, now in the Paris Louvre, shows Laura brushing her hair and is catalogued as *Laura Dianti at her Toilet*; the man dodging around holding up mirrors for her to see the back and side views was originally intended to be Titian. However, Aretino in his PR capacity persuaded the artist it would be more diplomatic to paint in the likeness of the Duke instead of himself. In fact he went further and succeeded in talking His Grace into marrying Laura, who thus became Donna Laura d'Este, Duchess of Farrara.

'I have no prejudices against nude Duchesses,' Titian told his friend, but he had not bargained for his next one, the Duchess of Urbino, the vain and ugly wife of the Duke of Urbino, who happened to be Titian's most profitable client, regularly ordering portraits of his family, including several of the Duchess. One evening after dinner, when slightly in his cups, Urbino confided that his wife had been pestering him to commission Titian to paint her unclothed. The great man must have been appalled at the prospect, for had he not always instructed his pupils: 'Never paint an old woman under any circumstances'? But Aretino insisted it would be unthinkable to offend the Urbinos and proposed a compromise. He suggested they might hire from the local brothel Titian's favourite and most seductive girl to pose for the body,

Duchess of Urbino

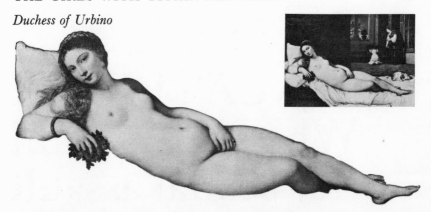

sticking on a glamorized portrait of the Duchess for the head. When Her Grace saw the finished picture she was delighted, especially as it was dubbed the *Venus of Urbino*, and judged by Vasari as the most beautiful nude that Titian ever painted. Was the Duke at all surprised, we wonder? We only know of his remark to Aretino: 'If I could have had that girl's body even with my wife's head I'd have been a happier man.' At which quip, so the story goes, Aretino laughed so heartily that he had a stroke and died.

The Duchess, quite convinced that no one doubted she was the authentic model, became obsessed with being 'undraped'. No more formal portraits in regal court attire for her. The Duke commissioned a Grecian myth theme, much in vogue at the moment, with the proviso that his Duchess be included in the cast. Titian, now ageing, took the opportunity of assembling a grand bevy of nudes into one composition under the title of *Diana and Callisto*. There are two versions of this picture and in one the Duchess appears as the nymph Callisto; Diana amidst a crowd of naked nymphs is revealed to be pregnant, obviously by the God Jupiter. The poor old Duchess was sadly mortified when none of the art critics who acclaimed the picture recognised her as the young Callisto; moreover when she contrived to have the fact rumoured around, they seemed to be in league to refute any implication that an elderly woman of high rank would permit herself to be involved in such goings-on. 'Would a Duchess allow herself to be painted nude?' scoffed the leading art commentator of Venice.

Sadly the Duchess told Titian, 'You will never paint a more beautiful woman than this,' and she was right; he never did, for as he got towards a hundred, Titian seemed to lose interest in beautiful women, complaining that 'the pleasures of the flesh are spent and mistresses useless'.

9. CATERINA
Who sued Cellini for sexual assault

It is difficult to imagine that, way back in 1540, a no-account little French waif sued the foremost goldsmith of the Renaissance. The charge—sexual offence.

Caterina posed for Cellini's greatest work, the famous golden salt-cellar, as well as for the *Nymph of Fontainebleau* and a score of ornamental bronze and silver pieces. And she suffered more than most in the creating of them. In her case, however, there was no question of high-minded sacrifice for Art's sake: it was all passion and fury and uninhibited intercourse; and indeed wallopings and sadistic enforcement of posing for hours in impossible positions. Although according to Cellini she was a savage, grasping little street-girl, backed up by a scheming mother, he was, at that time at any rate, completely enthralled with her, and without her there would have been no salt-cellar for the King of France. But apart from acknowledging her value as a model of great beauty and the pleasure he had from possessing her, Cellini does nothing but revile her as a vicious drab, a little hussy, a young wretch. He writes of her with so much feeling and at such length, however, that there is no doubt that—oddly matched as they were, and whatever perversions they indulged in—they could not stay away from each other.

Caterina was barely sixteen, and already a prostitute, when she started her sordid liaison with Benvenuto. He was searching for a model to express the new type now becoming fashionable among the French, who were already developing their much-vaunted sense of style and considered it smart to portray a nude figure elegantly slender, with elongated arms and legs. Always anxious to be in the forefront of fashion, Cellini now rejected with scorn the voluptuous brunettes of Raphael and the stalwart blondes of Rubens, and went further than any

contemporary French artist in distorting female proportions and stylising the pose. As models, the girls from Normandy were usually taller and longer-limbed than the short-legged Latins of the South, and Cellini found one of these in Caterina—'a very handsome girl'. But even she could scarcely have had those remarkable measurements—for example, legs six times the length of her head—which one notices in the *Nymph of Fontainebleau*, the first figure for which she posed. In this painting, she looks like a fashion plate: ornate, useless, unreal, although somehow more provocative than the traditional, child-bearing females who, while ready and willing for rape, are much less tempting.

Caterina and her mother were installed in the servants' quarters in the château outside Paris, which the King had lent to Cellini in which to carry out his commissions. Caterina spent her days posing in the studio and her nights in the master's bed. Cellini had come a long way in a very short time. At eighteen he had run away from home in company with Fransesco, son of Filippino Lippi and grandson of that gentle nun, Lucrezia Buti. The two young men trained together to become gold-smiths and Cellini says, 'Such love grew up between us that day or night we were never apart.'

But however much he loved Fransesca, he soon became a fantastic womanizer and served a couple of prison sentences for 'moral offences' as well as becoming involved in countless brawls and killings. His famous autobiography is full of boasting descriptions of gangster-like violence including slashing off his enemies' limbs.

A braggart, a bully and a wild extrovert, he was, amazingly, a superb craftsman and a perfectionist, fast becoming recognized as the greatest living goldsmith. As things became too hot in Italy, he escaped to France and with his followers lived in luxury under the Royal patronage in what he called 'his castle'. He had tennis-courts and servants . . . and Caterina. Or had he? How sure could he be that she was not whoring around with every apprentice and foundry-worker? Caterina was not subtle enough to disguise her roving eye or to pretend that she could ever be 'respectable'. She wondered how he could expect her to play the naughtiest role one minute and the next moment vow to stay alone with her mother while he was away. He didn't trust her and when he next took a day off to go to a garden party given by an engraver friend, he asked his assistant, Pagolo Micceri, to stay behind and look after things. Pagolo was not only a fellow Florentine but a prissy and pious lad, 'always muttering psalms and telling beads'. Benvenuto confided in him, 'You know that poor young girl, Caterina; I keep her prin-cipally for my art's sake, since I cannot do without a model; but being

a man also, I have used her for my pleasures, and it is possible that she may bear me a child. Now I do not want to bring up another man's bastards, nor will I sit down under such an insult. If anyone in this house had the audacity to attempt anything of the sort, and I were to become aware of it, I verily believe that I should kill both her and him. Accordingly, dear brother, I entreat you to be my helper; should you notice anything, tell it me at once; for I am sure to send her and her mother and her fellow to the gallows. Be you the first upon your watch against falling into this snare.' Pagolo crossed himself violently. 'Oh, blessed Jesus! God help me from ever thinking of such a thing!' Pagolo reassured Cellini, his timid soul showing terror at the awful threats. He vowed that he would never leave the house but would spend his time in religious exercises while he kept watch.

We will never know whether Pagolo was a double-crossing hypocrite and already having-it-off with Caterina at odd moments behind his employer's back. Or did Caterina seduce him to get back at Benvenuto for his bad treatment of her? The fact remains that Pagolo and Caterina were making love in the studio when Caterina heard her mother rushing down the passage calling, 'Pagolo, Caterina! Here comes the Master!' Benvenuto describes how he had returned home unexpectedly and caught that little wretch Caterina *in flagrante*. Cellini, in his flamboyant style, dramatises the rather corny situation; how he found the two of them in dishevelled state, looking terrified and guilty, not knowing what they said, nor, like people in a trance, where they were going. 'It was only too easy to guess what they had been about. The sight drowned reason in rage, and I resolved to kill them both. The man took to his heels; the girl flung herself upon her knees, and shrieked to Heaven for mercy.'

Benvenuto confesses that, in his fury, he would have killed them both, but realized in time that, with his record, he'd stand a poor chance in another murder case. So he threw them out, all three: the girl, her mother ('that French bawd') and the craven Pagolo, 'slamming into them with fist and foot' as he hurled them down the studio steps.

But Caterina did not always take things lying down. She straightway went off to consult a lawyer who came from her own village in Normandy —an insular man, and, like many French, suspicious of Italians and convinced of their wicked sex habits. He was sure that Cellini must have forced Caterina to comply to love-making in the 'Italian fashion' and, moreover, that threat of exposure would be certain to force a substantial cash settlement.

So he coached Caterina carefully until she was word perfect. They

had it all tied up and Cellini was in real trouble. The charge brought against him of using the young Caterina in the 'Italian manner' could mean the gallows. International law on this crime was a bit confusing. In France the crime was 'Italian manner' while in Italy it was known as the 'English fashion'; and in England they came down on anyone behaving in the 'French fashion', but in any language it meant gaol, and for Cellini, with his record of violence, a likely death-sentence.

Apparently none of this intimidated Cellini. According to his report, he, followed by a band of his faithfuls, pushed his way into the court-room and called boldly for the judge. All that perturbed him was the sight of Caterina and her mother with their lawyer, laughing at him.

But from then on, Benvenuto took over . . . that is, if there is any truth in his bragging version of the proceedings to follow.

Judge (in a subdued voice): 'Although your name is "Benvenuto", this time you are not "well come".'

Benvenuto: 'Get on with things quickly. Tell me what you have got me here for.'

Judge (turning to Caterina): 'Caterina, relate all that happened between you and Benvenuto.'

Well primed, Caterina then reeled off her story that she had been used in the Italian manner.

Judge: 'Benvenuto, you hear Caterina's accusation?'

Benvenuto: 'If I have had relations with her in the Italian manner, I have only done the same as you folk of other nations do.'

Judge: 'No, no. Caterina means that you have improperly abused her.'

Benvenuto: 'Far from being of Italian origin, what she describes must be some French habit—as *she* seems to know all about it, while *I* am ignorant of what has supposedly been done to her. Let her explain precisely how I consorted with her.'

So Caterina proceeded to tell the court. 'The impudent baggage entered into plain and circumstantial details regarding all the filth she lyingly accused me of,' recounts Cellini. When she had finished, he asked her to repeat it. And then again. And then for the third time. After which, he got up and in a loud voice made his plea for justice.

Benvenuto: 'I know that in this sort of crime both agent and patient are punished with the stake. This woman confesses her guilt. I admit nothing whatever of the sort with regard to her. Here also is her go-between of a mother who deserves to be burned for either one or the other offence. Therefore I appeal for justice. The girl and her mother must be sent to the stake. To the stake with them both! To the stake with them both! To the stake with them both!'

Cellini continued shouting his venomous demands. Caterina appears to have crumbled under the onslaught and she and her mother were soon in tears as Benvenuto's shouts drowned every other sound in the courtroom: 'Fire! Fire! To the stake! Fire! Fire!' and then he threatened the judge that he would report him to the King for miscarriage of justice if Caterina were not sent to prison on the spot.

The judge was entirely deflated, boasts Cellini, mumbling apologies and making excuses for the feminine weakness of the two women.

So all cock-a-hoop, Benvenuto, followed by his cortège, stamped out feeling more than a little pleased with himself. He says, 'I thanked God with all my heart and returned in gladness with my young men to the Castle.'

The most incredible part of this whole unsavoury episode is that Caterina, without any hesitation, followed him home, proving that whether he made love in the Italian manner or the French fashion it was bliss as far as she was concerned, whilst he, despite having done his best to get her burned at the stake, admitted that he would never find

Caterina

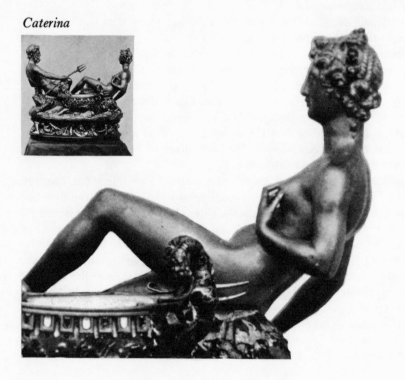

her equal either as a model or a bedmate. So she resumed her poses for the salt-cellar, suffering hours of aches and pains from trying to balance herself in that strained and difficult position, until, in due course, he went off to have a row with the King. While he was away, Caterina decided to return to Pagolo who had found a house for her and her mother nearby. She knew Cellini would probably murder them but perhaps she relished these highly charged scenes, or perhaps she would risk getting her throat slashed rather than take any more bullying. Or, again, perhaps she had come to love the quiet and timid Pagolo who was so devoted and kind to her.

The two of them stayed quietly in their new house. They were prepared for Cellini. When he came they were sitting side by side and Pagolo had one arm around her shoulders while in the other hand he held a dagger. All this Cellini noted as he charged in. He admits he was mad with rage and ready to kill, for on his return he had found people sniggering as he passed, jesting over the predicament in which the boastful Cellini now found himself, and he could not tolerate mockery. He was like a mad bull lunging at Pagolo's throat. Little wonder that meek youth once again lost his nerve. He did not raise a finger to protect himself; all he did was to yell, 'Mother! Mother! Help me!' Cellini says his rage abated on hearing this idiotic exclamation and he suddenly had an idea for a more subtle revenge. At the point of the sword he forced Pagolo to take the ring from his finger and marry Caterina.

Not only was he burdening his victim with a little vixen for a wife— surely enough punishment for any man—but he had more complicated plans which he carried out after he had called for a notary to make the marriage legal and binding. Cellini writes: 'I employed her for thirty sous a day plus a good meal. For this I made her pose for me naked. Then I made her serve my pleasure out of spite against her husband, jeering at them both the while. I kept her for hours on end in position, greatly to her discomfort, causing her as much annoyance as it did amuse me. For she was beautifully made and all envied me such a model.'

Caterina stood it for so long and then started to demur that he did not now treat her with the same consideration as before her marriage, in fact, she received no consideration at all. Cellini considered that she was extremely disagreeable and rude, always prating on about her husband. 'The mere mention of the fellow roused me to an intolerable fury. But I put up with it as well as I could, telling myself that I'd never find another model so suited to my special art. Also, by misusing her, I was having my revenge on her husband and at the same time in-

flicting the discomfort of posing in strange attitudes for such a length of time. What more could I desire?'

All this petty spite showed Cellini's unpleasant nature though obviously Caterina knew how to infuriate him. But now she was going too far. What happened in this episode is well known and has been often quoted from Cellini's memoirs. 'The little wretch redoubled her insulting speeches, always prating big about her husband, till she goaded me beyond the bounds of reason. Yielding myself up to blind rage, I seized her by the hair and dragged her up and down my room, beating and kicking her till I was tired. There was no one who would come to her assistance. When I had well pounded her she swore she would never visit me again. Then for the first time I perceived that I had acted very wrongly; for I was losing a grand model, who brought me honour through my art. Moreover, when I saw her body all bruised and swollen, I reflected that, even if I persuaded her to return, I should have to put her under medical treatment for at least a fortnight before I could make use of her.'

When he had calmed down a bit Benvenuto yelled for his old cook Roberta who was shocked to find the girl beaten up and bleeding. 'Rub a little bacon fat into her worst wounds,' he directed and he noted in his diary 'after rubbing the fat into her wounds they ate what was left of the meat together'. She then helped the weeping Caterina to dress who went off home cursing all Italians.

Forthwith Roberta turned on Cellini and gave him a piece of her mind, calling him a cruel monster for ill-treating such a handsome girl so brutally. Nor would she listen to his excuses of how the slut had double-crossed him. It didn't matter, she insisted, what tricks the young woman had played and anyway, it was only the normal behaviour amongst the French . . . there wasn't a husband in France without his horns . . . she was quite sure of that.

Somewhat reassured, Cellini now urged Roberta to go fetch her back immediately. Scornfully, she refused. 'Leave her alone and she'll turn up in the morning, but if you show all that concern she'll give herself airs and keep away.'

Sure enough he was awakened soon after dawn by 'someone knocking so violently that he ran to see if it could be some madman or a member of his own family', and there was Caterina who laughingly threw her arms round him, asking him if he was still angry with her and would he give her breakfast.

Cellini goes on to state that he not only gave her food but, as a gesture of reconciliation, he actually ate with her at the same table.

'Then I began to model from her, during which some amorous diversions occurred,' he continues, which shows that bacon fat is a splendid remedy when a model gets beaten up. After a few hours, however, Caterina became restless and started taunting him just as on the previous day 'and at last, just at the same hour as on the previous day, she provoked me to such an extent that I gave her the same drubbing. So for several days we went on like this repeating the old round like clockwork . . .'.

Whatever might have been the effects on Caterina, being young and strong she apparently survived it and Benvenuto reached the zenith of his career. The salt-cellar, wrought of solid gold, stood twelve inches high, entirely covered with finely chiselled figures and ornate decoration. When the King saw it he 'uttered a loud outcry of astonishment and could not satiate his eyes with gazing on it'. Before delivering it finally, Cellini invited several of his best friends to dinner and with the salt-cellar on the table celebrated its first time in use. We do not know whether Caterina was allowed to appear at that party but she certainly deserved credit for inspiring the artist just as much as did any pure-minded muse.

She continued to pose for the ornaments Cellini wrought so skilfully in gold, silver and bronze, the jewellery, the grilles, the statuary and the gates, until the fierce love-hate relationship suddenly ended.

How it actually finished we can only gather from his own words, 'I had done forever with the disreputable Caterina.' She and Pagolo moved out of Paris and he had no option but to find another model to replace her for the unfinished *Nymph of Fontainebleau*. He found one, a poor girl of about fifteen. She was a beautifully made brunette. 'Being somewhat savage in her ways, silent and quick of movement, with a look of sullenness about her eyes.' He nicknamed her Scorzone—which is in Italian 'the rough rind', a name given to rustics. Scorzone is also the name for a little black snake—her real name was Jeanne.

Scorzone soon became pregnant and gave birth to a daughter on June 7th, 1544, when Cellini was just forty-four years old. He finished this episode with: 'This was the first child I ever had so far as I remember. I settled money enough upon the girl for dowry and from that time forwards I had nothing more to do with her.'

Nothing about her appears in the famous *Memoirs of Benvenuto Cellini* but his biographers have traced the legal documents from the complicated court proceedings, in which for the second time Cellini-versus-his-model had to come before a judge. This time it was in Florence, not in France, and the model involved was married and a mother; and this

time he was an older man with none of the fiery temper from which poor Caterina had suffered. Indeed he cuts rather a pathetic figure, and maybe he had acted from only the best intentions.

For many years he had had a model called Dorotea, a tall blonde with two young children and a no-good husband, Dominico Paragi. On one occasion, after a brawl, Dominico was clapped into the Stinche prison. The family was left with only Dorotea's earnings and 'out of pity and the goodness of his heart', Benvenuto said, he took all three of them to live in his house. Later Dorotea maintained that he wanted her to pose for him, and this was the simplest answer. Be that as it may, Benvenuto not only housed and fed the lot but also paid for Dominico's board in prison. Furthermore, he decided to adopt the young Antonio, Dorotea's son, and settled a thousand crowns on him which he would inherit at the age of eighteen on condition that he became a sculptor. But the poor lad was not cut out to be an artist. According to Cellini he was like his father, 'stupid, ill-conditioned and intractable', and there was no other course to take than that which was customary with such maladjusted boys—he was sent to be a friar.

But Dorotea had not let Benvenuto have her son in order to shut him up in the Franciscan Convent of the Nunziata. She had built up a picture of the *dolce vita*, the sweet life, from which they would all benefit. There ensued the sort of row which often crops up today in similar circumstances. Benvenuto, fearful of a bad influence, forbade his adopted son to see his real father, and when he found that his orders were ignored and the family was as united as ever, he flew into one of his rages and proceeded to cancel all his commitments towards Antonio, 'to wash his hands of the whole affair' as he wrote to his lawyers. But neither Dominico nor Dorotea would stand for that; they took the matter to court and sued for maintenance of their son, or alternatively they would accept a part of Benvenuto's estate in settlement. They won the case and Cellini was ordered to support Antonio. Refusing to accept this verdict, Cellini went higher and appealed to the Grand Duke. His Grace did not help much; he revoked the claim, but he made Cellini responsible for paying the boy an annual sum during his entire lifetime. Despite the suspicion that such a ruling was bound to provoke, no one has ever seriously implied that Antonio was, in reality, Cellini's son, but a strange fact emerges. During the time all this litigation was going on, Benvenuto Cellini, now in his sixties, married. His late-day bride was Piera Parigi, bearing the same family name as Dorotea's husband, Dominico Parigi, and they named one of their daughters Dorotea!

10. HELENA FOURMENT
Fat and happy and hoisted on high

In contrast to Cellini's boasting scallawaggery and his neurotic-looking models, all of them in constant trouble, Peter Paul Rubens, a gentleman, accomplished, rich and clean-living, forever painting his healthy, bovine giantessess, seems rather dull. And it is true that although the mere mention of his name brings to mind enormous canvases crowded with fleshy women, Rubens is the least sexy of painters; for being monogamous and well satisfied with each of his wives in turn, he had no erotic fantasies to express. As in the case of Titian, the 'brutal directness had the negative effect to an aphrodisiac'. He showed his females as superwomen, too calm and well balanced for coyness.

In the opinion of Herbert Read: 'He made gods and goddesses of his people. To use his wife Helena Fourment as a model for the Virgin was not a gesture of worldliness or scepticism, it was merely a banality, a statement of the factual. It was a realization that the greatest moments of life come, not to those who wait for them, but to those who happen to be in the way.' Helena happened to be in the way when Rubens was ready for a wife. In 1630 he had returned to Antwerp with the intention of settling down after all his travelling to and fro from one court to another, in Europe's great capital cities, for he had become not only one of Europe's foremost painters, but was highly reputed as an influential statesman. He had the entrée to palaces both as an artist and as an arbiter of international affairs. Now he had just finished decorating the Banqueting Chamber in Whitehall, and although Charles I had paid

him handsomely for the job, he was thankful to be home, away from the raw-boned, angular English women and back amongst his plump Flemish girls with rolls of fat that he could paint falling in folds like drapery and billowing buttocks that he could build into interesting patterns on canvas. His host, the Burgher Meer Fourment, had seven overweight daughters, supposed to be the most attractive girls in the Lowlands and reputed to be heiresses, although Rubens refers to the family as 'humble'. One writer describes them as 'each a perfect Northern Goddess, large and meaty, but stately in her health and strength'.

Stolidly they all pegged away to ensnare the handsome, rich and famous painter who, having been a widower for four years, was now ready to replace his beloved Isabella. He had married her on her six-teenth birthday; he writes of her as 'big and strong and built on Flemish lines', which is true to his portrait of them both holding hands as bride and groom, all dressed up in their wedding finery, radiant with health and affluence. She also posed for one of his most famous pictures, *The Descent from the Cross*, and for more than twenty years it was Isabella's face and Isabella's luscious curves that inspired his enormous output of pictures, which poured out in such quantities, and with so many assis-tants to keep the production going at full blast, that the vast studios came to be known as the Rubens Factories.

His first choice for a model among the Fourment girls fell on the eldest, Susanna, who posed for the portrait called *The Straw Hat*, though oddly she is wearing a hat obviously made of felt. But Susanna was already married and without further delay he decided on fair-haired, blue-eyed Helena, only sixteen but already vast with a double chin and fifty-four-inch hips, which delighted him. He wrote to a friend: 'When I found that I was not yet fitted for a life of celibacy I resolved to get married again. I found a young wife born of honest but humble parents. Everyone tried to persuade me to marry a lady of the Court, but I feared the airs of the grand ladies and I was loathe to exchange my precious liberty for the embraces of an old woman.' There was also the consideration that high-born elderly ladies might be unsuitable for all the violent goings-on which were to keep Helena busy for the rest of her married life. True, her first pose was, like her pre-decessor, for a portrait in her wedding dress, and she once wore a fur coat over nothing at all, but Rubens preferred to paint his models nude, adding the costume, if any, from his imagination.

Helena is on record as having no inhibitions. 'She did not blush when I took up my brush,' wrote Rubens, as she well demonstrated in posing

for nineteen portraits and some nine thousand great canvasses, where we can see her being hauled onto horses by her captors, being raped, rescued and dragged about 'exposed to the world, in unabashed naked womanhood', as one American art writer relates of her trials.

And although it may not be particularly unusual for a young wife to pose unblushingly nude for her husband, it must be remembered that Helena had to face a whole gang of assistants, pupils, colour-boys, carpenters, frame-makers and the rest of the huge entourage employed in mass-producing the Rubens masterpieces. Three or four employee artists could work on her at once, one sketching in a leg, another painting her hair, another arranging her arm at a suitable angle, while the others milled around as on some huge movie set. Posing as Andromeda she would cling stolidly to her rock, ignoring the noise and bustle. She would be dragged from the fiery steed by two naked bandits in

Helena

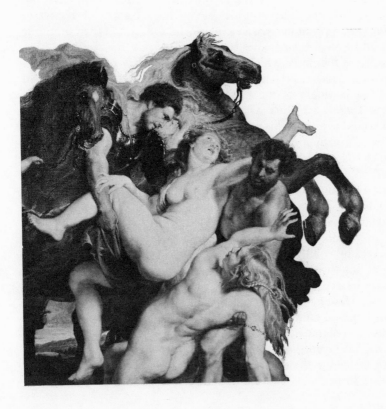

Rape of the Daughters of Leucippus and she submitted unflinchingly to rough handling for *Rape of the Sabine Women*. She remained as placid when crashing down a rock for *Fall of the Angels*, as when she was near drowning in a sea storm for *Angers of Neptune*. Always unflappable and unflinching, Helena interpreted Rubens' visions of 'superb female nudes in vehement action', a feat of endurance when more or less ground based, but far more exacting in the 'aerial abductions' which necessitated being thrown up in the air by an old and sinewy athlete. For each of the nine different versions of *Time Carrying Away Truth* and for each of the eleven paintings of *Boreas Abducting Orietha Through the Sky* she was always airborne, held aloft in mid-air by the muscular old fellow. A regular visitor to the household said: 'She performed all such arduous chores without showing a vestige of temperament; she might have been churning butter.'

Because she was happy and secure, she had no complexes. Kenneth Clark stresses this when he observes: 'Rubens' women are both responsive and detached. To be so well favoured makes them happy but not at all self-conscious. Even when rejecting the advances of a satyr or accepting the Apple of Paris, they are grateful for life and their gratitude spreads all through their bodies.'

These were the poses which gave the opportunity to show the play of muscles in Helena's strong body and the strain on her outstretched limbs. 'The contours of the female nude and the movement of the floating draperies can thus stand out in perfect freedom and beauty,' Rubens would explain to his pupils as his wife sank down for a breather before the old man appeared to toss her up again.

At least Helena, who did all this for Art's sake, had much to compensate her. Not for her the starving and poverty of the traditional helpmeet of genius; they were very rich and Peter Paul paid £20,000 for the Château de Steen with its galleries and formal gardens, terraces and parkland. Like some stately-home owners of today, he made it pay its way. He could use the view and the vistas for his backgrounds, and on his acres he could build even bigger studios and workshops where additional employees could turn out a greater quantity of canvases. Moreover, he could now realize one of his pet projects and have his private zoo. Here he kept the animals that served him as models for his wonderful animal studies, horses, wolves, lions, apes, donkeys, sheep and dogs, in readiness for the great allegories which were always in progress. This arrangement was far more convenient than when they had to be stabled in the studio where, apart from their smell and noise, they added to the model's hazards—especially for a child posing as a

pink plump cherub or for a fleshy Helena being swung temptingly under a lion's nose just before feeding time. Rubens had use for the

Anyone else would look sexy

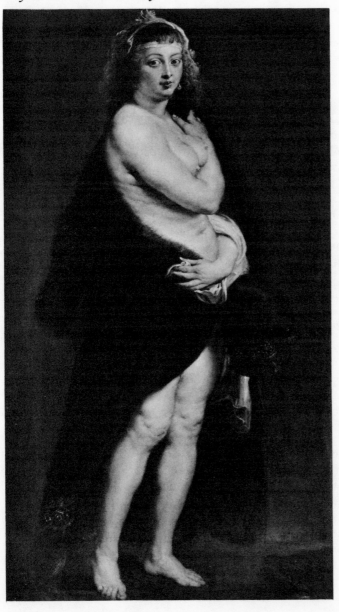

animal skins, too, for he, like many other painters, was absorbed in portraying the contrast between fur and skin texture, which is the reason why we find so many nudes with only a fur around the neck or wearing a fur coat with nothing on beneath. To the uninitiated, these must always seem an unreasonable sort of composition, and Helena, despite their riches, is painted wearing a rather cheap-looking fur coat over her birthday suit. In some cases, the effect can be very sexy, but not on Helena, for nothing about her is provocative. The same applies to her sisters. They were married now with plenty of children, and were often called in to make up a foursome of goddesses or to lie about with their dozens of babies as cherubs, angels, cupids and seraphim. Peter Paul was at his happiest surrounded by the huge family, painting the children at their pranks, one pulling at the hair under a nude aunt's armpit, another tripping up the heaviest Venus, another pinching his mother's stout thigh, and all of them getting under everyone's feet. However happy the family atmosphere, there are always occasions when Art must come first, and we hear, for instance, that Helena had to hold her youngest boy upside down to dip him, head first, in the water for *Thetis Bathing Achilles in the Styx*. It is probable, however, that no one in that commonsense household worried unduly over any harmful psychological effects.

The Rubens family had a high social status and lived in grand style; old books about the town and its inhabitants give proof of the esteem in which Peter Paul and his wife Helena basked. She is listed as performing the duties of hostess at important receptions, entertaining visiting nobility, looking beautiful at state balls, although we know she had probably spent all day in some arduous pose. After ten years of marriage to the great Rubens, after nearly three thousand canvases had been sold and paid for, Helena, at twenty-six, found herself a widow. One wonders if his distaste of undernourished-looking females over-encouraged big appetites in his family, for unexpectedly Rubens, a temperate drinker and never a womanizer, the strongest and healthiest of men, began to suffer from gout and suddenly died of a heart attack at the age of sixty-two. He had lived on the grand scale in every way, in a big house with a big family, with large women around him, painting great numbers of vast pictures. He had no time for the tiny things in art or in life. 'There is no task too large for my brush, but I can't paint little curiosities,' he said. Even after death, things were on a bigger scale for Rubens than for ordinary men. Seven hundred masses were celebrated for him by the religious orders of Antwerp, for 'his soul was too expansive to be content with less', they said.

11. HENDRICKJE STOFFELS
The servant who was model, mistress and manageress to Rembrandt

While Rubens was alive, his young wife had been the most envied and most talked-about woman in Flanders. Her great house, her rich clothes and her famous husband, her youth and strapping beauty created a sort of show-biz splendour around her. It could be said that part of the Rubens cult was to acclaim the marvels of the nudes for which Helena and her sisters posed. Just the same, some people regarded it as slightly shocking that the rich young matron entertaining visiting statesmen in her grand salon had spent the morning stark naked in the clutches of a horseman. How could any have guessed that *The Rape* and *The Reconciliation* would sell as a pair for £350,000 in 1969? But whether from jealousy or prudishness, there existed, especially among the women, a slightly critical tinge to their admiration.

This is well illustrated in an appealing if not authenticated incident included in the dubious memoirs of Van Loen, the author who called himself Rembrandt's doctor. He relates how, when Rembrandt's first wife, Saskia, still in her twenties, lay dying of tuberculosis, he took two specialists from London over to Amsterdam to advise on her condition.

In order not to frighten her, he pretended that they were art dealers who had been staying with Rubens in Antwerp. Highly flattered that such grand people would be visiting her family after seeing Rubens, Saskia perked up; she wanted to know if Helena were as handsome and well dressed as people said, and did she really pose in the nude for Rubens, and added that 'that was something she, herself, had never done, however much she had loved her husband'. Van Loen goes on: 'To which they had answered to the best of their ability and being experienced physicians and therefore accustomed to the telling of many innocent lies, they had so well acquitted themselves of the task that Saskia was quite satisfied and had dozed off, firmly convinced that she was a much better-looking woman than Helena Fourment and also, to a certain extent, a much more respectable one, since she had sometimes appeared in her man's pictures as Flora but never as a Venus.'

Frail, fair-haired Saskia died later that same night. Saskia is the pretty, delicate girl we see in Rembrandt's *Flora, Goddess of Spring* holding a red flower, and in the well-known nude of her as Suzanna, as well as scores of studies. But coming from a rich family, higher socially than Rembrandt, the pretty, delicate girl was far too genteel to admit that she had ever posed in the nude even for her husband. Doubtless she had been happy, though Rembrandt never painted anyone actually smiling; with the exception of his wedding picture of Saskia and himself, no one looks happy in Rembrandt's portraits. She left him her money in trust for their baby son, Titus, and only to be enjoyed by Rembrandt so long as he remained unmarried.

That great genius was a difficult man, untidy, irritable and a compulsive collector of antiques, bric-à-brac and odd lengths of material, as well as whole wardrobes of fancy costumes of every period and nationality. Everything lay strewn around the old house, undusted, pile upon pile. No wonder he had domestic problems. One after another, housekeepers came and left. One ran off and was never heard of again, another was carried off to a lunatic asylum. Then he found himself in a worse quandary; a sour-faced woman called Geerten Dirks, widow of a trumpeter, had, as many contriving widows have done before and since, taken the job with the idea of marrying her employer. When she discovered this to be impossible, owing to Saskia's will, she threatened to bring a breach of promise case against him on the grounds that he 'had taken advantage of her'. Besides obliging in bed, she had made a new will leaving her 'fortune' (the trumpeter's demob pay) to the delicate little Titus. They lived a cat-and-dog life, and in desperation Rembrandt wrote to a priest he knew who was working in a small

village near the German border, asking him to find a servant, with the result that on a winter morning in 1645 eighteen-year-old Hendrickje Stoffels turned up at the big house in Amsterdam.

She was no beauty and a most unlikely candidate for the honour of her high place amongst the best-known women in art. In fact she can rank as one of the few artist's models without any glamour—yet who doesn't know the name of Hendrickje? She was squat, with sad, dark eyes and large hands and feet. Professor G. Baldwin Brown describes her as 'amiable and pleasant looking but of the lower part of her figure not much can be said. Indeed, the women of that day and race hardly possessed amongst them a pair of delicately modelled limbs or a body that did not beg for a straight-fronted corset'.

But if Hendrickje was not trim-figured enough to please the Scottish professor, Rembrandt considered her 'handsome' and the minute he set eyes on her he was struck with the idea of what a fine Bathsheba she would make and how he would paint her with his baby son for the Madonna and Child. Even in those days such a treasure seemed rare, and Rembrandt appreciated his good luck in finding her. 'The type is scarce nowadays,' he told his friend. 'They all want to do some dull job like curing tobacco or making paper boxes rather than cook for an old

Hendrickje

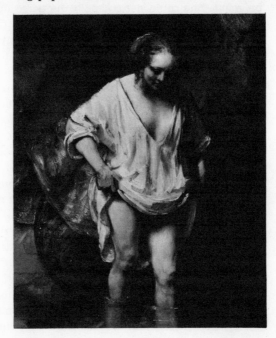

widow man.' One can hardly imagine a housekeeper of today who, after she had done the vacuuming, would obligingly stand in a tin bath in inches of cold water with her skirts gathered up around her thighs, as Hendrickje posed for Rembrandt's famous painting of *A Woman Bathing*.

No wonder she never looked cheerful, for apart from the big untidy house and the ailing Titus to care for, money was short and debtors hounded the household. Then the thwarted housekeeper Geerten brought her case to court and the magistrate ruled that Rembrandt must pay her two hundred louis a year maintenance. Not that she enjoyed it for long, as almost immediately she was taken off to Gouda Mental Asylum and her relatives got her money.

Rembrandt now depended entirely on Hendrickje—a treasure, a marvellous woman without whom the art world would have been unthinkably deprived and who lived a sad, hard life for Art's sake. If Hendrickje's expression is anything but gay in *Girl at the Window* it is probably because she was watching for the debt collectors to appear at the front gate, and while she posed in her white wrapper for *Study*, Titus was tossing with a high fever in his cradle. Worse yet, when she discarded the white wrapper for *Bathsheba*, it was obvious that she was pregnant. She could not escape being persecuted for 'living in sin', for a wave of prudish respectability sweeping the country at that time whipped the intolerant neighbourhood into action. The Church Council came down on them for 'living together without being united in legitimate marriage'. Greatest blow of all, they withdrew her 'kirk-card' which meant she could no longer go to Communion. While Rembrandt lived on bread, cheese, pickled herrings, and a great deal of alcohol, quarrelling with friends and customers and piling up debts, Hendrickje hid away the original plates from which they made the beautiful engravings that now constituted their only source of income. Although she could neither write nor read she combined with her inherent peasant shrewdness a marvellous business sense. Rembrandt is quoted as saying of her: 'Besides being an excellent cook and caring for Titus like his own mother, she is wonderfully shrewd about spending money, a quality which is not out of place in this particular household.' An instance of this is that she stowed away Saskia's jewels with her own cheap baubles, thus succeeding in saving them when the creditors demanded all valuables. But even she could not keep the household from the bailiffs, and while she awaited her baby she faced up to increasing troubles with all the practical commonsense of her simple, kindly nature. Her baby was named after Rembrandt's mother, Corde-

lia. He found quiet happiness in the little daughter and his first painting of her with Hendrickje is in *Venus and Cupid*.

Now Saskia's brothers, who were trustees for the money left to Titus, came down on Rembrandt to account for it and he had to confess that he had spent it all. His house and all his possessions were sold to a shoe-maker. When things were at their worst the ignorant servant girl, who was both model and mistress to the great genius who painted people's deepest souls and sufferings, rescued him. Perhaps he would never have painted again had she not worked out a scheme common enough today among tax dodgers but rare in the seventeenth century. She appointed herself as manager and employed Rembrandt as a common labourer. Thus his entire output became her property and his creditors could not touch it. Soon she set up as a registered art dealer and sold the paintings for a fair price. One of the works she saved and hung in the kitchen was Rembrandt's painting of his father, a serious old man with moist eyes and many unanswerable thoughts. She refused continual offers for this painting and even withheld it from Rembrandt who, when short of canvas, wanted to paint over it. Christies sold it in December 1969 for three hundred thousand guineas. Who gave a thought that, but for Hendrickje, it would not have been in existence?

With young Titus as a partner, the new business looked promising and Rembrandt was producing some of his greatest paintings. He painted more religious scenes, and many self-portraits. Then he started on a portrait of his son, but before it was finished the delicate young man died. Overwork, drink and bad times were killing Rembrandt, but it was Hendrickje who first succumbed. Like Saskia she contracted tuberculosis, and in 1667 she died. She had been posing for the *Presentation at the Temple* as St. Anne, when she felt so ill that she determined to make a will there and then, an odd thing for a woman under thirty-five to do. Shrewd to the end, she bequeathed all the pictures to their daughter Cordelia, making Rembrandt executor. So once again she had outwitted the creditors and even in death she was looking after the great Rembrandt and saving his pictures for posterity. Rembrandt went on painting sadder, older faces with his genius of showing the suffering underneath.

12. ANON
When posing nude was a criminal offence

All societies except permissive ones like our own have viewed suspiciously the women who make their living by posing for artists, but only once has the Establishment cracked down on them and made posing in the nude illegal and punishable by imprisonment. This, strange as it may seem, was in the land of *La Vie Bohème* itself, France, in the seventeenth century. Since this was the time of the founding of the French Royal Academy of Art, it might indicate that the motives behind the laws were less anti-vice than a move to protect the monopoly of the nude for artists recognized by the French Royal Establishment.

The facts behind illegal modelling are brought out in this diary, which cannot be authenticated and, obviously not written by an ignorant girl, must be a forgery. But cases brought against artists who drew from the nude, and the fines imposed on them for doing so, are recorded in French legal history.

PARIS, May 6th, 1655

This day tried for employment as a model. Two of the establishments were of a nature far from artistic and of the remaining three, one only offered me a remuneration, and that was of a negligible amount, the Maître in each case explaining that 'the gentlemen who came to study the figure under the ideal conditions provided by his specially equipped private rooms, were invariably of a very generous disposition'.

Monsieur Gres, for whom I start work on Monday next, is less the procurer by nature and more the shrewd business man. He studied my face and figure as if I were, indeed, already on canvas, and then asked me to take a turn about the room, which I did while he continued to observe me in complete silence. At last, he granted that 'I had not beauty, but a certain wild, savage quality that might attract "Les Flambeaux".'

On enquiring who the Flaming Torches were, I was told that they are a group of amateur artists inspired to make particular study of the effects of strong light and shade and that they therefore always work by torchlight. Upon my remark that this was indeed strange, M. Gres went on to say that all this was the doing of an ill-natured Italian by the name of Caravaggio, who was esteemed out of all proportion by this particular gang of artists. I furthermore gathered that the consumption of torches shocked M. Gres' businesslike soul, there being, in his opinion, more than enough hours of darkness in every twenty-four when the expense of illumination was a necessity, without creating an artificial night by closing the shutters and draping the windows to keep out the good daylight which was free to all. But as the Flaming Torches were prepared to pay for their eccentricities, it was good business to attract their patronage. He could get twenty times more rent from his rooms by putting a model in each and letting them to amateur and professional artists as studios, than he could from letting them in the ordinary way, so he did not mind what they did so long as they paid the high rent he asked and did not actually burn the roof over his head.

M. Gres' remarks explained much that had mystified me in my previous encounters with proprietors of private 'art schools'. But my apprehensions concerning the strange task which I have undertaken, viz., to sit in a darkened room in the midst of a circle of strangers all intent on rendering the effects of flickering torchlight upon the contours of my form, were only partly assuaged by M. Gres' assurances. Yet as he so rightly observed, 'your eyes soon get accustomed to the smoke of the torches and stop watering in no time'.

May 23rd, 1655

Am becoming accustomed to the torch smoke as M. Gres foretold. Indeed, on comparing my lot with Jeannine's, I find there is an un-expected advantage in posing to these ragged disciples of Caravaggio. These May nights can be remarkably chill, and as M. Gres' facilities extend to light but not heating, the flambeaux, artistically arranged so that they bring up the highlights on my thigh or underline the hollow of my armpit, also cast a little warmth upon my chillsome task.

June 24th, 1655

Arrived at M. Gres' this morning to find all in turmoil and confusion. Monsieur himself, unshaven and dishevelled, was crying that yesterday's events in Parliament had made him a ruined man. When Monsieur had regained his composure with the aid of a little alcoholic sedative, I learnt that Parliament yesterday had ratified the new and enlarged code of rules for the Académie Royale de Peinture, including a clause which gave the Académie a virtual monopoly on life drawing in the whole of France. Henceforward, nowhere outside the Académie schools was any public life drawing to be allowed, and even private life drawing circles in artists' own studios were illegal. In a word, it was a crime for a model to strip for an artist in Paris.

In M. Gres' distressed state of mind, I did not take seriously his suggestion that the Royal Academicians were plotting to make money out of life classes themselves, by putting honest men such as he, M. Gres, out of business. I rather inclined towards a suggestion, put forward by one of the Flaming Torches, that 'the aim of the new Académie was to train artists in a particular style of drawing and modelling, the style of the French Court, befitting the majesty of Le Roi Soleil'. I could see that by preventing artists from independently exercising their gifts, the Court would have complete control over all the pictures painted in Paris—which would, no doubt, have its advantages. But I could not refrain from feeling sorry for M. Gres, while at the same time wondering whether this turn of events had brought my career as artist's model to an untimely end.

December 18th, 1661

Jeannine, who has an influential gentleman friend at Court, tells me that daily there are complaints of overcrowding at the Académie School life-classes. This is not really surprising and one wonders how *Les Anciens* of the Académie could believe that the whole of the artistic needs of Paris might be served by one two-hour life drawing session a day.

I have also heard rumours of blackleg life classes being held in the more disreputable quarters of the city but so far have not met any models who have actually posed for these clandestine sessions. This information, however, has determined me to apply to the Académie to be taken on as a model there, particularly as they are known to allocate as much as 1,000 francs a year for a list of items including 'oil, models and chalk'.

January 5th, 1662

I have to record only failure in my attempt to become a model at the Académie Royale de Peinture. With an introduction from the influential friend of Jeannine, I presented myself at the studio of the great Charles Lebrun, not without trepidation at the prospect of finding myself in the presence of the famous artist, protégé of politicians, and renowned throughout France as the illustrious founder of the greatest Academy of painting and sculpture in the world.

I was requested to wait in a small antechamber, filled with numerous plaster casts after what I presume to be masterpieces of antiquity. There was, for instance, a dismembered arm of great delicacy on the window-sill and a foot of exquisite proportion on a small slab of black marble, besides several complete or only partially mutilated figures. I was just beginning to feel discomposed by the blank plaster stares and the haughty disdain of the all-too-regular marble features all around me, when the door opened and the Master himself arrived and launched into a tirade which discomforted me more than ever the plaster silence had done. 'Did I' he demanded—and fortunately seemed disinclined to await a reply—'believe that proportion remained completely under the guidance of the canons of antiquity? Did I believe that even nature

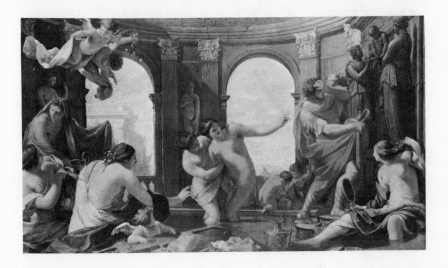

had to be corrected, if she did not tally with Greek or Roman sculptures?'

My response that such questions were beyond my province, my

concern being only to pose for pictures and not appraise them, disturbed him greatly and he began to stammer. He had not been given to understand that I was ambitious to be a model . . . he could not believe that anyone with such . . . forgive him please . . . irregularities of feature could imagine she might serve art in any other way than as a spectator. Feeling, no doubt, that words could not convince me—although I had recalled M. Gres remarking upon my 'wild, savage' qualities—the great man snatched the calipers from his pocket, whipped them on to my wrist, and darting to the window-sill, jabbed them onto the wrist of that exquisite antique hand, allowing the discrepancy of at least three-quarters of an inch to speak its own mute criticism of my unclassical proportions. This antic he repeated with ankle, calf, and would have gone further, no doubt, but that I, by now convinced that I fell hopelessly short of his classical ideal, agreed never again to aspire to pose either for the Master himself or any of his loyal pupils at the Académie.

Leaving the Master's studio in great dejection, I called upon Jeannine, whom I found in great spirits. On hearing my miserable story, she swore she had the best of antidotes for so untoward an experience. She had been approached by the son of an old friend of hers, a student artist, who with a group of others of aspiring talent had decided, in the face of the Académie monopoly, to start a private life-class of their own. 'Find us a girl of spirit who will model for us, even though it is breaking the law,' he had asked Jeannine. Feeling much in sympathy with the spirit of rebellion against the Académie, I have decided to model for them.

February 22nd, 1662

My life-class is a companionable affair, and the ever-present threat of discovery by the law makes the evening even more enjoyable. As these students are studying allegorical compositions, I have posed for all the abstract virtues, including Justice with sword and scales (wearisome); Poesy, seated with a tablet on my knee (uncomfortable); and Innocence, although I felt that a younger model might have been more suitable.

There is much talk amongst the students that *Les Anciens* of the Académie, hearing of these clandestine life classes, have warned them that if they are caught drawing from the nude out of school hours, severe disciplinary action will be taken against them. The students, however, are lighthearted about this, maintaining that they wouldn't *dare* enforce the law.

December 1662

How wrong those misguided youths have proved to be! I look back

on a year which has turned out to be an epoch-making one, not only for me as one whose sole ambition is to earn her living as an artist's model, but for the whole course of art. Artists have drawn from the female form since the fourteenth and fifteenth century and further back into the days of ancient Greece and Rome. Only in France, in this year 1662, has it been a crime to pose nude for an artist, and a punishable offence for an artist to draw her.

13. LA MORPHISE
The provocative nymph on the French King's ceiling

Understandably, the generation of artists to follow on this inhibited period in French art showed signs of complexes and conflicts before swinging over to paintings that were almost pornographic.

Both these extremes are illustrated in the curious contrast between the neurotic Jean Antoine Watteau and his sexy-minded pupil François Boucher. The latter started life as an engraver to Watteau and claims to have been influenced by him always in his choice of subject and decorative treatment. Watteau was very delicate; he died young. He suffered from a crippling complex, a terror of women together with an urge to paint them. His recurring dream, he said, was to pose a nude girl on the banks of a river, but actually he was so petrified of the female sex that he was unable to look at a woman, let alone use her as a model, and had to rely on his memory and the glimpses he snatched of young females walking on the opposite side of the road or in a shop. Gilbert Parker writes on the plight of this neurotic young artist: 'Unable to enjoy physical relations with women, ravaged by tuberculosis, handicapped by a shy diffidence in the company of strangers, Watteau had to fall back on memories and dreams of frustration. As a young man, ill-fed for he could not afford to eat well on his earnings from mass production copying, he used to go the Luxembourg gardens. There he would hide himself away so that he could watch the Parisians at a favourite occupa-

tion—walking under the great trees of the Luxembourg. He would wait until a group had passed, then quickly note down the retreating silhouette of a lady and her cavalier in his notebook. Back at home, he would choose a figure here, a group there from his notebook, and compose them onto his canvas. No other artist has ever painted so elegantly the back view of a woman; no other artist given such pathos to a pair of lovers, arms entwined, disappearing.'

Watteau painted moods not women: a whiff of romance or sadness or longing, but no tinge of desire. When in 1717 he was invited to become a member of the French Academy, he used for his model the vision of how Charlotte Desmares had looked to him (from the cheapest part of the theatre, no doubt) when she had starred in the musical comedy *Three Cousins* eight years earlier. He remembered her in the last act, departing for the Island of Cythera with her lover. Arms intertwined they set off for the enchanted isle singing:

> 'Come to the island of Cythera,
> On a pilgrimage with us,
> Young girls never come back
> Without lover or spouse;
> And everyone has a lovely time
> *Des amusements les plus doux.*'

This picture turned out to be the famous fantasy painting, *Embarkation to the Island of Cythera.* Watteau died at thirty-seven and his youngest pupil, Boucher, carried on something of the element of fantasy but certainly none of the ethereal sexlessness. He made a reputation for himself as a sort of eighteenth-century talent scout, finding beautiful girls in unlikely places; indeed he became almost a procurer for the randy old gentlemen of the nobility. But in this case of his most famous model, it was not he who actually discovered her; no less a connoisseur of the love-game than Casanova was responsible for first recognizing the child's charms, and in a most unglamorous setting.

The four Irish-born O'Murphy sisters had been brought over from County Cork by their father, a drunken labourer who had long since given up work, allowing his daughters to support him. They all lived in a Paris slum and the three elder girls supplemented their daylight earnings as artists' models by undertaking various other occupations after dark.

The eldest sister Bridget—known in France as Brigitte—had beautiful hands. She posed for students at the Académie when any classical

hand studies were required, usually either waving a bunch of grapes or offering an olive branch. But the *specialité les mains* marked on her card proved to be a poorly paid asset and forced her to sing every night at the dubious Café de la Lune where clients couldn't have cared less about her hands.

Marguerite did very little modelling and made no bones about being a *fille de joie*. Victorine danced in the chorus of the revues at the Théatre Flamande; she also posed for the court painter François Boucher and his group; one well-known picture, *Femme Couchée*, brought derogatory remarks from the critic, de Heiz, who complained that she was pockmarked and had fat legs.

When Casanova found the O'Murphys, the youngest, thirteen-year-old Louise, had just been brought home from a convent by her father, who was impatient that she, too, should start contributing towards his drink bill. Casanova says he had first seen her sprawling on an unmade bed in a pigsty of an attic. He notes in his memoirs: 'A filthy but attractive child, blonde, yet her beautiful blue eyes give the effect of being dark and luminous.' He told Boucher: 'Your model Victorine has a little sister who is the plum of the whole family.'

Doubtless Boucher made it his business to investigate, for he had to keep clients happy with ever-changing designs in nymphs and goddesses. They were in the latest fashion, a new ideal of naked beauty which was nothing like the bulky Rubens women; they were small and round and dimpled and critics described them as 'the petite, the manageable body which has always appealed to the average sensualist'. Little Louise turned out to be just the cheeky adolescent Boucher needed for his forthcoming series. By using mythological subjects Boucher could get away with what what would otherwise have been classed as near pornography. He realized that to emphasize her innocence it was a good gimmick to play up the surprise element in the various rape scenes, so he taught the little girl to look convincingly astounded when the bull, descending from the heavens to rape her, turned into the god Jove. And then again, *Jove in the Shape of Diana Surprises Callisto*; she had to look surprised that she would not have to submit to the advances of a goddess, since the hard-working Jove had again taken over. But perhaps most surprising is her pose in *Venus and Mars Surprised by Vulcan* where she is shown caught off guard with legs flung apart in an attitude which would shock *Playboy*. Today, all these, along with *Diana in her Bath* and *Venus at her Toilette*, can be seen in London's Wallace Collection as proof of the charms of the little O'Murphy girl.

While posing for Boucher for such permissive paintings, Miss

Miss O'Murphy

O'Murphy was being groomed for her future as La Morphise, the corruption of her name by which she is known in the history books of France. Boucher, more of a decorator than anything, kept her in constant practice while he decorated the homes of noble clients. She must have felt almost like part of the wallpaper reproduced over and over, filling every inch of wall space and stretching across vast expanses of ceilings in the great châteaux.

Meanwhile Boucher waited for the plum job about which his friend Mme la Pompadour kept him alerted. The King of France planned to have his newly built Summer Palace at Versailles decorated from top to bottom *en style Boucher*. Acres of walls and ceilings waited to be covered with a riot of rosy nymphs. King Louis ordered that his salons, ante-chambers, retiring rooms, banqueting halls, and even the closets, must be plastered over with plump pink poppets to provide an atmosphere of weekend abandon. Poor Louis was starting to hate the Royal Palace in Paris with its gloomy statues, where you had *Justice* in gray stone gazing at you from one corner and *Truth* on the opposite side, with several assorted dreary Virtues lined up between them. He yearned to move into Versailles surrounded only by pictures of nude and provocative girls in pretty, peaceful settings. For his bedroom, His Majesty thought up two pictures illustrating the rising and the setting of the sun, with himself as the Sun God, for he fancied himself in this role, shedding his light on lovely maidens.

Between them, La Pompadour and Boucher understood exactly the type of girl who figured in His Majesty's sex fantasies. La Pompadour was one of those understanding women, often found amongst the great courtesans, who regard it as part of their service to provide a change of fare for a satiated Protector—so long as it is such simple fare as to offer no competition and be easily disposed of when necessary.

So certain were they that Louise O'Murphy would send the King sky high that Boucher decided to use no other models, but had her posing for all the nymphs and goddesses, in various positions and at different angles. In one pose she rises from the sea foam at dawn to greet the Sun God, while in another she is putting him to bed at sunset. She is all over the house, floating on a cloud, lying on her back, kneeling, or stretched on a couch, face downwards, kicking her legs.

La Morphise

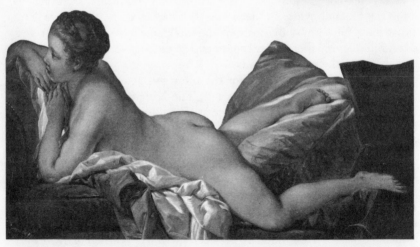

Only by having her hair differently arranged in each pose did Boucher make any attempt to disguise the fact that it was the same girl who modelled for the whole cohort of nymphs. In one instance she wore her hair in her everyday fashion and, sure enough, it was this one which took the King's eye the minute he saw the paintings. He was so struck by

her feminine allure, that he could not believe it was the likeness of a real girl. 'Of course she is only made up, there is no live girl like this,' he is supposed to have said and Boucher answered: 'See for yourself, Your Majesty,' producing the original.

The story continues that the King then took Louise on his knee. She dissolved into a fit of giggles and when asked what was amusing her, she answered: 'You look so much like the picture of you on the coins.'

It was this sally, which struck His Majesty as being extraordinarily witty, at which he succumbed completely to her charms. He gave her a thousand louis, those same gold coins that bore his likeness—plus fifty for the painter—as the first instalment of the riches he was to heap on her, and which was payment in advance in every sense because, before she could move into the royal bed, it was necessary that she should be screened by Security.

Inspector Meusnier of the Secret Police was put on the investigation. He went forthwith to check up on the O'Murphy background and wrote it all down in detail in his black police notebook. He notes that 'the family lived in what could be described as a very disorderly state with undergarments and suchlike strewn on all sides and with several male characters who have no proven relationship or right to be there coming and going at all hours. When I saw Morphise she was occupied with the washing up, her hands were dirty with cleaning an alleged brother-in-law's shoes. Her face has fine features and is a little on the long side. Her hair is brown like her sisters', but she is not pockmarked as they are.'

Pa O'Murphy was not friendly towards the police and pretended to horror when he learned what was going on. As the Police Officer noted: 'Monsieur O'Murphy then threw up his hands and said: "Ah me! Among all my girls then not one is virtuous." '

However, the investigation must have been merely a matter of form for Louise was duly classed A.1 and installed in a little 'bijou' house in the Parc aux Cerfs. Boucher kept her busy posing non-stop during those first few weeks, for he had a lot of pictures to finish before her pregnancy showed and, knowing the King, he knew there wouldn't be much time. Also His Majesty commanded that his favourite must be the model for all the rooms, even for the religious pictures, including a Holy Family for the private chapel of his Queen. The Queen, who suffered from religious mania, considered Morphise most unsuitable and it got very much on her nerves having to pray every day in front of this Holy Family, knowing that the Mother of God was a portrait of her husband's newest little mistress.

But what the Queen thought was of little importance at the Court of

Versailles, for La Pompadour had all the say and Madame was only too thankful to be having peaceful nights again. Until Louise took over she had been suffering from indigestion from overdosing with aphrodisiacs; the diet then in fashion to revive waning passion consisted entirely of celery, vanilla and truffles, which became boring as well as wind-making. So it was with relief that La Pompadour moved out of Louis' apartment and had the suggestive statue of *Love* in the Royal Park taken away and a statue of *Friendship* (suitably draped) erected in its place to mark the switch in their relationship. She never begrudged Morphise any of the diamonds and magnificent dresses that Louis gave her, and the set-up seemed satisfactory and peaceable to all three.

How, then, could Morphise, with everything going her way, have been so stupid as to commit the gaffe that every rich man's mistress knows to be unforgivable? She asked him one night in the middle of love-making: 'Do you still sleep with the Pompadour?'

Then and there he ordered her to leave his bed and within a month he had married her off to an elderly widower who lived out in the country, a fate worse than death to any Parisienne.

The strange sequel to this story is that after this the artist Boucher completely soured on the idea of models. Peter and Linda Murray write of him: 'He made many tapestry designs and painted charmingly indelicate scenes. Reynolds who visited his studio was scandalized by his working without a model. He said he "had left them off for many years".'

14. AMY LYON
Alias Vestrina, alias Emma Hart, alias Lady Hamilton

There is only a short story to tell of Emma Hart as an artist's model. What happened to her as Lady Hamilton has been often repeated, but Emma as Romney's *Divine Lady* is less well known.

It starts in 1780 when Dr. Graham, a phoney health specialist, proved that the best way to make money out of popular science was to demonstrate with girls. He inserted the following advertisement in the *Morning Post*:

'Wanted: A genteel, decent, modest young woman; she must be personally agreeable, blooming, healthy and sweet tempered and well recommended for modesty, good sense and steadiness. She is to live in a Physician's family, assist at public exhibitions and lectures on electricity. If she can sing, play on the harpsichord, or speak French, greater wages will be given. A good performer on the Harmonica or Musical Glasses is likewise wanted. Enquire of Dr. Graham, Centre of the Adelphi Terrace.'

The morning after this advertisement appeared in the 'Wanted' column of the *Morning Post* there was a long queue of girls waiting outside Dr. Graham's house in Adelphi Terrace. Amy, a barmaid from a pub near the Prospect of Whitby in Wapping, got the job.

Amy Lyon, who had been 'in service', and worked in public houses, could neither play the harpsichord nor speak French, nor was she particularly gifted on the musical glasses, but the Doctor was convinced that she would make a first-class Electrical Demonstrator. He assured

her that all she had to do was to strike a series of provocative poses to pep up his lectures. She was billed as *Vestrina* though what connection Vestrina (Goddess of Love) had with electricity, only the Doctor knew.

Although Dr. Graham's lectures were condemned by a gentlemen's magazine as 'grossly lewd and salacious', they attracted an enthusiastic audience of artists in search of a model. Some of London's top Academicians welcomed this gorgeous new girl who provided a repertoire of exciting poses for free; Cosway, Romney, Tresham, Flaxman or Gainsborough grabbed the front seats at every session. Hone said: 'This combination of goddess and milkmaid delights me. She has the most luscious thighs that ever straddled a milking stool.' Famous artists of the period preferred her to their own models; Gainsborough sketched her while she was massaging pins-and-needles from one foot after a long pose. Later, at home, he drew in the background from a model landscape made up of bits of parsley, herbs and old cork, as he often did, and this is the study he used for the well-known *Musadora* in the Tate Gallery.

Amy revelled in being portrayed and it flattered her to know that she was giving these great artists new ideas; but the Doctor had other plans for her. He launched his 'Celestial' or 'Hymeneal' Bed as a cure for impotence, the current worry of middle-aged men. In the advertisement published to announce the Bed, Amy is seen 'lying on it elegantly unclad'. The advertisement shook London, and according to contemporary reports, 'a regular concourse of judges, ambassadors, clerics and all the highest members of society' flocked to pay £50 a time for the cure. Amy threw herself into her new job of giving physiotherapy treatments to the sexually deficient, although she discovered that lying in a bed 'supported from the floor with forty pillars of polished glass filled with abundance of the electrical fire' was much harder work than it looked. Her patients found it beneficial to lie beside Amy and the combination of girl and an electric shock usually produced curative results. Aided by the mirror above the bed, Amy learned a lot of new Attitudes. After the course was over, a number of the grateful patients took her up socially and invited her to strike her Attitudes at their parties, where they proved a great success, especially with elderly gentlemen. She also delighted the young bloods; Sir Harry Fetherstonhaugh, describing her act as the sexiest thing he had ever seen, persuaded Amy to return with him to Upp Park so that he could play his musical glasses as an accompaniment to her poses.

For some months their collaboration worked well, but one day Amy,

now heavy on her feet, being seven months pregnant, shook the floor and ruined his treble arpeggio. They quarrelled and Sir Harry, in a rage, threw her out. Where could she go? Not back to the Bed, for Dr. Graham's electrical business, having been raided by the magistrates, was closed down. Various gentlemen friends came to the rescue—board and lodging were provided by Charles Greville, whom she hardly knew, who kindly invited her to stay with him at Paddington Green. 'She is the sweetest smelling bedfellow any man could wish for,' Greville wrote to his uncle Sir William Hamilton. Luckily too, society painter George Romney, who already had three large portfolios of her in Art Poses, welcomed her back to his studio and gladly re-engaged her as his special model.

Romney has been called 'a good painter but a bad husband', which is putting it mildly considering the way in which he completely abandoned the wife he had married when he was twenty-two. After she had nursed him through a long illness he told her that 'a man married is a man that's marred' and that they must live apart because married life would interfere with his ambitions. She must have been some sort of saint, for when he was old and decrepit she smilingly took him back and never once gave expression 'to an act of unkindness or an expression of reproach for an abandonment of forty years'.

Meanwhile, he adored his 'Divine Lady', as he called Amy, and he painted forty-one pictures of her in all kinds of attitudes and characters, some considered very inferior technically. Established as Romney's chief model, Amy Lyon took the professional name of Emma Hart, which she considered more elegant. The first picture for which she posed had to be painted back view because from any other angle her pregnancy was too obvious to be classical. Engravings of this picture, *Diana*, were best-sellers at £2,000 each and laughing over her shoulder, looking so happy and innocent, Emma Hart, an unmarried mother-to-be, hung on many a Victorian wall, a laughing symbol of the wholesome innocence of girlhood.

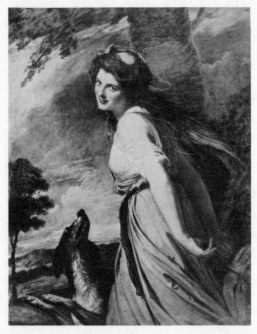

Lady Hamilton as Diana

Whether Romney rehearsed Emma or it was all done on her own initiative we cannot tell, but she soon introduced a heavily classical element into her Attitudes and for the next five years posed for Romney as a *Cassandra Bewailing her Ravished Life, Clytemnestra with Dagger, Niobe all Tears, Calypso Goddess of Silence,* etc. Romney's son claims that it was his father who really brought out Emma's unusual range of talents, 'she being requested to imitate those powerful emotions of the

mind which he wished to paint'. Apparently, he put her through
stringent 'method' acting exercises and no model ever suffered more
from the mental agonies of Antigone or the traumatic experiences of
Electra.

This was the final phase for Emma of having to earn her living as a
model, because one of the pictures, a Titania, caught her the British
Ambassador in Naples as a husband. He fell in love with her and married
her and she was at last 'respectable'. But out in Naples, she continued
with her Attitudes so successfully people said she 'competed with the
ruins of Pompeii as a tourist attraction'. Heretofore, her talents had
appealed primarily to the gentlemen, but now she developed a new and
useful branch of her art which especially attracted the ladies. The
Queen of Naples fell passionately in love with Emma and her Attitudes
and soon they were sharing 'the same bath and the same bed'. Also
a close woman friend of the Queen's, the artist Vigée le Brun, was so
excited by Emma's Attitudes that she insisted on dressing her up in vine
leaves and painting her in an abandoned pose as a Bacchante. Between
the Queen, Hamilton, Lord Nelson and others, Emma was kept extra-
ordinarily busy, yet nevertheless she found time for charity work among
the poor who hailed her affectionately as 'Miladi Lesbia'.

Throughout her life Emma's greatest treasure was not the package of
Nelson's letters to her, but a book of reproductions by Rehberg showing
her in a series of seventy-three of her most successful Attitudes. But
poor Emma went out of fashion and when her Attitudes were no longer
admired an unflattering parody of them was published called *A New
Edition Considerably Enlarged of Attitudes Faithfully copied from Nature
and Dedicated to all Admirers of the Grand and Sublime*, depicting her
not as a lush and lovely siren, but as an ageing woman in ludicrous poses.

15. CAYETANA
The Gypsy Duchess
Goya painted and
hated

After Lady Hamilton we meet another titled nude. In Cayetana, the kinky Duchess of Alba, we find the three ingredients that go towards the making of star quality in an artist's model.

First her rank, for it seems that artists are much excited by a naked duchess and many a masterpiece has been inspired by Her Grace stripped. Then, like del Sarto's Lucrezia, she was supposed to have poisoned her husband, and there is obviously a fascination about a cool and calculating little murderess. And third, like Raphael's Fornarina, she dabbled in witchcraft. By an extraordinary sequence of circumstances, Cayetana had grown up under Fornarina's spell. One of her ancestors was Viceroy of Naples when the Spanish sacked that city. In the chaos he had helped himself to one of Raphael's paintings of Fornarina and brought it back to Madrid to hang in the family chapel. This picture seemed to fascinate Cayetana. Brought up by her grandfather, an eccentric old general nicknamed 'the most bloodthirsty man in Spain', she was left to the care of the chambermaid Brigida, who was the leading local witch. She was also the leading *maja* in the district. As well as teaching her charge the first lessons in magic, Brigida trained her in the exciting folk lore of the *maja*, their tempestuous dances and exciting songs. The Spanish *maja* is the girl friend of the *majo*. A contemporary describes her role: 'She works in the fields, or as a servant, or sells chestnuts or oranges in the market place. A successful *maja* must be proud and temperamental and quarrelsome. If she is un-

married she gives all her earnings over to her *majo*, for which he beats her.'

Before she was six the spoiled little heiress could go through the whole mating sequence of the Flamenco as well as produce simple occult manifestations. Brigida died early but she returned often to her young pupil, so that it came to be rumoured that the high-born Cayetana was possessed by Brigida the *maja*, the witch. We don't know whether this was true or merely part of the interest in the occult which prevailed at that period. Historians have often hinted that it was because the Duchess identified herself with the *maja* that she became attracted to the burly peasant artist Francisco Goya. He was middle-aged, balding, fat and very deaf and he and his wife, sister of his first art teacher, had twenty-one children. Despite this they hardly spoke to each other and she appeared to be in a perpetual state of shock at being the wife of this uncouth genius.

But the rough manners he retained from his boyhood on the poor plot of land on the mountainside where he was born and brought up were what appealed to the pampered and sophisticated Duchess of Alba and she insisted on his painting her over and over again as a *maja* though Goya constantly argued that she looked nothing at all like one. Apart from never having done a hand's turn in her life, she was not the type. She was tiny, affected and conceited. Although she had a dark, warm, brown skin she covered her face with a heavy white make-up. She was almost ugly, yet someone wrote of her: 'The Duchess of Alba has not a hair on her head that does not arouse desire.' She painted her eyebrows in a heavy, black, exaggerated arch, and she had those peculiar eyes like Fornarina's, with the very large iris and hardly any white, associated with the eyes of wizardry. Every time Goya tried to paint her as a *maja* she came out like the Duchess masquerading, with her little white poodle with red velvet bows on its tail. No other artist would attempt it and one prominent Court painter, Augustin Esteve, said he never saw the *maja* personality in her at all. He always portrayed her as a haughty, fastidious, immaculate and typically grand Spanish aristocrat. When she remonstrated with him that she was really a simple peasant, he answered: 'You are the most talked of woman in the country.' 'That is because, of all the ladies in Madrid, I am the only true *maja*,' she retorted.

As one of Madrid's leading society hostesses, coming from Spain's richest and highest ranking family, Pilar Teresa Cayetana, Duches of Alba, set the pace and was followed by all who aspired to social standing. She, besotted by the *maja* image, played at being a *maja* just as Marie

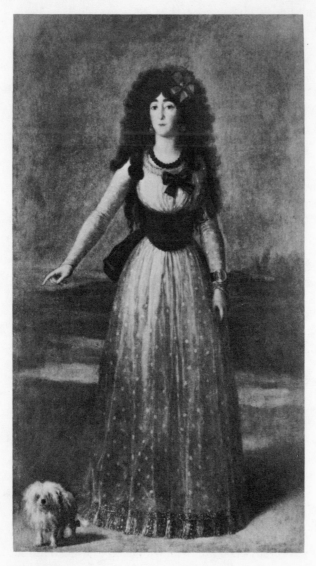

Duchess of Alba

Antoinette had played at being a milkmaid, and all her circle were
forced into a round of phoney picnics, *fêtes champêtres*, and rustic
capers in sylvan glades. They mimicked what they imagined to be the

goings-on at Versailles, but Madrid being somewhat behind the times, she had not heard the news that Marie Antoinette had lost her head quite a while ago.

Some say she was a little mad, and certainly her love-hate relationship with Goya was hardly sane. They destroyed one another. She tormented and wrecked him; he loathed her and doted on her and recorded it all in paint. Once he asked her how many names she had; the higher you were on the social scale the more names you were christened with. She answered that she had thirty-one names, so Goya drew her in thirty-one different interpretations, one for each name; seven as a seductive charmer, four as a thoughtful beauty, six as a spoilt aristocrat, six laughing and gay and the rest as the weird evil witch she seemed when she had been visited by Brigida, the dead maid. Beneath one of these he wrote: 'In a lovely bosom beats an ugly heart.' Another was captioned: 'An angel in church, a devil in bed.'

A man needed a lot of energy to be Cayetana's lover; she had seventeen castles to which she expected her admirers to follow her. She boasted that she could circle the whole of Spain without ever leaving her own estates for more than a day's ride between one property and another. 'I can never sleep well on land that isn't mine,' quoth the Duchess of Alba.

Goya spent much time and energy chasing from his Court work on a portrait of one of his hideous Royal sitters to join his imperious lady at whichever castle she summoned him, to make love and enjoy themselves according to their separate ideas of having fun. He liked to stand on his head and act the clown; she danced the night through with the youngest and roughest of the local labourers. Life was leisurely in her castles in Spain; there was no hurry, and following another of her strange whims she had all the sundials painted to give the illusion that time stood still. It was always the hour for love-making, maybe with a visiting French noble, maybe with a young matador picked up last night at the bullring, but best of all with Francisco Goya. She hated him to leave her. One of her ploys to keep him with her when he talked of returning to Court to finish a portrait of the ugly Queen or some of her diseased and dwarfed family, was to make him send a message to the Palace that he was delaying his visit owing to the illness of one of his children. He made this excuse twenty times; strangely enough, whenever he did this, it so happened that one or another of his sons or daughters did actually die, for which he blamed Cayetana and her damned witchcraft. At last, when there was only one of his twenty-one children left, they quarrelled so fiercely that he returned to his thin and pious wife, who though

perhaps not all that good at child-care, had, in her martyred fashion, never ceased loving him.

She accepted Goya's oft-repeated vows to his friends that he was a real home-body, and liked nothing better than dinner with his family, though he rarely managed it more than one night a month. He and she never argued, for the simple reason that he was too deaf to hear her complaints and she, although better born than he, was unable to write.

On this particular visit, however, he noticed how paintable she had become; the eyes, being deep sunk, were much more attractive, the lines of pain round the mouth gave interest to the whole face and the fine bone structure of the head showed to great advantage, while the hands, thin, veined and emaciated, were beautifully expressive of suffering. In fact, he couldn't stop painting a marvellous portrait of her although she seemed to be trying to summon up energy to shout something or other. She lasted until he had finished the final wisp of faded hair and then she went behind the model's screen and died. According to the story, there was a quiet funeral and as Goya returned from the graveyard to join his friends, he greeted them with an old Spanish country saying: 'The dead to the grave, the living to the table,' and sat down to a delicious paella.

Now that he was a widower with only one no-good son left, Goya spent more time with the arrogant little Duchess than ever.

In Spain at that period there existed a custom among the gay ladies to take what they called a 'Gala Bed'—a two weeks' holiday spent in bed as though you were ill, although you had nothing the matter with you. Friends visited and sent flowers and the 'patient' was loaded with sweets and gifts. She wore her best nightie and was spoiled and cossetted as she lay between luxurious embroidered 'gala sheets', aglow with health and beautiful instead of sickly and ailing. During Cayetana's Gala Bed Goya visited her and remarked to her that now, at long last, she looked the real *maja*, a wily *maja* who had become a successful courtesan . . . and now he would paint her like that. Thus developed the Duchess-cum-*Maja* nude which, in the abandoned provocative pose, was praised as 'the most desirable woman in the world'. But at what risk this masterpiece came into being! If the Inquisition had got wind of the fact that the great Duchess of Alba was posing nude for the Court painter Goya, neither her rank nor his genius would have saved them. With luck they might have been given the choice between being disembowelled and then burned, or having their arms and legs chopped off before being hanged. This daring nude could never be shown, so Goya painted another just decorous enough to get by; the *Maja Veiled*

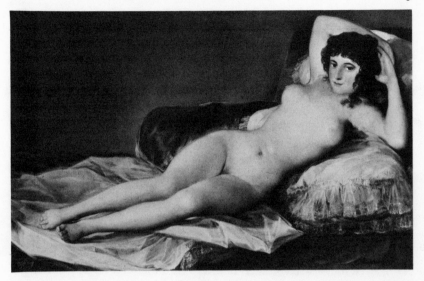

was, at least, not a nude, and this was hung in front of the nude *Maja*, quite concealing it until it was swung aside to reveal the nude.

Thus the casual callers and relatives and servitors who came and went would see only the draped figure in the picture above the bed, but a favoured guest, by pressing a button, could make this slide away to be replaced by the famous *Naked Maja*.

Cayetana's husband, the delicate Duke, seldom bothered her and spent most of his time in highbrow chat with his mother. Mother and son both enjoyed studying poetry and music and politics and resigned themselves to the Duchess amusing herself in her own way, so long as they could trust her to conduct her affairs with the well-bred discretion to which Alba ladies were accustomed. But when serious gossip started about Her Grace and the Court Painter, it was time to worry. So the Duke decided he needed a change of air and would take Cayetana and his mother to France to hear some music. Cayetana unenthusiastically agreed and invited Goya and a couple of current admirers to join the party. 'Oh no,' said the Duke. 'It's to be only the three of us, Mother, you and me and the fourteen servants.' Cayetana said nothing, but an onlooker noted 'the whites of her eyes almost disappeared in the way of witches when thinking'. The poor Duke heard no concerts in France that Spring. 'A creeping poison has been administered to him,' they said as he lay on a couch, too weak to speak. When he died no one doubted

that Cayetana had murdered him. Around her wafted such Spanish pleasantries as: 'Bloody hands and clever brains go down from genera- tion to generation' and 'Think the worst of everyone and you think the truth.' Suspicion also fell on the family doctor, Dr. Peirez, a close crony of Cayetana, who was thought to have obliged her in getting rid of her inconvenient husband.

So, as a gesture to show that she would allow no criticism of a man worthy of such a gift, she gave the doctor the most valuable present in the country, the *Raphael Madonna*, the patron saint of the House of Alba—a mad thing to do which shocked the whole of Spain and for which the Queen exiled Cayetana from Madrid for the whole of her three-years' mourning period.

Goya, hating her more, yet more than ever fascinated by her, shared her exile at her country estate, but his scorn of her was clearly expressed in the pictures he drew. One shows a woman with two faces, one face turned to the man with whom she is making love (a glamorized likeness of the artist himself in younger days) and the other face turned enticingly towards other lovers. And in another picture she is at her most un- cannily bewitching, flying above the clouds beckoning on three of her lovers, easily identified as the bull-fighter who had spent some weeks in her country château with her, the young French fop who had been living with her off and on for a couple of years, and the family doctor who preferred to be paid in art treasures from the famous Alba collec- tion.

Goya considered this picture among his best works and called it *An Unholy Version of the Ascension*. Cayetana smiled. 'Witches have their own theory of art,' she said, taking the tiny dagger she wore, *maja*- fashion, in her garter, and slashing the canvas to bits. Goya couldn't speak; the shock had brought on another attack, and this time he was stone deaf for the rest of his life. When next he painted her it was in two companion pictures. In the first, called *Cayetana's Flight to the Witches' Sabbath*, she was again in flight; the second picture shows her celebrating the Black Mass. No one could mistake the exact likeness to Cayetana of the leader of the group of witches who are dancing around the he-goat. The goat creature in the centre of the ring of witches is presiding at the sacrifice of a pinkish pile of babies skinned alive. Cayetana made no attempt to destroy these paintings, though she was moved to ask him: 'I sometimes wonder if you really love me.'

Disaster soon followed. The young Duchess lay dying. According to medical reports, she had been trying to bring on an abortion on finding she was pregnant with Goya's child. Many doubted this and suspected

she had gone too far with black magic; those at her death-bed testified that 'a strong odour filled the room as she died,' taken to be proof of the supernatural at work.

More than a vaguely spooky death was needed to kill the legend of Pilar Teresa Cayetana, Duchess of Alba, and the question as to whether she really posed nude for Goya has been constantly debated during the past one hundred and fifty years and still makes news. *The Times* at the end of 1969 published a story headlined: *'The Maja's Secret May Soon Be Out'* and told of the disputes going on in Madrid's Prado Museum where the pictures hang. Did the Duchess of Alba pose for those two masterpieces, the *Majas*? Some people still feel this is something too outrageous to accept as possible. Art circles continue to rage and rant to 'clear the good name of a famous lady'.

The internationally recognized art expert, Francisco Javier Sanchez Canton, denies that she modelled for either of them, while the former Deputy Director of the Prado, Xavier de Salas, is writing an essay on the subject. Antonio J. Onieva in his *Complete Guide to the Prado* holds that the love affair between the Duchess and Goya remained platonic but he adds: *'The Clothed Maja* was undoubtedly painted from life, and his aristocratic friend might well have served as his model with her face intentionally made unrecognizable. On the other hand, *The Naked Maja* was surely painted from memory, or better, "deduced" from the previous painting.' So the argument for and against the honour of the Duchess of Alba goes on.

16. LIZ SIDDALL, ANNIE MILLER
Models and painters, dreams and drugs

In 1828, the same year that Goya, last of the traditional great masters, died in Spain, there was born in London, of Italian political refugee parents, Dante Gabriel Rossetti. This flamboyantly handsome poet-painter is, perhaps, the most popularly romantic figure of the pre-Raphaelite Brotherhood, just as his muse, Elizabeth Siddall, is the only name most people would remember of all the long-necked girls with goitres and bushy red hair who served them as models, mistresses and sometimes as wives.

The group of young men who banded together as the pre-Raphaelite Brotherhood—seeking to emulate the painters earlier than Raphael—spent most of their spare time model-hunting, 'chasing stunners', as they termed it in the slang of the day. They found them among the shop-girls, servant girls, field girls, slum girls; they also looked higher, for Burne-Jones recounted that they 'attended Church with the sole purpose of spotting potential models amongst the congregation'. Rossetti affirmed that 'before meeting Siddall he had held all models to be whores', but Miss Siddall was certainly most genteel and carefully 'refined'.

It was Devereux, one of the best-looking in the group of uncommonly beautiful young men, who first saw the sixteen-year-old auburn-haired girl in a milliner's shop off Leicester Square. Immediately he knew he

had found their perfect image, and forthwith captured her. One minute Liz was serving a customer with a cerise poke bonnet; the next, she had been recognized as the pre-Raphaelites' dream come true . . . which meant that instead of developing, like other girls, into a woman, she was to turn into an Idea. From that instant the girl born Elizabeth Eleanor Siddall was to function as a Victorian version of the Renaissance Simonetta, except occasionally, between times, when she was Dante's Beatrice. Despite the unsuitable English climate she had to dress for the rôle; in mid-summer the heavy velvet robes may have been hot but they were Dante Gabriel Rossetti's idea of what a medieval maiden should wear doing her spinning up in a tower at Camelot or wandering alone beside the River Arno dreaming of her love. Or at his whim she would change, even in the middle of winter, into a transparent, flimsy tunic which reminded him of what Simonetta wore when Botticelli painted her in *Mars and Venus*.

She started off by posing for all the pre-Raphaelites, paid at the rate of one shilling an hour if they could afford it, or seven shillings a day when shared by three or four all painting together. They raved about her, although when Holman Hunt painted her as Sylvia in his *Valentine and Sylvia* the top critic of the day, Ruskin, while praising the picture, 'regretted the unfortunate type chosen for the face of Sylvia with its commonness of feature'. Which must have shattered poor sensitive Miss Siddall, who entered heart and soul into the pre-Raphaelite dream. 'Art for Art's Sake is a Sin. Art Must Have a Message' was their dictum, and Liz was the greatest martyr of all to their Cause. A well-known story proves this, telling of how when Millais painted her as drowning

Liz Siddall

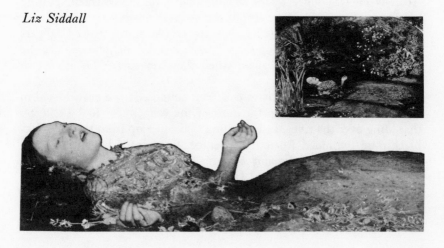

Ophelia, lying on her back in a tin bath, fully dressed in a waterlogged velvet and brocade gown, he became so deeply engrossed in painting the weeds entangled in her hair that he forgot to relight the lamp under the bath which heated the water. She lay there uncomplainingly for five hours, and one wonders if she was not as mad as Ophelia to put up with it. The result of this episode was a chill that kept her in bed for two months and started the lung trouble that persisted all her life. When she started to pose again, the artists found her even more inspiring—'she was looking thinner and more beautiful and more ragged than ever,' said Ford Maddox Brown expressing their admiration of her hectic flush, her fever-glazed eyes, gaunt shoulders and clammy brow. 'She was truly medieval,' they said, and the nearest to their ideal of Botticelli's Simonetta that they ever hoped to find.

Rossetti was particularly entranced by 'The Sid' as many called her. In her he saw the reincarnation of the ethereal creatures who wafted about during the golden days of Florence. She sat for him hour after hour, day after day, never moving, hardly breathing, holding one of her three poses, and it was only the occasional ladylike little belch when her indigestion was bad that showed she was alive. 'Her complexion was clear, ominously suggesting delicate health and her somewhat drawn and c..n acid expression may have been due to physical pain,' comments William Gaunt. 'She was passive. Inertly she sat for him long hours gazing into the fire, then she trailed slowly towards him, a melancholy doll.'

She inspired Rossetti to make his scores of studies of her in what they called the 'death-trance' series, lying back in a 'languishing' attitude. Actually she was doped by the sedatives taken for her constant splitting headache, because his Soho studio was above a rowdy dance hall. Later she inspired him in her 'withdrawn, trance-like state' at the Highgate studio, after the long haul up the hill had given her palpitations. But he found her most inspiring of all when they moved to 'The Crib', in Blackfrairs.

'The Crib' was not nearly as cosy as it sounds. It was enshrouded in fog and sodden with damp for most of the year, but it had a balcony that hung over the river, and the stink that came up from the greenish-black mud reminded Rossetti of Venice. He painted his Liz there as *The Blessed Damozel Leaning over the Bar of Heaven*, with her hair soaked by mist, spray or rain! He felt then that he too was in heaven. He was indeed so transported by the delicate green tones reflected in Liz's face, that he hardly noticed when, after hours with her head bent over the mud, she was genteelly sick.

Perhaps because of her somewhat limited repertoire of poses Gaunt describes her as 'a few poses on a frail stand', but her limitations did not, at that time, make the young Rossetti see her as other than 'sheer poetry', which decided him to make her into a poetess like his sister Christina. 'Anyone looking so beautifully poetic must be able to write beautiful poetry,' he insisted.

Liz longed to show herself the equal of Gabriel's snooty sister, who still treated her as a model and often ignored her or left her out of the conversation; she had developed a great feeling of inferiority about being classed with those common models girls whom she regarded with contempt, and she determined to become a poetess if it killed her. That it nearly did, for it was one thing to look as though you were thinking beautiful thoughts but quite another to think them, let alone to write them down. And even when she got one, how could she make it rhyme? But at last she discovered that all she needed was a good dose of laudanum and brandy, and there it was:

> 'I can but give a sinking heart
> And weary eyes of pain
> A faded mouth that cannot smile
> And may not laugh again.'

The pre-Raphaelite Brothers went into ecstasies of praise; but the strain proved too great for the poetess and after writing the last word she collapsed. 'Her mental power has been overtaxed,' said Dr. Acland and ordered her to Brighton to recuperate.

He also suggested to Rossetti that perhaps marrying her might buck her up, for although Miss Siddall had been living in Mr. Rossetti's studio for the past nine years, no one imagined anything as coarse as sex taking place within her rarefied and artistic orbit. When the restraint had grown too much for Rossetti's Italian blood, he roared off to Wapping to see Miss Fanny Cornforth, a buxom and obliging model, whose healthy sweat smelled good after his angel's fevered breath. Elizabeth did not mind, as Fanny made a spiritual liaison possible. He was much easier to manage when he came back from Wapping and she could go on being a virgin without much of a struggle. As David Larg described the situation between Fanny and Liz, 'They were as complementary as a lavatory and a drawing room.' But once, at least, Rossetti must have got mixed up and gone in the wrong door, for a biographer mentions the birth of a stillborn baby after which, he says, poor Liz was left with constant neuralgia. She grew to be touchy, neurotic, and

she was too preoccupied with death to care whether she married
Rossetti or not. She certainly knew, like many women around today,
that her aches and pains kept him as captive as any wedding ring.
Occasionally he escaped, and once in the midst of a spell of bachelor fun
and freedom, while painting the Hall at Oxford, he received news that
sent him scurrying back to her, leaving a message: 'Lizzie is ill at
Matlock. I am most wretched about her. What to do I know not.' So he
married her.

Larg relates how it happened. One day while they were out walking
in the country a storm came on. 'A clap of thunder sent her swooning
with fear into Rossetti's arms. She lay there while the rain dropped
through the leaves on her cheeks. He asked if she would marry him.
And her model's head nodded with the gesture of a woman accepting.'

The shock of the proposal, though they'd been together for nine
years, knocked her flat and she was rushed into the Florence Nightingale
Hospital in Harley Street to recuperate. When she emerged, they
married and went to Paris for their honeymoon, though neither saw
much of the 'gay city'. She never left the hotel on account of her
neuralgia and he spent the time doing the watercolours of *Martyrdom
of St. Ursula and the Ten Thousand Virgins*, and a strange composition,
How they Met Themselves, loaded with psychological suggestions in
which he showed his wife and himself in duplicate—both odd pictures
for a honeymoon.

Back home in London the young Rossetti's house had to be furnished
as medievally as possible with chairs 'such as Barbarossa might have sat
in'. At meal-times they perched on the sort of bench 'fit for a lackey at
Arthur's Court and they ate off rough pottery platters'. Apparently,
none of this period background helped their personal relationship
which deteriorated along with Liz's health. A friend wrote: 'They could
only endure each other when Liz had taken her chloral,' and another
intimate reports that 'he loved her best when after a dose she layed in
her armchair and acted dead.' All she had to do was to take a good gulp
of chloral and brandy three times a day, lean back in her chair and go
off.

Rossetti, too, went off in another way, with the gay and happy-go-
lucky, if loose-living, redhead Annie Miller, condemned by Siddall as
'noisy and vulgar with her high spirits and raucous laugh'. But it was
neither the naughty Annie Miller nor the forthright Fanny Cornforth
who broke the Sid's heart. It was the fact that Gabriel was now con-
stantly painting Jane Morris. Jane had also been a favourite model and
now, married to William Morris of handcraft fame, she was considered

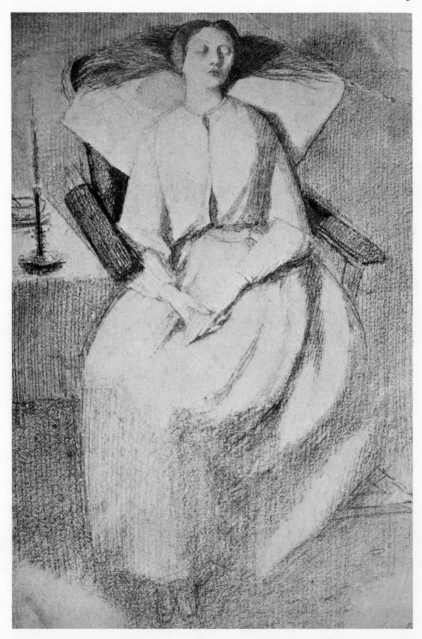

Liz after her chloral

the archetype of pre-Raphaelite beauty. Robertson-Scott described her as 'pure Cotswold type—ancient British', and she had the longest goitre-looking neck and was as thin as any ailing Sheffield-born Liz, who could claim no pure Cotswold blood. And this it was that literally killed the Sid; she could not tolerate another dream-girl on the scene. She claimed the long-suffering, other-worldly look as her own secret weapon and now she was left with only one way in which to out-martyr Jane. Though barely twenty-eight, she took an overdose of drugs, knowing that she would leave Rossetti with an insupportable guilt, never again to be much good to any woman.

She was right; his conscience tortured him as he read the poems written when he should have been at her bedside. As a token of remorse he buried them with her, slipping the manuscript under her head 'between her cheek and her hair', so that 'she might listen to his songs even in death', not realizing that the poor girl looked very uncomfortable lying there in the coffin with her face wedged up against an exercise book.

Seven years later, Rossetti could have kicked himself. If only he had kept a copy he could have sold those poems! But being an artist and sensitive, he could not bring himself to dig Liz up to recover them. Fortunately he found a friend to do it—for a price—and the manuscript proved to be still intact, except for one page where a strand of the famous red-gold hair had become entangled.

The story of Liz Siddall's other rival, Annie Miller, the 'gay girl' of the bunch, has been kept pretty quiet although she is now recognized as having been of great importance among the pre-Raphaelite painters and their models. But Rossetti and Holman Hunt's friendship was jeopardized and it was tacitly accepted that any publicity given to her love life could only harm them and other more important gentlemen involved.

She is said to have been 'a blazing beauty with a great mop of auburn hair, strange dark violet eyes and a divine figure'. She is first heard of as a London slum child, 'illiterate, infested with vermin, living in the foulest yards, using filthy language, in a state of absolute neglect and degradation'. When she was ten she was sent out as a servant girl, at puberty probably becoming a 'dolly-mop' as they then called a skivvy who eked out her pittance by a bit of whoring. At fifteen she was unearthed by the group of young pre-Raphaelite artists and set on the way to becoming a popular courtesan and ultimately a respectable married woman. Holman Hunt, having taught her how to speak correctly and how to behave politely, created an early version of Pygmalion. Although when he had groomed her sufficiently to become a wife he

intended somewhat vaguely to marry her, she was meanwhile allowed
to pose for the Brothers, though not in the nude. In her biography of
her grandfather, Diana Holman Hunt says that the lovely model was
'all things to all men'. Millais sees her demure with hair drawn back

Annie Miller

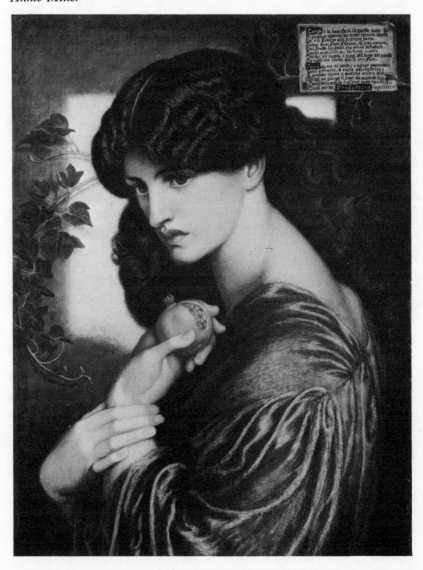

under a poke bonnet, while Rossetti takes a completely different view, portraying her as almost a vamp in his seductive *Helen of Troy*. According to Swinburne she has a 'Parian face with a mouth like an ardent blossom framed in broad gold of widespread locks'.

This beautiful, promiscuous girl, despite her many lovers, seems to have lived in continual financial crisis. Nevertheless she became London's top model, in great demand and earning ten shillings a day. She was voted Queen of the Artists, an honour awarded to the model considered most highly amongst all who posed for the pictures hung in the Royal Academy Exhibition. In the spring of 1853 Annie 'dazzled all at the Private View and was named as "The Belle on the Line" '. And it is odd to discover that the painting that made her the most fêted and sought after light o' love in London was Holman Hunt's highly moral narrative picture *The Awakening Conscience*. Annie is portrayed as a goody-goody young woman who suddenly realizes that she is about to act in an unladylike fashion. She is jumping from the knee of a would-be seducer, wearing an alarmed expression which is supposed to indicate that she 'sees light and renunciation' while the thwarted trifler is obviously irritated and bored by all her nonsense. How could Annie, who had probably sat on every male lap in Belgravia, be expected to simulate the awakening conscience! She had no bother with her conscience at the time the picture was being acclaimed, for its creator, Hunt, was away in the Holy Land painting biblical scenes and unaware (though perhaps suspicious) that his protégée was living it up with his soul-mate Rossetti. With Hunt out of the way and Liz Siddall having one of her health cures in Hastings, Annie moved into Rossetti's house and these two colourful extroverts were, according to the diarists of the day, painting the town red, dancing at Vauxhall every Saturday night and spending their days at races or river parties. On one such occasion she met the rich playboy Lord Ranelagh, which started off a long and luxurious affair, eventually ending in her marriage, not with him but with his more respectable cousin. The wedding took place in St. Pancras Town Hall in 1863, and from then on, erstwhile model Annie Miller lived like a lady in a big comfortable house in Richmond. Thanks to the artist Holman Hunt, she could sign her name instead of 'X' on the marriage certificate.

17. VICTORINE MEUREND
Who didn't dress for the picnic

Early that summer of 1863 when in London the slum-born Annie was being made into a respectable married woman, in Paris another model, Victorine Meurend, was being literally spat at for the picture in which she modelled nude at a picnic. This was the now famous, but then infamous, *Déjeuner sur l'Herbe* by Edouard Manet. The painting scandalized Paris and caused gibes and insults to be heaped on Manet's favourite model, earning her the somewhat dubious distinction of being the most insulted model in modern art.

Her story had started three years earlier. Having spent an hour in the Louvre one wet afternoon to get out of the rain, she was skipping down the steps on the way out when she bumped into a grumpy-looking young man who nearly knocked her over. Perhaps no unusual circumstances for a Paris pick-up this, but it brought quick results. Plain and puny little Victorine went along with Edouard to be, from then on, his 'comrade' and his model.

Manet, at that time, was having a *crise-de-nerfs*. He had been on the bottle for three days to forget a bad experience. He had been using the Académie Suisse, a studio run by an ex-model who provided a twenty-four-hour non-stop model service for the convenience of artists who felt like working at any odd hour of the day or night. Most of the models willing to pose under such conditions were scruffy little waifs who had no roof over their heads except the studio they happened to be working in at the moment. They were known as 'studio-rats'. A studio-rat would sweep the floor and run errands between stints of posing and

didn't even aspire to sleep with the artist, which was the most usual way of earning a bed. One of these 'rats' attached herself to Edouard Manet, knowing he was one of the few artists with money who ever came near the Académie Suisse, but one night, bored with her scrounging, he pushed her roughly enough to send her skidding the length of the studio. Probably ashamed, for he was a well-brought-up young man, son of a magistrate, he flung out to the nearest bar for a cognac. When he returned to the Suisse he found the poor little 'rat' hanging dead from a beam of the studio roof. Manet remembered very little after this until he found himself in the familiar entrance to the Louvre . . . and, *nom de Dieu*, nearly knocking down another girl. The shock brought him to his senses and the relief when she smiled up at him was enough to create an illusion of beauty which no one else could ever see.

'She is not strictly beautiful but she is like one of those macabre dwarfish demi-virgins in a Baudelaire poem,' he told his wife, a broad-minded piano teacher from Holland, to whom he had confided every-thing ever since his youth when she had given him music lessons. Between scales and fugues she had become his mistress and ended up by marrying him. But she never hampered him. Smiling tolerantly, she went on playing while Edouard and Victorine were busy at the far end of the studio and the training of the new model began. With beginner's enthusiasm Victorine started by taking up the attitudes she had seen in pictures in the Louvre, which only infuriated Manet, who was obsessed with the latest idea in modern art of painting people 'candid camera' fashion. Once he slapped down her upswept arm pointing to the skies in what she assumed was a beautiful and goddess-like pose. 'Is this how you stand when you are at the greengrocer's waiting for a bunch of radishes? Why the devil can't you be yourself?' Perhaps she would have got on more quickly if he had kept his word and allowed her to pose as herself. Instead she had to stand in for whatever character Manet wanted to paint, matador, schoolboy, brothel-keeper, sailor, gypsy dancer, Christ, an angel, three beggars, or a bugler boy, it is always Victorine, with Victorine's face, Victorine's big bust crammed into a small fifer-boy's uniform, or Victorine's fat thighs bulging out of the Spanish matador's pants. It is said that Victorine Meurend was Edouard Manet's Gioconda, and just as Leonardo painted the Gioconda into every character, male or female, young or old, he painted Victorine. Some thought Manet went too far. Looking at her as *Mlle Victorine in the Costume of an Espada*, now in the Metropolitan Museum in New York, we hardly feel the fire of Spanish passion. She gives the impression that the pinkish garment she is holding out is a soiled pillow-slip she is

about to drop into the laundry basket, rather than a red cloak tò bait the bull, and her expression is more that of a patient housewife than a daring and alert bullfighter.

Manet had a fixation about Spain and the Spanish, although he had never been there. He dreamed up flashing-eyed señoritas and Castilian noblemen as well as Andalusian dancers and picturesque bull-fighters and gypsies and fiestas. All this glamour very much dimmed when he eventually visited his Utopia to find it, after all, not so very different from the scene at home in France.

Meantime there came the day when Victorine was to get the chance to pose naturally, not in any fancy costume, but in no clothes at all. When Manet did a nineteenth-century version of Georgione's *Déjeuner sur l'Herbe* she, like Violante, sat naked while her two male companions at the picnic were fully dressed. The parts originally taken by Titian and Palma Vecchio were posed by Proust and the artist's brother.

But whereas the original picnic scene had been called a work of pure genius and beauty, Manet's was immediately spurned and scorned because of the obscenity suggested by the 'vulgar contrast of fully dressed males and a nude female'. Odium fell not only on the artist but also on Victorine, 'that disgustingly natural-looking model'. Behold

Victorine . . .

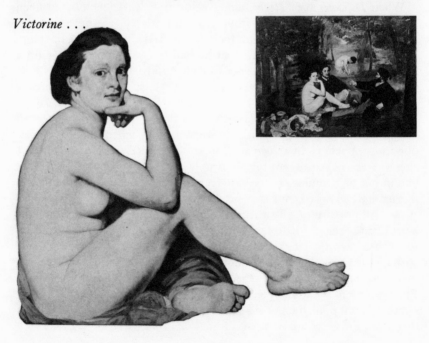

Victorine, if you please, leaning her elbow on her knee, glancing around as perkily animated as though she were clad in a high-necked blouse and ankle-length coat instead of nothing at all. Thousands of words were published attacking Victorine, apart from the actual art criticism of the painting. 'The two escorts, being completely and fully dressed, even to cloth caps, make her look even more naked by contrast.' 'Neither of the men is paying the slightest attention to her, which underlines the grim hint that they are undisturbed by nudity sharing the same picnic cloth, so to speak.' And another casual touch to inflame every decent Frenchman: 'Not only do they all ignore each other, but no one is attempting to eat the food which is spilled carelessly into the foreground. What a title for a picture in which a naked woman fails to look modest and two well-known men, fully dressed and without seeming to want to discard trouser or shirt, are paying no more interest to the food than to the woman.'

One of the kinder critics said of Victorine: 'She might have got away with it if she was looking like she was getting into a Roman bath and wearing the accepted blank expression which marks the whole difference between "Nudes in Art" and the woman next door without her clothes on.'

When *Déjeuner sur l'Herbe*, along with other works which had been thrown out of the Academy that year, was shown at the Salon des Refusés, the Emperor Napoleon took the Empress along to the opening. 'The Emperor was so shocked that he had to force himself to stand a few seconds in front of it in order to collect himself sufficiently to pass on, but the Empress just pretended not to see it,' reported the prestigious magazine *L'Art*.

If Victorine shocked the world by the way she didn't wear clothes in the picnic picture, she got into even worse trouble when she posed as an out-and-out whore in *Olympia*. She lay on white satin cushions and sheets, stark naked except for a string of black velvet round her throat and in her hair, mules on her bare feet—and a bracelet. 'There she lies disgustingly exposed, not as a pitiful whore, but as a triumphant and successful prostitute,' gibed André Gustave. 'She has the white flesh of a prostitute,' raged Fleurot, though why, wondered Victorine, should a prostitute have a paler skin than a wife? Had she been lying on a cloud, with a little Cupid bringing her flowers, instead of a black maid bringing in a huge bouquet from a satisfied client, the picture might have got by. But even then, what offended most was not the blue-white skin tones, not the blatant pose, but her shape, with none of the curves and roundness that were the accepted form of a nude, one that could be excused as a

. . . disgustingly exposed

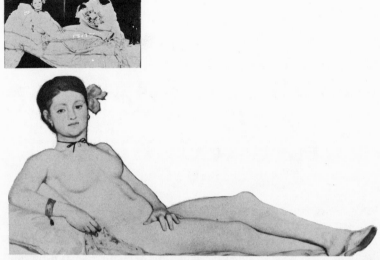

'study'. Victorine's breasts and hips may have been too feminine for the military uniform of a fifer boy, but they were not the fulsome feminine beauty that people liked to see in a nude painting. 'What is this yellow-bellied odalisque, this wretched model picked up from heaven knows where, a sort of female gorilla?' Victorine read in the press next day. Dégas had said: 'I look on her as on all women—as animals'; Renoir had frankly declared her 'not my type'. Victorine had been insulted enough for art's sake; she never posed nude again.

It may have been all for the best, because Manet switched to another type of model, very young blonde girls, big-bosomed and blue-eyed, the skin warm with a beautiful golden glow. His *Blonde with the Nude Bust* is so different from Victorine that the American art historian Lane Faison comments: 'It is hard to believe that this mild blonde nude was painted by the same artist who gave us *Olympia*. It is even more disconcerting to discover that Victorine Meurend, Manet's favourite and deeply admired model, posed for the bony asperities of the *Olympia*, while a professional whom he painted only once or twice again served him for this lovely evocation, all wistful and warm. Here the flesh tones, the ochre hair, and the pale blue eyes—their colour tied to the blue accents in the fallen chemise—all these blonde harmonies are set against a springtime green to suggest a kind of human flower.'

How different from the hard things that had been written about Victorine who, poor girl, could never have been called a 'human flower'!

18. CAMILLE
The model who married an 'Eye'

Despite being supplanted as his model, Victorine remained Manet's close companion, and that summer the two of them joined a group of the Impressionists on a houseboat lent to Claude Monet and his wife Camille. There they spent most of their time sketching each other and painting sweet Camille, everyone's favourite. They erected a canopy over one half of the deck to make a floating studio, and here Camille could for once, because she was pregnant, lie quietly instead of switching from pose to pose. Manet, Monet, Pissarro and Sisley painted from dawn to dusk; the light was wonderful, the whole set-up ideal for painting. Camille was the perfect model, never tiring, never grumbling, never bothering about meals—for the very good reason that there was no food to cook.

Nevertheless Renoir wrote: 'She is the perfect model and the perfect hostess.' He might have added that he was the perfect guest, as he scrounged bread from his mother's kitchen to bring them that they might not starve. Even in their poverty, Renoir said Camille kept the family life going and it was due to her that Monet was able to go on painting. This state of affairs was nothing new for Camille. She was surely the quintessence of the self-sacrifice art demanded from girls who linked their lives with the Impressionists.

What if, while chopping up the chairs for firewood, she could have foreseen a hundred years ahead. Could she have imagined that the morning paper of June 9th, 1965, would carry a paragraph on the front page: 'A painting by the Impressionist, Claude Monet, was sold by auction for 2,520,000 francs (about £200,000) to an unnamed buyer in Paris tonight. The work, entitled: *On the Cliffs 1876* is of Mme Monet and her son.'

During the painting of that picture Camille was probably feeling extremely hungry, and it is unlikely that the family had any settled place to live. No one dreamed the picture would ever be worth the price of a good meal each. Even so, what difference would it have made? Camille believed in Claude Monet's genius, money or no money; throughout all their privations she insisted she would rather go hungry, thirsty and cold than allow him to 'prostitute his art' as he called accepting a commercial assignment. Camille has been called the most dedicated of all paint-and-palette martyrs in promoting the birth of modern art. She is perhaps the only model to suffer hardship not only for the man she loved but for what he was trying to create.

For one thing, she understood what they were getting at; she never expected the pictures she posed for to look like carefully detailed portraits. She had no ambition to have her beauty perpetuated for posterity. She knew she was merely a shape on which the artists experimented with the play of light and colour. She was, moreover, a shape in movement, so for her there would not be many quiet hours posing passively lying on a couch. She did most of her posing outdoors, flitting or swooping so that Renoir or Sisley or Boudin or Pissarro, Manet or her beloved Monet could make hundreds of studies of her according to the new concept. And if she ever envied the old-fashioned artist's model, well sheltered from boiling sun or east wind, cosily naked in a heated studio, she never complained. Cézanne said of Monet: 'He's only an eye—but what an eye!' Camille soon learned that being the other half of an Eye demands stoicism.

She knew hardly any other life. She had gained quite a reputation as a popular artist's model when, at only sixteen she, a 'dark and fragile beauty', met twenty-two-year-old Claude Monet, burly and bearded Normandy beatnik. He and his friend Bazille had just moved into a new studio which they celebrated by giving a fancy-dress party. Camille, wearing a green-and-white-striped dress with a little fur bonnet and a black velvet jacket (it is not clear what she was meant to be dressed as) caught sight of dark-eyed Claude in a blue fisherman's jersey and red cap which showed off to advantage his muscular good looks and contrasted with his tall, exotic friend and co-host Bazille, in Arab costume. She and Claude fell in love. In France at that particular epoch artists and intellectuals were usually more attracted to girls than to boys and it is hardly likely that Monet and Bazille were homosexuals, but the sultry African-born Bazille took a bitter dislike to Camille on that night and never got over his jealousy of her, though in the years to come he forked out often enough to feed them.

The two of them, we hear, never left each other's side the night of the party, which, even by Montmartre standards, must have been pretty riotous, because although Monet and Bazille had just moved in, the concierge came up next morning to tell them to leave. Bazille went off sulking, and Claude and Camille, she still in her best silk frock, started house-hunting. They settled on an attic, the first of a succession of garrets and cellars and sordid lodgings they were to drift into and be thrown out of during the years ahead.

And if you would expect that the gay little artist's model and the unconventional young painter would be making love all day, you'd be mistaken. From the first, work took priority; when Claude told Camille that he had nothing ready to enter for the Salon the following week, she jumped out of bed, popped on her striped dress, her bonnet and muff, and was about to rush off in order to leave him quietly alone to work. That was how he painted her, glancing back over her shoulder as though she were on the verge of running from the room. That was how she posed for him for three solid days and most of three nights, only stopping for a bite or to lie down on the divan for a few hours of sleep, and never even taking off her dress, let alone the long flannel drawers she wore beneath.

On the fourth day they took the painting along to the Academy. *Camille, or the Girl in the Green Dress* was accepted and created the big sensation of the season. For a few weeks Camille found herself treated like a star, talked about, pointed out on the boulevards, recognized in the cafés. Milliners made little fur bonnets called *Camille caps*, girl babies born that month were named Marie-Camille, and it was considered chic to pose 'as though you were slipping through a hole in the wall', as someone described the girl in the picture. Renoir praised her as the ideal model. 'She can wear every type of garment with distinction.'

Back in Normandy, old Père and Mère Monet were so impressed when they read what Emile Zola wrote of their son: 'Here is a temperament, a man in the crowd of eunuchs,' that they straightway started sending him a small allowance. 'Only sufficient for yourself,' they wrote, for they would never dream of encouraging an association with an 'artist's model', to them the most disreputable of all types of naughty Parisienne.

But even this tiny allowance stopped when the short-lived success turned to failure; disillusion came with the reports of sneers and mockery on the Impressionists, which Monsieur and Madame Monet now read in the newspapers. That dreadful little model girl was all to blame, of course, and their anger was understandable, for even 'nice

Bazille, a young man of good family', wrote to them to that effect. 'She is fettering the man to kill the painter,' he said. They wrote to Claude that until he became a success they could not send him any regular money, and never would he get a sou while he continued this scandalous liaison; however, he could always return home, where they would feed and house him and welcome him . . . alone.

When young Monet read this letter to Camille she realized how much he must be missing the good country food and the fresh air and all the home comforts of the Normandy farm, and how dreary he must find their damp, dark cellar with no money for food or wine or heat. It must be more than ever depressing for him, she thought, now that she was pregnant, apt to flop about fainting when she was hungry, and vomiting with morning sickness. Camille had suggested asking the well-off Dégas for a loan, enough for bread and paints for a few days. But Claude had refused in horror. 'After he has called me no more than an interior decorator, never.' So he wrote to Emile Zola instead, telling him that 'Tuesday we shall be thrown out into the street and every stick of furniture sold.' They also appealed to Pissarro, Baudin and Bazille, but no one could afford to give them enough to last long and Camille insisted he should return alone to his parents' home. 'I'll write again to Bazille and insist he lends you a few francs,' he promised as he left, which indeed he did. 'She is a good sweet girl,' he wrote. 'I should be full of unhappiness if she had to go through childbirth without a mid-wife or food or heat or anything to wrap the baby in.' And he ended with a stiff rebuke that Bazille had to be asked for money at all; the least one could expect was to receive regular remittances from one's friends. Bazille, who still disliked Camille, answered: 'I doubt that she has any maternal feelings,' and enclosed another loan.

When this was gone Camille burned the chairs and table for firewood, and when the baby was due she managed alone in the cold cellar. She wrote not a word of that to Claude, fearing to depress him and disturb his work. When he had a stack of canvases ready, Claude returned to Camille and their frail undernourished son, Jean. The pictures started selling well and their creditors expected some of their debts to be paid, but Camille realized they would soon have nothing left if they started that. It would be wisest to get out of Paris, away from everyone to whom they owed money, and into the country. They found a little house with a garden, and Camille planned to grow all their fruit and vegetables and keep a patch of lawn for Jean to run around on. But no vegetable garden materialized, and no lawn was left for Jean, for Monet, wholly obsessed by the need to paint out of doors with the play of sun-

light on moving figures, uprooted the roses and the flower beds and the grass plot and dug a deep trench, into which slid, when he was not using it, his huge easel and the enormous canvas on which he planned to paint

Camille

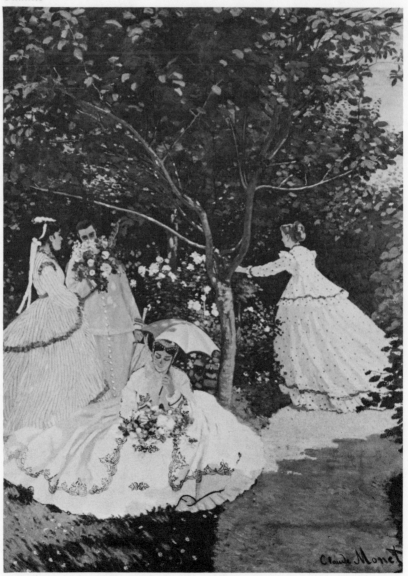

the life-size *Femmes au Jardin*. Camille, posing for all of the four women, each in exactly the same play of light each day, rushing from girl number one picking a bunch of flowers, indoors to change for girl number two, smelling the flowers, change again for girl number three, looking at girl number two having a sniff, then yet again to girl number four, speeding off down the garden path as though in a rush to the lavatory.

Sadly, however, the gigantic canvas was turned down by the Academy and generally slated. The artist, the model and their baby faced poverty once again. When down to their last sou there was no question which got priority, paint or food. Cobalt blue won over red cabbage. Young Jean became used to being gathered up from the box or drawer that at the moment served as his bed, and bundled off along with easels, turps, brushes and stretchers ready for a midnight flit. One occasion he especially remembered was seeing his mother dart back into the room, catch up the vegetable knife and slash through the stack of two hundred canvases piled against the walls that they had to leave behind because they couldn't carry them on their flight, shouting: 'At least they won't be able to sell them.' But they did sell them. Later Camille was to hear that the creditors had tied them up in bundles of fifty and sold them for thirty francs a bundle.

One episode that the little boy recounted later was of their stay at the waterside inn at Fécamp. Their room overlooked the harbour and the wharf where the tugs and the little ships tied up. After a few weeks the landlady came up and threatened to turn them out next day unless they paid the bill. Her insults upset Claude and Jean remembered watching from the window as his father stamped out of the inn, strode along to the end of the jetty and, fully dressed, jumped into the water. Jean called to his mother and Camille leaned out, yelling: 'You silly fellow, come in here before you get a chill!' Monet changed his mind about drowning and swam back to the steps, left his clothes on the wharf to dry, and returned to the inn stark naked. This was just too much for the landlady, who locked them out. Next day, Bazille got another SOS for money. 'I've just been thrown out of the inn and without a stitch of clothing, what's more. Camille and my poor little Jean have managed to find shelter in a loft for a few days.' This time no money came from Bazille.

Camille still held out. Whatever happened, Art came first and foremost. Commissions for conventional décors were refused one after another. 'You must paint as you believe,' she insisted.

Monet painted Camille into many sunny landscapes though he never disguised the fact that he would rather have painted a tree, but he

compromised by treating her as though she were an integral part of the landscape like the bush at the cottage door or the clump of greenery on the hillside or the path drifting off down the valley . . . she was a shape catching the light and proud to be the first artist's model to become a blob instead of the usual portrait-likeness with a face and two eyes and a nose and a mouth all carefully painted in.

There were others in their group who were no better off, which may have given them some sense of comfort. Nearby lived Mary Ann Guedes, the hefty peasant girl from Brittany who was the model-cum-mistress of the artist Boudin. She would stumble past Camille's window, heavily laden with stacks of canvases packed on her back as though she were a mule, taking Boudin's pictures to the nearest town ten miles away, where they were put up for auction. Nobody ever bid for them, so Mary Ann Guedes would come staggering home with the whole load. She never grumbled, never demanded or expected enough food or a fire. It was enough for her that Boudin always addressed her as 'Comrade'.

In a tiny cottage a short distance further along the coast lived Pissarro with his model Julie Vallay and their five children. Unlike Camille and Mary Ann, Julie could not resign herself to hardship and obtained no satisfaction from sacrificing herself for Art. She bullied and nagged Pissarro to find a job that would keep them all and to waste no more time on these daubs which never sold. Gentle Pissarro, a West Indian whose mother was a Creole and father a Portuguese Jew, must have made a gigantic effort to stand firm, but he remained the most dedicated of all the Impressionist School. Only for one short period did he succumb. When there was not enough money to pay the few francs for the cottage rent, Julie Vallay insisted that they all move in with her parents. The old people had to pack them into one room, into which were crammed the whole family, piles of canvases, easels and all their other belongings. After a few months eighty-year-old Monsieur Vallay had had enough. Why should he have to work in the fields at his age to keep Pissarro and his brood? His attitude deeply offended the sensitive artist; he fell ill and could no longer paint. So Julie brought them all back to live in a fisherman's shack near where Camille and Claude were temporarily lodged.

These two seemed less harried than usual. Their son Jean was a bit stronger, because Claude was currently working on a picture called *Le Déjeuner*; Camille and Jean are at table in the sitting room of the Fécamp cottage, a maid is leaving the room and a smartly dressed caller is leaning against the window. There are curtains at the window and a cloth on the table set with wine and food. Camille spent every sou she

could muster to provide these props. She posed for all three women in the picture, hurriedly switching from the maid to the guest and then back again to be herself watching young Jean tucking into the eggs, the grapes, the rolls and the cheese. But this happier interlude was short. Came the Franco-Prussian war and Camille began selling everything she could lay hands on in order to provide Claude with the fare to England, for it would be too noisy and unsettling for him to concentrate on his painting with a war going on.

She did, however, urge him to marry her before leaving in order to ensure that, should his parents get killed, she and Jean would be entitled to their money until Claude could return.

Thus, after five years together they were married, and hurriedly Monet nipped aboard the last Channel steamer bound for Southampton. She waited in Paris for his news but as the guns got nearer and the siege closed in it took a long time for his first letter to reach her. He wrote from lodgings in Bath Place, Kensington. He didn't like the English, who were uncivilized and horrid and did not realize that Art comes first, before family, *patrie* or anything else. He enclosed a little sketch of Hyde Park. She answered, encouraging him to be brave in depressing England; she said that she and the boy were eating rats, and she was 'as thin as nails'. The next letter from Claude expressed his anxiety and told her how upset he had been to hear from a neighbour that the Germans had taken over their cottage for a butcher's shop and had dumped his pictures in the garden, laid end to end to form a path from the slaughterhouse to the shop. And he concluded that life in London was more ghastly than could be believed, as he was now lodging in Lower Norwood. Camille couldn't reply; apart from having no paper or ink or stamps, for once she could think of nothing to comfort him for Lower Norwood.

As the long war ended she did, however, manage to get a message to him that she and Jean were still alive but that things were hard in Paris and it would be wise for him to get away somewhere for a holiday to recover from his trying experience of life *chez les Anglais* before returning to France. After he had recuperated in Holland, Camille was ready to welcome him, and they were together again with little Jean. But postwar conditions were too uncomfortable and Camille urged him to return to Holland and paint tulips until things got a bit more settled.

Camille determined that on his return she should devote herself more than ever to working for him as his model, but she was still very thin and had lost much of the curving roundness that Monet valued in her. She suggested, therefore, that in the first picture she posed for on his

return she should wear a Japanese kimono, the Japanese cult being all the rage in Paris just at the moment. Mainly to please her and also as an exercise in colour and texture, Monet painted Camille in her kimono and they sold the picture for 2,000 francs. Their friends and their houseboat studio soon ate that up and after the summer—the happiest in their lives, when the Impressionists painted together with Camille lying pregnant in the sun as their model—they were on the move again. Once more Claude started selling canvases for twenty francs each when by luck he could find a buyer. More scrounging, so Zola received the usual 'We haven't a sou in the house to keep the pot boiling . . . send two louis or only one.'

After Michel was born, understandably as delicate as his brother had been, Camille was left with little energy for darting about in order to catch the fleeting light at that precise second of action which could never recur or last for more than the instant. She tried but could not make it. Claude, though desperate and heartbroken, set about making his last studies of her. Excitedly he recorded what he saw; he had never painted a dying woman before. The tears of the lover did not dim the 'Eye'. The Eye noted the changing colours, how the reds and pinks of the flesh tones faded, giving way to the blues and greys which soon predominated. To the end, always different, always changing, the ideal model.

19. ROSE, CAMILLE AND CLAIRE
Fifty years of Rodin

After a long model-mistress relationship, it seems not unusual for an artist's model to die within weeks of marrying her painter-lover. Cecilia bore Titian four children, died a couple of months after their tardy wedding; Liz Siddall, having spent nine years with Rossetti, lived only a short time to enjoy being a respectable wife; and the same applied to Camille, whom Monet married to safeguard the inheritance of their son. And now Rose Beuret. Rose became the mistress of Auguste Rodin in 1864 and married him in 1917. She died two weeks later. In all that time, despite his succession of other loves, Rose's loyalty never wavered. In traditional story-book style, she was a simple country girl who came to Paris to earn her living as a seamstress. Next to the shop where she worked, the old Théâtre des Gobelins (later a cinema) was being redecorated and the red-bearded young stonemason, hired by the building firm, kept looking in at her sewing away by the window. They called it 'love at first sight', and in his memoirs he recollects how 'her handsome peasant type with strength and vigour of features' inspired him during those early days of poverty and hard work.

The first portrait bust of her, *Young Girl with Flowers in her Hair*, shows her as she was at twenty, a steady, practical working girl more fitted to farmhouse chores than a Paris salon; and the second portrait of her he called *Mignon*, though any title less suitable it would be hard to imagine, for she was by no means dainty or sweet, as the word suggests. The figure of *Bacchante*, rounded, vigorous, rather clumsy, is a more truthful picture and his most treasured work of those early days;

Rose

indeed he never got over the grief that it was damaged when they moved into their stable. The stable was the only place they could find that was cheap enough and large enough to house the piles of stone, the huge, unfinished, headless torsos, the great plaster limbs, odd legs, arms, hands, fingers and toes which he produced in quantity. The stable was freezing cold, draughty and damp in winter; in one corner a sunken well brimmed over, keeping the air dank and humid and very smelly. And to make it worse, there was the eternal smell of cabbage for, whether because they could not afford anything else or because it was Rodin's favourite food, they lived on cabbage soup. 'Monsieur Rodin likes it every day,' Rose would say; she always referred to him as Monseiur Rodin and he spoke of her as 'my companion'. He would say: 'I choose a pose my companion can easily resume after the rests.' She could not

have had much 'resting' for, as he was out all day doing his decorating, she had to get up before dawn to fit in a couple of hours of posing before breakfast and they resumed work again at night.

'Sunday was our afternoon off,' he wrote in his memoirs. 'After a long morning working in the studio we used to make up for the hardships of the week by going for walks across the fields and woods on the outskirts of Paris.'

When their delicate son was born there was no reason why they should not marry except that he was horrified at the mere mention of marriage. 'I don't like tyranny of any sort—not even of tenderness,' and though he acted tenderly towards her he confided to his diary that 'she is too much of a savage'. However, he did consent to his son being called after him, 'Auguste', though he did not give him his surname of Rodin. Sadly, the boy grew up maladjusted; he married an epileptic girl and both became alcoholics and died of drink. We do not hear whether this meant much to Rose, for she devoted her life entirely to Rodin and his art. For his part, no artist has ever attached more importance to his models. He declared: 'I can only work with a model, the sight of the human form sustains and stimulates me; I have a boundless admiration for the naked body, I worship it.'

Most of the artists living in Paris found a great variety of models to suit every subject at the Models Market held every Monday in the Place Pigalle. Clive Holland described it: 'The artists scan them all narrowly and critically; sizing up their various defects and excellencies, sometimes feeling the contour of limbs and examining the development of muscle as one would do if purchasing an animal. But the models didn't seem to mind and appeared to be thoroughly enjoying Monday Market Day.'

But even when he could afford it, this method was not for Rodin, who fervently detested the conventional academic model trained at the art school to take up a few static poses. He gathered in a dozen or so men and women: circus people, wrestlers, sailors, dancers and washerwomen, and paid them one franc an hour to walk around the studio nude. He worked among them like a modern photographer, catching a movement here, a gesture there. When a girl scratched her back he would call out: 'Hold it!' and speedily sketch the pull of her shoulder muscle as she stretched her arm. When a man stooped to pick up a tack from the floor he would rush with his paper and charcoal to make a quick study of the curve of the spine. With a score of naked people milling around among great blocks of marble and unfinished casts and busts, Rose could never find a corner to do her ironing, and it was worse when Rodin took in his father, gone prematurely senile, for the poor man refused to leave his

bed. The models had to walk around him, while Auguste junior wailed away in a cot. This was the only noise that made Rodin angry because he said it distracted him from his work. And Rose would do her best to appease him, for to the end of her days she lived in dread of his forsaking her.

She had plenty of cause to feel insecure. He admitted that he adored women and he worshipped a beautiful nude. Jules Desbois, the French biographer, describes how: 'The sitting over, the model still lay stretched out on the couch. Heavy lidded eyes aglow with fervour Rodin advanced on her and planted a reverent kiss on her belly as though in gratitude for her beauty. A chaste gesture.' And he once remarked of a woman undressing: 'What a glorious sight, like the sun breaking through the clouds.' His woman-worship did not stop at models. Despite his shyness, he had a great attraction for all types of females and had love affairs with women of every age and rank from *les filles des quartiers* to the countesses who sat for portrait busts. But the great love of his life was none of these, nor was it the humble Rose.

Camille Claudel was the rival Rose most hated and feared and of whom she was most fiercely jealous. When dramatist Paul Claudel became a close chum of Rodin's she had no idea of the misery that would result. Paul's sister, Camille Claudel, was a twenty-four-year-old art student. In addition to her striking good looks, she had great talent. Her bright auburn hair and extraordinarily deep blue eyes must have

Camille Claudel

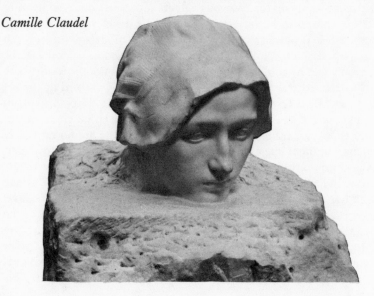

been unusual. 'A superb young woman, triumphant in her beauty' is how someone has described her. She became Rodin's pupil, his secretary, his mistress and his model. First he modelled her head but later her nude figure. He proclaimed her his inspiration and his great love, which disgusted her brother Paul, who turned against Rodin.

The association between Rodin and Camille lasted for nine years. It was during this period, with her to inspire him as collaborator and model as well as mistress, that he turned out all the erotic couples, cold marble figures in hot clinches, nudes showing changing sex, groups of lovers which had to be named after classical myths in order to escape the charge of pornography.

A point to note is that neither Rose nor Camille modelled for Rodin's best-known naked embrace, *The Kiss*. The girl is Carmen, who was much in demand among the top artists, and the man is Antonio Nardoni, who had often worked for Rodin as a male model. In 1960 Nardoni, then an old man of eighty-four, was photographed for the *Daily Express*. He told how he had posed every day for six months, sometimes for twelve hours without interruption. 'I found it very difficult to keep a professional attitude towards the young lady I was posing with,' he is reported to say. In England there was an accepted convention amongst artists' models (maybe still existing) that only husbands and wives can be asked to pose nude together. But Antonio Nardoni was not led astray. He remained with his wife and had nine children.

In France as well as in England nude was rude, and Rodin and Camille suffered from bad criticism. Nor was it merely a matter of sex; Parisiens were disconcerted to find their intellectuals such as Victor Hugo and Balzac portrayed without their clothes on. People were not used to seeing Hugo, stripped sitting in the open air, as they had always thought of him in a suit and shoes; nor did it seem respectful to have middle-aged Balzac displaying his pot-belly as though just out of the bath. Camille could comfort Rodin for all the gibes but what she could not stand was that he went back to Rose every night. He returned to their horrid house in Meudon where she was always fearfully watching for him. 'If Monsieur Rodin ever left me . . .' she was forever murmuring.

Rose had lost her looks and was a shrewish old peasant woman, nagging and questioning and accusing him and forever abusing Camille. She knew he was bored with her, coming from the studio shared with the stimulating, younger, more beautiful, and highly artistic sweetheart. Poor Rose, though she sensed the danger of driving him off altogether, she could not control herself and there were continual and dreadful scenes. Camille went in for even more shattering dramas, threatening

suicide amidst violent outbursts of temper. Gentle Rodin said that all this emotional crisis rent his heart and sapped him to the point of collapse. Once when Camille suffered a nervous *crise* while entreating him to leave Rose, he compromised by taking her on a trip to the valley of the Loire. In their hotel room at Tours they spent the first evening in their room by candlelight. She undressed but not for making love. He finished sketch after sketch of her, hardly completing one before starting another, until dawn broke over the old grey stones and the grey bridge of Tours. As he had told Rose that he would be back within a few days but did not return for a month, he found her ill from a heart attack. But eventually it was Camille who cracked up and left Rodin for ever. She shut herself up and lived as a recluse for thirty years. In the end they found her neglected and demented and took her away to die in a poor-house. Ten years later her work was exhibited in the Musée de Rodin in Paris.

Rodin was to have yet one more art-and-heart episode. When he was sixty-five he carried on what has been called 'a disastrous affair' with the Duchess de Choiseul . . . bringing us to yet another nude Duchess in the history of the artist's model. This scandal caused raised eyebrows in Paris and New York, for the Duchess Claire Cordet was the daughter of an influential American legal family who were no better pleased at the idea of her posing nude for Rodin than Paul Claudel had been to see his sister Camille in similar circumstances.

Claire devoted her whole time to Rodin, would not leave Paris, and evidently had to put up with as many difficulties as the more lowly girls who served as models. To quote an extract from one account of the Duchess at work: 'Some days Rodin said she looked tired; other days he said she had done her hair badly. When the clay study was well advanced he suddenly noticed that she wore false hair. From that day onward he modelled only her face . . . (she) lay down on the floor on her back, her head turned towards the light, her neck firmly between his knees, while he modelled with his thumb, first touching her flesh and then the clay, his thumb still warm, so to speak, from her skin.'

She was his final Muse; as he became famous, achieving high position, he seems to have accepted the conventions. He was more socially at ease and less shy of being lionized, he had no more mistresses. He returned to Rose—not that he had ever really left her—but she presented a different sort of problem now that he was a celebrity. She had remained an uncouth peasant woman, sheltering in the kitchen and still cooking her cabbage soup every day. When Rodin's new friends made the journey out to Meudon he never introduced her to them, nor is she ever

glimpsed except dimly as she scurries down a dark passage. Edward VII came to pay his compliments during the big Rodin exhibition of 1908 and on this occasion Rose came in to drop a curtsey and retreated as fast as she could.

When World War I broke out Rodin was rushed to the safer shores of Britain and he brought Rose along with him. Queen Mary requested him to conduct her around his London exhibition but Rose stayed in her room.

A couple of years later they were back in Paris, and on January 29th, 1917, the old sculptor Auguste Rodin married the old woman Rose Beuret. A fortnight later, on February 14th, St. Valentine's Day, Rose died. Her death, they say, was due to a chill caused by a lack of heating in their house. Rodin survived her by only a few months. He asked to be buried by her side with his bronze figure of *La Pensée* as their tombstone, and what the thinker is meditating on, neither Rodin nor Rose will ever know.

Madame Rodin

20. SUZANNE VALADON
The laundress who became a great artist

During the 1880's a great vogue for laundresses flourished around the Paris studios. From Renoir to Degas, the artists seemed to be mad to paint lusty wenches, sleeves rolled up over brawny arms and dimpled elbows, stalwart shoulders bent over washtubs, sticking out their behinds as they splashed amongst the suds. Paul Poiret, celebrity, dress designer and boulevardier, writes: 'There were scores of laundresses and washerwomen around the butte, full of gossip and high spirits, exchanging their bawdy jokes and singing the current music hall songs as they worked.'

Among them Marie-Clementine (later known as Suzanne Valadon the artist, but best remembered as mother of Utrillo) was about to set out on her colourful career, the only model to become herself a successful painter. At the age of twelve she was training as a trapeze artist with the Cirque Medrano. Had Picasso been in his 'Harlequin Period' at the time she was doing her act, he would surely have gone to the Circus every night to sketch her, and he might even have snatched a quick impression at the critical instant of that last performance, when she fell from the bars. Safety nets were not in use at the period, but she was not killed, although her sprained back forced her to leave the circus. She was still only thirteen.

She returned to her mother (no one in the Valadon family ever bothered about fathers) who worked as a laundress in the Impasse Guelma, high up on the Butte de Montmartre. Her customers were the artists of the quarter. Marie-Clementine Valadon joined the laundresses.

The youngest she may have been, but she was as tall and strong as any, and as noisy, bold and sexy, as she went clip-clopping up the steep cobbles, delivering and collecting the laundry.

She called at the studio of Pierre Puvis de Chavannes who decided at first sight that here was the most paintable laundress on the route and suggested she should pose for him for *Le Bois Sacré*. Unhesitatingly she undressed and sat for him for two hours, then put on her clothes and hurried off to deliver the rest of the laundry. She worked for him on and off for several years, periodically threatening to leave because she objected to his using her to pose for male as well as female figures. Soon she was posing for many artists who later became the greats of the art world and for many who were never heard of.

From the start she was part of the truly Bohemian way of life that existed on the Butte, compared to which the subsequent artists' colonies in Chelsea, Greenwich Village or Montparnasse appear dull and square. She danced all night and worked all day, and just after her fifteenth birthday she had a son, Maurice Utrillo, destined to become more famous than his mother.

There are stories that he was brought up on absinthe, and it may well be true that the teenage mother who was out all night found it convenient to leave the baby sound asleep after a bottle of two parts cognac to one part milk. This way he would sleep until dawn.

She understood painting and started to criticize—could it be that the little laundress was herself the bastard daughter of one of the Montmartre painters? One of her biographers recounts how her employers were at first surprised and then irritated when the tough little gamine found fault with the turn of a shoulder or the tone of a background. They were puzzled by the signs of talent which appeared in the uneducated child of the people. One artist, Utter, who later became her first husband, was sketching in the Rue de Moulin when she passed by, glanced at his easel and tossed over her shoulder: 'Sky isn't painted like the earth.' This incident sounds as though it has become distorted through the years, for although Utter was not a great painter, he would surely know that. However, the great artists recognized her ability and one said of her: 'None could believe that this untaught girl could possibly produce work of such superb craftsmanship.' Shrewd enough to take advantage of advice and guidance, she stopped criticizing and while she posed she watched the way the great painters worked.

Renoir was one of the first to take her up. Kenneth Clark says: 'We know that Renoir, like Praxiteles, was dependent on his models.' He was asked when he felt he had finished a painting. 'When I feel I could

smack its bottom,' he replied. Mme Renoir complained that the maids had to be chosen because their skin took the light well, and at the end of his life it was the sight of a new model that gave him the impetus to start painting again. At this time he was painting big peasant women; he took Marie-Clementine on as a model, and painted her in *La Natte*. 'How superb she looks on this occasion transformed by the artist's brush,' gushed a critic. His next work with Marie, *Dance à la Ville*, resulted in complications with Mme Renoir. Madame, the fat blonde beauty of most of Renoir's loveliest nudes, wanted to be the model for this picture, for had he not told her that it was she who had inspired him with the idea? He compromised by allowing her to pose at alternate sittings with Marie, but in the end no one was bluffed—except Madame. Critics agreed that there was no doubt about the model, for who could fail to recognize Marie's curves and dimples, and especially her very small hands, a strange characteristic in such a big girl. In her later years she was proud to relate that when Renoir selected her as the model for this painting he had to search all over Paris to find a pair of gloves small enough for her tiny hands.

Marie remembered another detail concerning this same picture, marking Renoir's first attention to her drawings. She was late for a sitting and after waiting a while he went out to look for her in the garden. He found her behind the high lilac bush that screened him from passers-by when he was at work. She was painting. 'Seeing Renoir approaching I hid the canvas behind my back . . . laughingly he dragged it from me, then he stopped laughing. "This . . . you did this . . ." ' These few words, though they may not sound very exciting, were remembered, and encouraged Valadon for the rest of her life. She learned from Renoir to reproduce the pearly pink tones of flesh like the bloom of a flower; Renoir had always painted roses, explaining that it was in this way one could find the secret of a woman's skin.

We can see from her self-portrait that she was a strong-jawed, self-willed young woman. Degas, no flatterer of women, refers to her as 'his terrible Maria', Toulouse-Lautrec delighted in her looks and often used her as a model, and she can be recognized in his *Morning After* sitting at a café table looking decidedly off-colour. He was enthusiastic over her drawing and did a great deal towards helping her to develop as a painter. He also hoped to elevate her socially and, rather stupidly, persuaded her to discard her own attractive name of Marie-Clementine and to adopt the more ordinary 'Suzanne', considered more distinguished at that period. However, she appears to have been fond of Lautrec and grateful, and she tried to keep him off drink and drugs. But she boxed his ears

with fury when she found him surreptitiously supplying brandy to her
six-year-old son when he knew the doctors were trying to cure the little
boy's alcoholic habits.

Eventually Suzanne became a painter of note with successful one-man
shows in every capital. A Paris taxi-driver tells how he came to own
some of her now valuable pictures. Every morning he went to Mont-
martre in his taxi which he parked in the garage of the house shared by
Utrillo and his mother. He switched on the meter and then left his taxi
and drove the two of them around Paris in their own car. Not only did
they pay him double the fare shown on his meter but they insisted on
his having some of their paintings.

It is interesting to discover what type of models a woman painter
chooses and to find that Valadon brought in a vogue for the mature
peasant woman. This new type was too vigorous to stay on the dais
holding studied classical poses. They flung themselves into down-to-
earth (very down-to-earth) positions, sprawling on the bed, washing
underparts over the bidet, shedding corsets and scratching the tummy,
drying feet after a bath, taking off drawers, putting on stockings. Con-
sequently, poor country girls from smallholdings deep in the provinces
found work among the artists of Montmartre. They were not particular
whether they earned their keep by modelling or washing clothes or
doing the housework, it was taken for granted that a young *femme-de-
ménage* would double as a model.

Valadon, a poor housekeeper, admits in her diary that she could
never tell when anything was cooked until she smelled burning. In her
heyday she entertained the great men of the day in her Montmartre
studio. She gave dinner parties which made the food-conscious Parisiens
shudder. Edouard Herriot, known as a great gourmet, says the only way
she knew of cooking meat was to put it in the stove and take it out when
it caught fire. But even this did not shake Herriot's admiration of her
work. Once he kept waiting the special diplomatic train that was to take
him to London for a conference in order to attend the opening of her
exhibition in Paris.

Suzanne found a 'perfect treasure' in Gaby-la-Brunette, a large,
fleshy, bovine creature who kept the pastry light while lying naked on
the kitchen floor posing for her mistress; or whipped up a souffle
while Utrillo stood behind her and sketched her big bare rump. Renoir,
Lautrec and Degas would drop in to sketch Gaby and enjoy a bowl of
her wholesome *potage*.

Suzanne proved herself as a true Bohemain for unlike most mothers,
who discourage their sons from marrying the servant girl, she did all

142

she could to make a match between Gaby-la-Brunette and Maurice Utrillo. Gaby was too good-natured to refuse anything and on the rare occasions she had seen the young master sober during the years she knew him, she had liked him. But liking was not enough to make a permanent thing of looking after a drunken husband, posing for the whole family as well as their artist friends, and on top of all that doing the housework single-handed. Anyway, one morning shortly before the wedding, Gaby had gone, taking her little basket which contained the vest, drawers and petticoat she had worn so seldom.

At the same time, the Renoir *ménage* was having domestic trouble with their model-maidservant, another Gabrielle, Mme Renoir, being by now a difficult character, objected when her husband made the little maid-of-all-work stand for hours over the basin in her camisole washing

Gabrielle

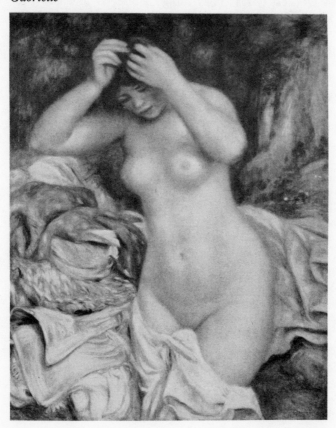

her hair instead of washing the dishes. Renoir's most devoted admirers suggested that he was too stingy to pay a model's fee and found it more economical to hire an extra servant girl.

Once when he was asked how he preferred his models he replied: 'Naked. Housemaids make the most satisfactory models. I have been fortunate in having several with lovely figures who posed like angels.' Eventually, Mme Renoir decided it would be more provident to keep the business in the family and had a poor relative come and live in the house as a nursemaid. They called this one Gabrielle too, which may have been her real name though it was, in those days, the accepted name for a maid-servant. Now Renoir no longer needed his sixteen-year-old skivvies, for Gabrielle was the perfect model and posed for him for the next twenty years, only leaving to go to the United States as the wife of an American painter.

Their friend Gauguin went one better and got a native slavegirl. A rich banker who did a lot of business with the Far East had sent her back as a present for his temperamental opera-singer friend, Mme Nina Pack, who he remembered had once said: 'I'd love to have a little Negro girl.' While doing business in Java, the banker bought a dusky little girl called Annah whom he shipped to France with a label around her neck: 'Mme N. Pack, Rue de Rouchefoucauld, Paris.' She was found by a policeman wandering about the Gare de Lyon and was forthwith delivered to her new owner. But Annah was hopeless as a domestic servant and created havoc in the household. 'All you're good for is an artist's model, lying on the rug naked all day with a flower in your mouth,' scolded Madame, which gave Annah ideas and resulted in her becoming a welcome addition to the studios of Montmartre. She was soon attached to Gauguin who was searching for a girl to replace the beautiful Tehoura he had left out in Tahiti. Annah became a good substitute for all those dark-skinned beauties that Gauguin loved to paint. She almost felt as though she was back at home in his cluttered exotic studio in the rue Vercingetorix, piled up with tropical props. She could squat on the floor playing with brilliant seashells and deck herself with yard upon yard of coral necklace looped across the walls or lie on the gaudily covered couches and eat sweets or drink wine. For a time there was plenty of money; then suddenly it was all gone. Gauguin moved to Brittany, taking her along with him as though she were part of the studio décor.

Here in the port of Concarnau she found other memories of home— sailors. Gauguin caught some of them reminding her of how they passed their leave when on the Pacific Islands and in a jealous fury got himself

involved in a brawl. One of the sailors gave his leg a kick that broke his ankle and he had to lie where he was until a doctor could be found to set the bone. Any delay suited Annah as it gave her more time to whip everything movable out of the studio and make off. When Gauguin returned home, he found not even a note propped up on the mirror, not even a message pinned to the pillow. Moreover, she had taken his best camel paint brushes, which she thought might be useful for putting on the men's warpaint at the next ceremonial dances when she got back home to Java.

21. MRS KATHLEEN NEWTON
The gay socialite who never went out

Never had the artist's model sunk to such a low social rating as in Victorian England. She was not allowed to use the front door, and because the servants objected to her using the tradesmen's entrance, prominent painters had a special Models' Entrance to their studios, thus avoiding any danger of Mamma or the girls coming face to face with Papa's 'Symphony in Skin-tones'. For a girl who was poor-but-honest, posing nude was one alternative to a 'fate-worse-than-death'. Frith writes of a valiant daughter who always posed with her back turned to hide her face, because the tears flowed non-stop throughout the sitting. Oh, the shame of it! But poor Dad had fallen on hard times, and it was this or the debtors' prison. Frith kept a letter addressed to 'The Painter of Derby Day', dated 1870. 'I wish to become a model if you require one; but I must tell you that I could only sit dressed or draped. I could NOT possibly sit NUDE. I am about thirty; tall, commanding figure; VERY small EARS and VERY small HANDS and considered fine bust. I could have obtained a position at the Royal Academy but could not have undertaken THAT. I am a lady.'

One equally ladylike girl who never posed in the nude lived 'in sin' with the artist Tissot—and he, to make things worse, a Frenchman. Consequently she was completely ostracized, and Tissot, being a social climber, kept her hidden away in the ponderous Victorian house at No.

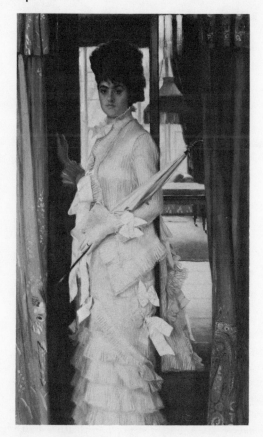

Mrs. Kathleen Newton

17 Grove End Road, St. John's Wood, behind the high garden walls
and dark elm trees. On a raw November night in 1876 as the fog drifted
around the tombstones of St. John's Wood graveyard, the only ceme-
tery in Britain where the four winds meet to make a perfect witches'
coven, twenty-four-year-old Kathleen Newton threw herself out of her
bedroom window. At last she was—at least she hoped she was—off on
a journey. Poised on the windowsill she looked back on the years cooped
up with James Tissot. Swallowing the rest of the gin she thought of all
those ghastly journeys, those cold mornings, the alarm set for five-
thirty, dressing carefully in her best travelling clothes; the trunk and
hampers locked and carried downstairs by the taciturn old gardener
Willingham, the sandwiches wrapped and flasks filled, rugs folded and

umbrellas rolled, topcoats and books and magazines stacked ready, everything piled up in the studio as though at any moment the hansom would clip-clop to the door to take them to the station and to foreign lands, or at least to Torquay. But no, they never got further than the studio where Tissot was ready with his palette mixed and his easel set up. He arranged Kathleen's eye veil and the three-tiered collar of her redingote—the latest thing in travel clothes in that year of 1873—and, fastening with a buttonhook the nineteenth button of her elbow-length fawn kid gloves, she took up the never-ending pose of Waiting to Go. Today it was *Waiting for the Boat to Greenwich*, tomorrow she would be waiting at *Victoria Station*, the same luggage in an interesting un-balanced composition piled around her. Not only would the same umbrellas and rugs be there, but she would be wearing the same coat and skirt. This seems strange, for Tissot was extremely fashion conscious and was rather deplored for painting his subjects in contemporary clothes, it being considered more high-brow to drape them in classical tunics or flowing robes. Tissot today would doubtless have little com-punction in portraying fashionably dressed beauties, and it is odd that he did not provide some sort of wardrobe for Kathleen. Instead she turns up repeatedly in the same outfit. Moreover, she appears in the same picture as different girls but always in the same dress and hat—

The Ball on Shipboard

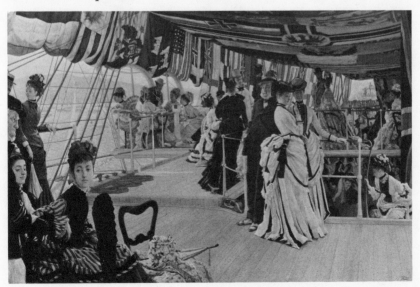

epitomized in *The Ball on Shipboard*. In practically every picture, there is Kathleen in the ubiquitous striped foulard for best, the everlasting bengaline *manteau-de-voyage* for travelling, and the hard-wearing flowered cambric for summer afternoons. The feather boa which she wears twisted around her neck at Victoria Station is left loosely hanging when *Off to Epsom* and if she isn't wearing her winter toque with the eye-veil, she is in the Dolly Varden bonnet. Her economical wardrobe made it difficult for James Laver, the art critic and fashion expert, to date the accumulation of Tissot's pictures for which Kathleen modelled. 'She wears a very elegant black gown, which can be dated as somewhere about 1878,' he said of *The Gardener*, but of *Visit to the Yacht* he can't get nearer than: 'She is wearing a dress of the late seventies.'

Almost immediately Kathleen found that life as the inspiration of a famous French artist was not as amusing as it sounded. It starts with that first dreary picture, *The Convalescent*, when they walked down to Regent's Park. There on a path near the gates Willingham, in false whiskers, posed as a drooling old dotard being wheeled in a bath-chair by a sour-looking attendant (also Willingham but with different whiskers) and Kathleen walked along beside them with the air of a long-suffering nurse-companion.

Mrs. Kathleen Newton was a well-brought-up, middle-class young woman, but contemporaries point out the exaggerated pains taken by the ambitious Society artist in order to hide the married woman who was his model and mistress. Consequently, when *The Convalescent* was hung at the Royal Academy that year, though all the other models were showing themselves off as usual at the Private View, Kathleen had to be content that Tissot brought her back the catalogue.

Tissot imagined he could solve this social problem by pretending Kathleen wasn't there at all, and kept her hidden in the house out of sight. Soon No. 17 became to Kathleen more of a prison than a love nest. Although he expressed love for her in paint, and thrilled to her curves on canvas, the pictures were stacked secretly with their faces to the wall.

Only once were they caught out, and since this awful incident which had shattered them both no visitor had been admitted to the house. On that occasion a few artists had been invited to tea and, as usual when guests came, Kathleen was banished to her room upstairs. Tea over, the painter Helleu, wanting to go to the lavatory, which no one ever did, asked if he could 'explore the geography of the house'. He landed up by opening Kathleen's door to find her taking off her corsets. Although, according to him, he fled in embarrassment, slamming the door behind

him, he had had time to recognize her and made no secret that he knew who it was whose pictures were piled up in the studio. After this catastrophe, Kathleen and Tissot were cut off and ignored, for despite all his precautions, the scandal seeped around and the neighbours were shocked (seemingly because Kathleen was a 'refined young married woman' and he was a foreigner). Gradually Tissot found himself ostracized. Even the flirtatious Mrs. Jopling, who in the old days had been so thrilled to go on sketching parties up the river with M. Tissot, sometimes even posing for him—in a ladylike way of course—could hardly go further in her diary than to comment that 'the subject of this *grande passion* is a *married woman*'. They were never invited to Whistler's gay parties at the studio across the road, or even to visit Boldini or Jacques Emil Blanche or Sargent. But though they never went out, Tissot continued painting Kathleen as the popular Society woman, coping with a round of social engagements. Without actually leaving the house she whirled through a picture life of gaiety that never let up; as the chic traveller, the pleasure-seeking gadabout, flirting at the dance on board ship, the sophisticated beauty at the races, the aristocrat at the Opera. She went sightseeing, still wearing the same striped silk dress, the same hat. We see her standing on the steps of the National Gallery surveying the London scene; a guide accompanies her and the other tourists pass by. She is shown at elegant garden parties and at tea parties and in several pictures she is one of the guests in a London drawing room, at a musical soirée—the great social entertainment of the period. During the season she posed non-stop in picnic scenes, for picnics were a very fashionable craze at the time, and however dull and chill the weather, Kathleen posed for a ladylike version of *Déjeuner sur l'Herbe*, only at teatime and wearing lots of clothes.

To give the authentic *Fête Champêtre* atmosphere to their suburban garden they would spread a tablecloth on the grass beside the miniature lily pond, lay out the silver teapot, a tea caddy, a currant cake, knives and plates, and she would dress up and wear her tight button-up shoes and carry a parasol.

Occasionally, as a change, if they wanted to do Henley or Squadron Lawns, they would get Willingham to help them push the heavy mahogany sideboard out of the french windows and set it up under a kind of marquee on the lawn.

She went to sea frequently, for Tissot, having been born and brought up in the seaport of Nantes, had a passion for ships and could imagine nothing more glamorous than a lady climbing daintily up companion-ways, resting on sea-chests, being gazed at by matelots or ogled by a

skipper. He knew as much as any sailor about rigging a ship, and Kathleen soon learned that she couldn't hurry him with his rigging. She stood up to the strain of balancing on the gang plank, fortified every half hour by a rum toddy slipped to her by the ever-watchful Willingham when she felt herself getting dizzy.

The strain of so much gadding about and travelling began to tell on Kathleen's health. Tissot noticed it one day when looking at a painting of her called *The Artist's Garden*. He remarked: 'Her face is thinner, as if she were no longer so robust as in former years and her eyes which were large are now almost unnaturally so.' Perhaps a visit to Brighton would do her good. He dressed her in a crisp summer dress, in the latest fashion with tiered flounces all around the skirt and bows in front, and she stood for hours in the studio with gay flags fluttering all around her and a little dog at her feet while Tissot painted a picture full of fresh sea breezes which he called *Fête Day at Brighton*. Another day he opened the window of the studio and sat her in front of it on a box ottoman for a sunny composition called *Seaside*. He seemed surprised to find at the end of the sitting that she seemed no better for the change.

Tissot gave up; he had lost interest in her and now, since his friends had cold-shouldered him, he became absorbed in the fashionable cult of the planchette, the Ouija board, and table rappings, he was glad to leave Kathleen upstairs with her drink while he sat up until dawn trying to get through to his guide, a beautiful Negro girl called Pomegranate. He could not use Pomegranate as a model and Kathleen no longer inspired him. Whereas he had enthused over her 'heavy brooding dark features', he now decried them as stolid and bovine. Similarly her English aloofness and dignity struck him now as 'wooden'. He wrote to one of the few friends he had left, that he was fed up with the whole affair and 'wanted to be rid of Kathleen and get married to someone else'. He then wrote to Kathleen the usual escaping-lover rigmarole that although he would always love her deeply, he felt he had nothing to offer and was ruining her life and she would be better off without him.

Whatever motive a psychologist might attribute to it, Tissot actually did what we all imagine doing at one time or another. He put the letters in the wrong envelopes and Kathleen got the note meant for his friend.

She stood reading it in exactly the pose she had taken when Tissot painted her in *The Letter*. Casually she opened it, read it, went upstairs, took several gulps of gin, and jumped out of her bedroom window into Willingham's cherished red geraniums.

Tissot only stayed to pack his planchette and night-shirt, tearing out of the front gate, leaving the house for good. Willingham tidied up the

geranium bed and continued with his duties much as before, faithfully keeping the house just as it was, paints congealing on the palettes, cloisonné colours hardening in the pots, dust and cobwebs gathering on the canvases stacked against the studio walls and on the books of esoteric writings in the library.

To keep up a front of respectability, Willingham spread it around that Kathleen had died of consumption, and to this day several art historians query what happened to the body and why the death wasn't registered. Willingham confided to one writer that he never felt lonely in the house because Madame haunted it regularly and he felt he was still in her service. It is said that every Tuesday morning when he went to air the studio, she would be on the model's dais posing for *In the Conservatory* or *The Last Evening*. She was still around when, two years later, the artist Alma-Tadema and his family moved in. Miss Anna Alma-Tadema, a very down-to-earth character, said she saw Kathleen so clearly she 'could discern the parting in her hair'.

But Kathleen wouldn't materialize for Tissot, although every evening after work he held séances in order to get in touch with her to explain the mix-up over the letters. Once she was supposed to appear to him at a house in Kensington, but the police raided the place at the critical moment and accused the owner of fraud.

Kathleen stayed in St. John's Wood and we felt her still very much around the last time we went to No. 17 and found it converted into flats, complete with dinettes and television and a row of lock-up garages where the lily pond used to be.

22. LILY LANGTRY AND OLGA ALBERTA Models who caught the Prince's eye

If you had alabaster shoulders you were 'in' when Edward VII was Prince of Wales. And the girl with the most alabaster-like shoulders in the whole of London was called 'The Jersey Lily', the name Millais gave to his painting of her and the flower that Oscar Wilde brandished as a token of his adoration. She was the type of ideal beauty worshipped during the last half of the nineteenth century, with regular features, smooth brow, deep bosom, tiny plump hands, and not a speck of neurosis in her make-up. Sickert, Watts, Whistler and Condor vied to employ her as a model, and Frank Miles who, being colour-blind, could not appreciate the gleaming whiteness of her famous arms and shoulders, made dozens of black-and-white drawings of her. 'This is the most beautiful woman I have ever seen,' he said, and in order to persuade her to pose for him in the rooms off the Strand which he shared with Oscar Wilde he bribed her with the promise: 'I with my pencil and Oscar with his pen will make you the most famous beauty of the age,' but that came to nothing for almost immediately Mr. Miles was taken off by the police for chasing little girls around Temple Bar. When all that died down he sold a sketch of her with a lily in her hair to Prince Leopold. The Prince had it framed and hung it above his bed at Buckingham Palace, but the beauteous Lily didn't smile down at his pillow for long. His mother, Queen Victoria, came in to ask if his sheets

needed changing; she saw the picture and summoned a footman; 'Take that down immediately,' she ordered him.

But even Queen Victoria couldn't banish the Jersey Lily from her sons' bedrooms for long. Lily was soon to become the established girl friend of her eldest boy, Edward, Prince of Wales, afterwards King Edward VII.

Meanwhile Lily was quite poor. 'They say she had only one black dress but she is a beautiful creature,' wrote Randolph Churchill. She worked hard at her job of 'professional beauty' which, loosely speaking, was the current term for what we mean by cover girl or top model. She had dramatic colouring, red hair, white skin, green eyes; she also possessed drive and a sense of showmanship. The first time she posed for an artist was when she was still living at home in Jersey and teaching in Sunday School. In this winsome little face with its timid kitten's expression, the straight brows and pretty mouth, who could have seen the woman to be praised as the 'physically-miraculous Lily Langtry'?

Having married a middle-aged widower to get herself to London, Lily had to organize some publicity. To that end she posed for painters and photographers, the first career glamour girl to use this modern formula. Evidently a born model, 'she knew how to move so that in every gesture, the folds of her dress fell elegantly around her, and when she posed in one position she never faltered and every line held grace'.

Lily Langtry started the pin-up picture vogue. For the first time, men, women and children bought postcards of a celebrated beauty to put up in their rooms. In sickening, sepia-tinted sentimental attitudes, she was pinned up on walls in army barracks and sailors' cabins, in Welsh cottages, in crofters' cabins, in undergraduates' studies, in tea planters' bungalows in India, in tall houses in Highbury, in terraced homes in Southampton, and in bachelor suites of the men-about-town of Westminster, in the bathroom and in boarding-houses, and in the school dormitory. Every postcard brought in royalties. Lily was no fool, though it was said she had more beauty than brain—but then she had a lot of beauty. Anyway, she was shrewd enough to make a deal with Downeys in Ebury Street, selling them exclusive photographic rights to her pictures, for which she got a solid down payment. Pears Soap used her for their advertisements—Lily was a best-seller.

When Millais told her that he wanted to be the first to put her classic features on canvas, she didn't tell him she was posing for Burne-Jones on Mondays and Wednesdays, and for Sir Edward Poynter on Tuesdays and Thursdays, but straightway arranged for the Prince of Wales to visit her on Saturday so that she could be free on Friday to go along to

Pears' Soap

"For years I have used your soap, and no other."

Lillie Langtry

Palace Gate where Millais had an Italian-looking studio with marble walls. 'Lily,' raved Millais after a long, long think, 'you're the most extraordinary subject I've ever painted, you look beautiful for fifty-five minutes out of sixty, but for the other five, you are amazing.' This was repeated nightly at the Café Royal as one of those witty epigrams. Millais painted her wearing her old black dress, but she added a white lace collar, sewed dozens of tiny bows down the front, and held a crimson lily. So he called it *The Jersey Lily*. When the picture was exhibited at the Academy, the crowds mobbed it until it had to be roped off to prevent men from touching the canvas alabaster shoulders—just as the ancient Greeks had been drawn by Phryne's marble allure. On varnishing day, when Lily herself came up the stairs, the crowds waiting in Piccadilly mobbed her, too, and she had to return to her carriage.

Whistler, toying with the idea of *Symphony in Lilywhite* (he already had symphonies in white Nos. 1 to 3) or another *Nocturne* in blue and/or gold, silver, or gray, offered to decorate her ceiling with ducks and birds flying across the sky. Watts, the octogenarian painter of famous allegorical nudes (*Love and Life*, *Life's Illusions*, etc.) came to life again for the Lily who gave him forty sittings at the house in Holland Park where he lived in solitary isolation. Burne-Jones brought his own morbid touch to the picture he painted, using Lily as a model for the tall, grey figure with a pitiless face turning the huge wheel of Destiny. But Balfour thought *The Wheel of Fortune* high art and hung it in his dining-room at Carlton House Terrace. Or did he think it would please H.R.H. if he found Lily herself hanging around in his host's house when he was invited to dine?

Not that this gloomy pose was in any way typical of the Jersey Lily. She was rarely moody and was in fact full of gay mischief. Her party trick of imitating a cock crowing sent everyone into fits, and when they went to country house parties she and the Prince of Wales had great fun romping on the lawn. The two of them were champions as partners in wheelbarrow races. She was a great joker, was Lily. At a party she had added soap to the cheese and once she filled a chamber-pot with ink which she fixed over the door to fall on her husband's head when he came in. On her dinner table the centrepiece was a golden statuette that she had had modelled of herself in the nude, to please Edward, as a little hors d'œuvre.

The beautiful Lily Langtry lived to the age of seventy-six and accumulated great wealth as well as fame. At one time her jewels were said to be worth £40,000, and she possessed one of the largest rubies in existence. She was known everywhere—not so long ago, tourists riding

out in the desert could hire a donkey called 'Jersey Lily' or Texas cow-boys riding in from the corral could stop off for a nightcap at a little joint called 'The Jersey Lily Saloon'.

Soon, however, came a reaction against the posturings and posings of beauties like Lily Langtry and many artists began to find inspiration in a strange nature girl, another protégée of Edward VII. She lived in Dieppe, that Bohemian and breezy little Channel port where Monet, Pissarro, Renoir, Dégas, Sickert and their hangers-on spent much of their time painting, where Oscar Wilde and Proust wrote and the snob intellectuals took their holidays. Here you could have the *vie Bohême* without the bedbugs of Montmartre or the smells of Bloomsbury, and the Prince of Wales had another attraction to bring him over for the occasional weekend—a godchild, a twelve-year-old called Olga Alberta, and her seductive mamma, the Duchess of Caracciola.

The story told of Her Grace was that on her wedding day she had run away from her fiancé accompanied by a Royal Prince, and then there was Alberta. The Duchess was only too proud of her unconventional life and boasted of her ancestor, the Baron Regnault; he was a painter and married his model who was the beautiful nude who poses in most of his pictures. 'What a girl was Great Grandmamma,' the Duchess would point out to the aristocratic dilettantes (men only) who were continually in and out of her château. These were not always as grand as they pretended; most of their titles had been made up and adopted by their owners as a barrier between themselves and the lower classes since they knew that once you were known as Monsieur le Comte or Monsieur le Duc, you were safe to hobnob with a starving artist or an unkempt poet without risking contact with the peasants. 'Art', after all, was one thing, but the 'common people' were another.

Olga Alberta was brought up with Art, in a strictly masculine com-munity; except for the servants no women entered her life. Today, Olga Alberta would be the most beat of the beat girls, with her long, straight, black hair which she let grow till it reached right down to her knees. She moved beautifully and had the personality of a ballet dancer, though this was a decade before the ballet came out of Russia. Aubrey Beardsley, Blanche, Condor and the other avant-garde young men found in her their teen-age girl of the future. 'The angular movement, the hare-like bounds Olga made when clearing the shingles,' as one art historian puts it, expressed all that modern artists of the day were seeking.

Although she was painted and sketched a great deal by Whistler, Bondini, Sickert and Dégas, it was Condor who was her favourite friend.

He commuted between the French Impressionist group in Paris and the Bloomsbury School in London; Olga's house in Dieppe provided a perfect stopover. While they tramped across the fields, or between sessions of sketching her skipping over a fisherman's upturned boat or amongst the piled-up nets, she would make him give her the latest gossip of London and Paris art circles and what Monsieur Zola had said about the new art movement.

London and gossip and clothes became an obsession with Olga Alberta, so the next time the Prince of Wales came over to visit Mamma, she wheedled him into a promise. She told him she was bored with posing for artists on the windy Dieppe beaches and the arty peasant picturesque atmosphere. Most of all, she explained, she longed for some girl friends to talk to about frocks and beaux and parties and babies and romance. She could put up no longer with only the odd fancy of dear Oscar Wilde or strange Monsieur Rimbaud. Mr. Condor had promised to paint her for the Summer Exhibition, she told H.R.H., and that would get her known and talked about; she would surely put all those fading beauties in the shade. For a while the Duchess flatly refused to consider the awful idea of her daughter being at the beck and call of every common artist and it took months to get the matter settled. In the end Godfather Edward settled it, arranging a *tout-à-fait convenable* match for Olga Alberta. She was married to the rich Baron de Meyer and went to live in London.

The Baron de Meyer is extolled as one of the early sponsors of studio photography, and his name is revered in the history of the glossies as the pioneer of glamour pictures. So here Olga Alberta throve in a glorious atmosphere of high fashion and elaborate settings. Art Nouveau was on the way in, and nothing was more so than Olga Alberta's clothes and parties. Condor conceived strange ideas in décor for her elaborate soirées, and he not only designed her dresses, but while she was having a fitting he would get down on his knees and paint a lovely rose pattern around the hem of the skirt, or splash a big impressionistic sunflower on her sitdown.

Any reader who can claim a grandparent in those high circles at the turn of the century will have heard tell of the sensation caused by Olga Alberta when she went to Condor's fancy dress party as Hamlet in long black tights, exposing her gorgeous and athletic legs. Proudly the Prince of Wales expressed his uninhibited admiration, and that night the Jersey Lily, more beautiful than ever, went home early.

23. MARTHE DE MOLIGNY
The model who stayed in her bath

Here we have an odd story, because Marthe de Moligny, although in some respects she follows the conventional pattern of the poor working girl, complete with hacking cough, who lives with her painter for thirty years before marriage, is yet unique; though a little dotty, she is responsible for the great quantity and lovely quality of the paintings left to the world by Pierre Bonnard.

Without her it is certain that he would have frittered away most of his time, for he was a man of diverse talent and great culture who could never settle down. Only the influence of his nervous, introverted 'companion', who shunned the outside world, separated him from his time-wasting, if definitely more stimulating, cronies, forcing him to paint and paint and paint.

They met in the usual way in which an artist meets his model. In October 1894 sixteen-year-old Marie Boursin was living with her grandmother and working every day except Sunday at a shop on the corner of the rue Pasquier. She made artificial flowers for funeral wreaths, threading thousands of tiny translucent pearls onto heavy wire frames, for they had to last. No thrifty French mourner throws away good money on fresh flowers when a beaded funeral wreath will last for years.

But the work was boring and while she threaded she escaped into her own private life of fantasy. In her day-dreams she was no longer delicate Marie Boursin with insipid colouring and a glazed stare who returned every evening to eat bread and cheese with *grandmère*. No, she was flamboyant and gay, the laughing Marthe de Moligny, the girl who was

the notorious prostitute and whose story she had read in an old copy of *le Matin*.

Gradually this dubious character, Marthe, seemed to take over, to dominate the weakly Marie Boisson so that when one day the artist Pierre Bonnard saw her getting off the trolley and followed her into the shop, it seemed quite in character that she should leave with him and become his constant model and devoted 'companion'.

One rather wonders what he saw in her except that she always looked immaculate. Her obsession for personal cleanliness must have been unusual among the sweaty little *midinettes* of *fin-de-siècle* Paris and may well have been the quality that first attracted the fastidious and culti-vated Bonnard. Or could he have gauged that beneath her cheap tasteless clothes she had a marvellous body and was a talented sex partner? One writer says: 'She was a washed-out Ophelia with pale hair and acid unexpressive eyes, but she had a beautiful body and the wildness of a bird.' Her passion for brightly coloured clothes and this birdlike quality caused people to describe her as 'birdlike in garish plumage' and one claimed that 'decked out in brilliant feathers and beads and ribbons she was like a frightened parrot in a cage', while another described her as 'unstable and eccentric, irritable and morose as a touchy elf'.

There is only one thing to assume; that without a pretty face or pleasant personality she must have been marvellous in bed to compen-sate. In all the pages of speculation that have been written on Bonnard's desertion from his friends and social life to devote himself to Marthe and his painting, no one has come up with any doubt that they were happy together in their quietly respectable if rather kinky way. 'He looked after her, feared her, put up with her, loved her. She caused him endless worry and distress but she was necessary to him, to his life and to his work.'

Her main peculiarity was her washing complex. The personal cleanli-ness he had found attractive soon developed into a mania. Had she some sort of guilt which urged her, like Lady Macbeth, into incessant scrubbing to wash away her real or imaginary sins? 'She felt the urge to lather herself with soap and massage herself with a sort of meticulous sinuousness for hours on end,' a friend of Bonnard's related, and he had no choice but to paint her stretched out and soaking in the rainbow colours of the soapy bath-water, bending over to lather her legs, crouching over the bidet, sponging herself down, putting on a dressing gown, taking off a dressing gown, and back into the bath. However, there is nothing particularly sexy about Marthe in the bath, though these pictures are considered to be among the finest nudes in modern

art. One version, considered by some to be Bonnard's best, *Nude in the Bath*, took two years to complete, so goodness knows how many hours she soaked in a few inches of water.

Marthe never ages; throughout the ensuing years Bonnard always saw her with the glow of youth she had had when they first met. He had no qualms over such glamourizing. He went so far as to state: *Il faut mentir* and justified his right to lie by recalling that Renoir, for his radiant nudes with peach-blossom skins, used models who were sallow and lined. Just as the ageing neurotic Marthe remained a teen-age sylph so did her surroundings take on unrealistic qualities. Bonnard's imaginary backgrounds were as idealized as the model.

Marthe could never forget her deprived childhood and was frugal to the point of stinginess. She panicked about money when there was no cause. They sat on canvas deck chairs and had no carpets, but they both enjoyed being poor and uncomfortable. A friend said: 'They shared a fondness for discomfort, Pierre hates money and puts all his luxury into his painting.' There was only one luxury Marthe ever yearned for. A real bathroom. If only she could have running hot water and not have to fill the copper can from the kitchen stove. After all, she practically lived in the bathroom. So Bonnard gave her one. In paint. Instead of the cracked walls, the board floor, the galvanized iron bath-tub, the ugly pipes and cheap wooden stool, he painted into his pictures a background of a luxurious bathroom with shining tiles and pretty mirrors and a large shallow bath, soft expensive-looking towels and a colourful bath mat. Sun streamed in the window, which looked out on to a splendid garden.

Marthe

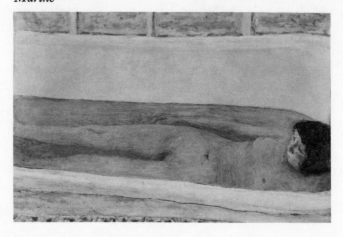

But actually the bare old-fashioned bathroom bore no resemblance to any of this and had no view at all. And even when they moved to bigger or better houses Marthe never had her luxurious bathroom, though they do seem to have acquired a glimpse of garden through the French windows of the dining-room or kitchen. Marthe's scrupulous cleanliness comes out in these interior scenes, the lunch table meticulously tidy with its freshly laundered cloth and neatly set plates, flowers arranged carefully and food laid out on shining dishes. No crumbs, no crumpled table napkins or wilting plants or pushed-back chairs. Even when Marthe is shown feeding her dogs after the meal, the animals are obviously too well trained to spill a morsel, and it would be impossible to imagine one of them gnawing a bone on the floor. There was only one extraordinary lapse, and goodness knows what on earth could have happened, but in the *Siesta* we see Marthe as an impetuous light-o'-love—for once her alter ego, Marthe de Moligny, the prostitute, in her true light—and completely out of character. It shows her having thrown herself down on the studio divan for a nap, clothes on the floor, coverlet and pillows piled around her, his pipe and tobacco still on the table, the dog snoring on the mat . . . where is the meticulous girl who was to develop into a chronic neurasthenic? By this time Marthe was already deeply preoccupied with her health to the point of hypochondria. For a long period she ate almost raw thick steak twice a day, supposedly to cure her anaemia; later we hear that she practically starved herself on a diet of sardines in oil with an occasional potato forced on her by an anxious neighbour.

Not that any neighbourly advances were encouraged. Marthe's complexes included a pathological horror of society: especially the wives and women of other artists. For instance, we learn of one occasion when Bonnard invited one of his few remaining friends, the artist Vuillard, to bring his young wife Suzanne to take coffee. Marthe banged the door in their faces and shrieked at Suzanne: 'Get out, you've only brought your husband along to copy Pierre's secrets.'

But the one she was most insanely jealous of was the popular and much fêted Misia Godebska. Misia was the daughter of a Russian painter and a talented musician herself, the centre of a circle of brilliant intellectuals. She had three famous husbands, she was gay and extravagant and money mad, and the leading artists vied to paint her, including Renoir, Toulouse-Lautrec, Vuillard and Sert (who became her third husband). But Bonnard was her favourite and she commissioned him to design the panels to decorate her drawing-room. Apparently he was having his affairs on the side, for one writer sets great store by his

consideration for Marthe, insisting that, however well the affair was going, he broke it off at the slightest sign that Marthe might be suspecting something was going on. 'You see, I haven't much courage,' he would explain.

But despite all, there seems to be no doubt that we have Marthe to thank for so many and such rarely beautiful pictures. Without her, he would have squandered his genius. He loved the theatre dearly and would have been happy designing stage sets and costumes. Or he would gladly have branched out into interior decorating, and nothing pleased him better than sitting in the cafés all night with his cronies endlessly talking, or walking the streets discussing poetry, or working out new theories in art around the studios of Montmartre. But he must live with Marthe, enclosed with her in the cocoon of her own narrow little world and the bathroom. Shut away with her, apart from all distraction, he was able to paint undisturbed while Marthe became more and more neurotic and odd until, one day, she blew up in a rage of self-righteousness. On a rare occasion when she had been to church, she had overheard someone say of a villager: 'One of those women whom men don't marry.' So next day Pierre arranged for the wedding.

Being elevated to the rank of a respectable married woman did nothing to raise the spirits of this melancholy model. The first portrait of her painted after the marriage is duly entitled *Madame Pierre Bonnard* and shows her as gloomy as ever, sad-eyed and haunted, yet dramatic and sensitive. There are other sketches of her at this time, including those where she is wearing the cheap finery which was her idea of elegance, and in some we see her when Bonnard took her rowing in a small boat on the river. She wore a sort of uniform, always the same, the white canvas shoes, the loose raglan coat, the cord twisted around the crown of her hat and falling in loops down her back. From time to time she became seriously ill and when they moved to a small villa in the south of France she would not let Pierre out of her sight. He devoted himself to caring for her, and no one else was allowed near. When she died he was devastated. He locked the door of her room which no one ever entered again. Then he painted a self-portrait but the background was of blue tiles, and it was dedicated to his 'lost girl in the bath'.

24. FERNANDE OLIVIER
Picasso's first love

The Victorians objected to nudes on the grounds that painting in the nude nearly always led to fornication. Of course it did! And still does. Picasso is quoted as saying: 'Where a beautiful woman is concerned, carnal desire and painting go hand in hand.'

He has clearly given much thought to the artist–model relationship and does not suffer from 'the occupational disease of the artists who show a preoccupation with the technical problems of the nude'. Even in his nineties it was obvious from his exhibition in London early in 1970 that he could still provoke as much shocked comment as John Lennon's exhibition. Here we saw the final series of the painter-and-model engravings, a sly comment on the artist and the tasty nude who poses for him. And in some he has a witty dig at the impotence of a group of middle-aged males who, engrossed in arguing a point with the artist, are ignoring his sexy model in her wildly provocative attitudes.

It was over seventy years ago that Picasso found his first important model-mistress. Fernande Olivier was a big brunette who wrote a book about those years with Picasso, when they were both young and poor and often hungry but full of zest and loving. But she makes it very clear that she never overcame her resentment that she had no place in his life when fame and success came. 'I was his faithful partner in his days of trouble,' she says, 'but I did not know those of prosperity. Perhaps he still remembers the girl who could not leave the studio for two months because she had no shoes to wear, and those winter days when she had to stay in bed because there was no money to buy coal to heat the studio . . . and those summers when it was so hot that the artists as well as the models had to work naked.'

People who knew Picasso and Fernande at that time laugh at such

Fernande

XI *Tête de femme*. 1906 (Fusain)

assertions. Fernande, they say, was always proclaiming her fondness for
bed and saying how much she preferred to stay tucked up while Pablo
went off to the market. Friends also hint that she need never have
suffered from lack of heating, since her chum the *charbonnier* around in
the rue Ravignon gave her fuel without payment.

In her own peculiar style Gertrude Stein has described La Belle
Fernande in her *Autobiography of Alice B. Toklas*.

'Fernande was a tall beautiful woman with a wonderful big hat
and a very evidently new dress . . . As I was saying Fernande who
was then living with Picasso and had been with him a long time,
that is to say they were all twenty-four years old at that time but
they had been together a long time, Fernande was the first wife of
a genius I sat with and she was not in the least amusing. We talked
hats. Fernande had two subjects, hats and perfumes . . . Fernande
spoke a very elegant French, some lapses of course into Montmar-
tois that I found difficult to follow, but she had been educated to be
a schoolmistress, her voice was lovely and she was very very beauti-
ful with a marvellous complexion. She was a big woman but not
too big because she was indolent and she had the small round arms
that give the characteristic beauty to all French women . . . van
Dongen broke into notoriety by a portrait he did of Fernande. It
was that way he created the type of almond eyes that were later so
much the vogue. But Fernande's almond eyes were natural, for
good or bad everything was natural in Fernande.'

If Gertrude Stein thought Fernande could talk only of hats and
perfume it was quite likely that Fernande could understand nothing at
all of what Miss Stein was saying, for she spoke a strange jargon that
more intelligent people than Fernande found confusing. Also Fernande
was extremely shy, especially when talking about herself. When much
later her memoirs, *Picasso and his Friends*, appeared in *Le Soir*, she was
so reticent about the role she played in his life that one critic writes:
'She talked of herself so discreetly that she might have been telling of
someone else.' But in other ways she seems to resent not being recognized
for her own sake; she hates being known merely as Picasso's model and
is furious when writers discussing Picasso refer to her merely as 'La
Belle F'. 'I have only physical importance to them and anyway what
could they know of the real me?' she complains.

Being ashamed of her conventional middle-class background, she
developed a bad inferiority complex. Fernande's family were not only
horribly respectable but they absolutely hated modern art, understand-
ably considering that they were in the artificial flower business. 'I was

mad about Manet which made my father furious,' Fernande writes. ' "Pictures must be an exact copy of Nature," he would shout and wave a branch of the artificial maidenhair fern at me. "The more exact and detailed the drawing of each vein on each leaf the greater the Art." ' Some Sunday afternoons he would take the whole family through the Louvre. 'He would point out the pictures we must learn to admire, and none of us dare loiter or. he would bellow: "Come on now, hurry past all this stuff by Ingres and don't you dare to look at all those nudes." '

When she was sixteen, the only way Fernande could think of to escape from her father's tyranny was to train as a teacher; but that was a bore and at seventeen she married to get away from the dreary routine of the teachers' training college. But marriage was a flop and before she was eighteen she ran away to Montmartre to escape from the husband who was worse than either the college or the artificial flowers. At last she found her métier, that of artist's model.

'I knew that life amongst the artists would be the only life for me . . . and so it was. I had taken a room at No. 13 rue Ravignon and was scuttling back there on a pouring wet night when the dark, thickset young man who had just taken a studio in the same building splashed up to me with a tattered umbrella.

'As another torrent drenched us we huddled in the opposite doorway. Outwardly he had nothing remarkable about him but he seemed to have an enormous magnetism for me. I was big and passionate and full of adventure and optimism, and I was very young. Another fierce down-pour sent us scampering for shelter into his studio . . . and that was how I started life with the twenty-year-old Pablo, the young artist fresh from Spain who could never afford to hire a model for more than an hour.' In future he would have one full time.

She recounts how she posed and froze and starved and cadged food (usually the traditional dish of macaroni) for the gang of hard-up artists who slept and fed in Picasso's bare studio. 'They liked to work and talk all night. Sometimes I would pose for them until dawn and then we would all sleep until noon.' But this, to Fernande, was the ideal life. 'I couldn't imagine how anyone could possibly live otherwise.' Picasso swept and shopped and, according to Fernande, kept her shut away in the studio 'out of morbid jealousy'. Perhaps he was still influenced by his upbringing in Spain where females were kept in seclusion, but perhaps it was just easier to leave her in bed while he did the chores himself.

'With tea, books, a divan, and only a little housework, I was happy

I was big and passionate

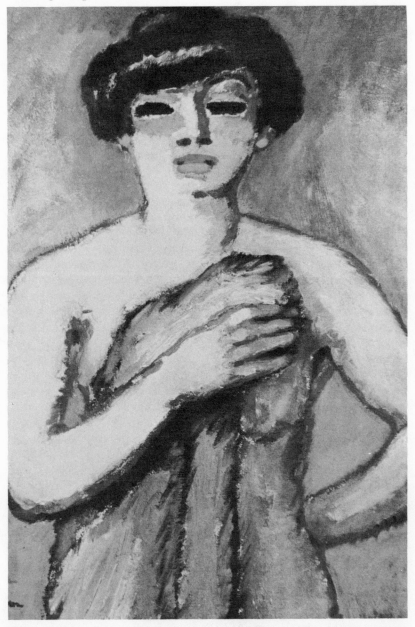

for I was rather a lazy girl,' she admits. She tried hard to make Picasso and his friends accept her for her brains as well as her body. 'In France there is always the tendency to consider women incapable of serious thought, especially in intellectual circles. I always felt this and it paralysed me. I made no attempt to join in and never dared utter a personal opinion. They treated me playfully, like a child, only occasionally I tried to show I had gifts which were not merely physical and that I could be high-minded and at the same time naughty,' she insists rather pathetically.

She admits that it was easier for her to talk once she got used to opium and hashish. People were so much kinder to her then and laughed at her jokes and praised her gay repartee. She writes to a friend: 'The penetrating fumes made everyone forget themselves and forget time. Sitting on mats the hours passed and we thought each other full of charm, intelligence and subtlety. Everyone talked away happily, everything seemed beautiful and noble and we loved all humanity. Around the opium lamp intelligence sharpened the talk of art and literature. Arguments were perfectly lucid and spiced with witty thoughts, acquaintances became confidential, friends became more tender and indulgent, and when we took hash-heesh tablets we had strange and beautiful dreams . . . but when we awoke next morning we would have forgotten all our uplifting thoughts and the old backbiting and irony replaced them.'

At one of these weekly sessions, Fernande confided to the painter Marinetti her ambitions to write poetry and to paint pictures, and told him how she longed to be more than just Picasso's *Nude in Green* or *Study in Charcoal*. Little did she know that each hour she lay naked on the hard studio floor with the draughts whistling around her shivering thighs she was contributing to works that fifty years later would be sold for huge fortunes to speculators, collectors, museums, and art galleries. She was convinced that anything he was or might become was due to her. Had he not sworn that his passion for her was the essence of his work? He had told her that he had to desire a woman so that he felt the urge to paint right through his body as well as his mind. She could not believe that there were to be others, though probably no one supposed that a girl so limited and middle-class as Fernande could continue to satisfy a genius of young Picasso's calibre.

The break-up started with his 'Harlequin' period when she found ballet dancers, trapeze artists and circus riders supplanting her as models. The girls of the ring put her nose out of joint and she was not amused by the joke that stopped the show every evening at the Cirque

Medrano. One glamorous bareback rider quips at another whose horse is edging against hers 'Oh, get out of my way, go pose for Picasso.'

Fernande decided to become as good a painter as Picasso. That would teach him! According to her, she succeeded well enough to disturb him. She affirms that, having listened and absorbed a smattering of technique she progressed so well that she suspected Picasso was a bit nervous of competition. She backs this incredible statement with a story of how one night a great name among the sophisticated Parisians, dress designer and art patron Paul Poiret, visited their studio. 'He saw a picture of me on the easel. "Oh, astonishing, charming, admirable," enthused Poiret. "It is perhaps a picture of Madame's?" "Yes," agreed Pablo with a twinge of jealousy.' The rift widened as Fernande grew more jealous and more conceited, and by the spring of 1908 Picasso evidently had had enough. He went off with Evelyn Thaw, who had been Fernande's greatest girl friend and her exact opposite, being petite and vivacious and assured, while Fernande was big, quiet and shy.

Only the clever Miss Gertrude Stein had any idea of what was happening, for she remembered that on a recent occasion she had found Picasso at work in his studio finishing a painting on which was the inscription *Ma Jolie*. As she left with her friend she murmured: 'Fernande is certainly not "Ma Jolie". I wonder who it can be.'

A few days later she knew. She wrote: 'Pablo has gone off with Eve . . . he said a marvellous thing about Fernande, he said her beauty always held him but he could not stand any of her little ways.' Poor Fernande was already a part of the great man's past; his tremendous future would blaze ahead, leaving her behind. Who was it who suggested a memorial to all those discarded women who have lived on spaghetti so that their successors could wear mink?

25. NEFERTITI
Pin-up of the
graven tombs

Around this time, a strangely different type of beauty broke into the news when archaeologists dug up the portrait head of a lovely young Egyptian Queen which had lain buried for over three thousand years. Exquisite, fine, slant-eyed Nefertiti immediately became the rage and was extolled as yet another example of 'the most beautiful woman who has ever lived'. Her picture was seen everywhere; shop-girls wore Nefertiti turbans, big German blondes used Nefertiti eye-make-up and surburban housewives wore snake armlets above the elbow. Apart from being the wife and helpmeet of Akhnaton (the rebel Pharaoh) and the mother-in-law of Tutenkhamun, she was a forerunner of 'the Beautiful People' with new thoughts on art and life and love. Being the consort of the richest king in the world, she could hardly be described as leading a hippie sort of life but her ideas of living in a commune, loving beautiful things and helping her husband to break away from traditional concepts to establish a new art was far ahead of any women's lib. talk of today.

Nefertiti qualifies as a professional model because, in her day, it was smart to have pictures of royalty painted on the walls of your burial-chamber and this fashionable craze made her the most popular pin-up of the tombs. All the best people in Egyptian society, circa 1375 B.C., liked to be able to say that when they were dead they would be sealed up in a rock-chamber with pictures of their beautiful Queen gazing down from the walls to keep them company. These tomb-paintings kept Nefertiti constantly in and out of the studios of artists hard at work on big funeral-picture contracts from rich and influential customers including Chief of Police Mahu, Royal Scribe Ramose, and Ay, Fan Bearer at the Right of the King.

She seems to have led a busy life as her appointments for sittings with

artists Auta, Thutmose and Bek had to be fitted in with all the other engagements arranged for her by her zealous, welfare-state-minded husband, King Akhnaton. As soon as she had finished posing for funeral stele—a gravestone—in one chic tomb-decorator's studio, sh﹖ would have to rush off to the next to be modelled for a little mortuary bibelot. Nearly suffocating under the clay while an artist took an impression of her features for some official statue was just another routine job in her daily round, like conducting services as Chief Priest-ess, in the Temple of Aton, once or perhaps twice a day, having to learn long, new hymns of praise to the Heat-which-is-in-the-Sun, nursing her brilliant though epileptic husband through one of his fits, listening to his difficult theories on monotheism and his new God, Aton, or holding his hand during official functions (not because he was nervous, but because he wanted to put his ideas about family love on record) and all the time fulfilling her role of enlightened parent, insisting that her children should run about like the commoners, wearing only a string of beads around the waist.

No one grumbled at the expense involved in building 'The Temple to Woman', a love token which Akhnaton gave her as a birthday present. This little nonsense has been described as 'One of the most elaborate monuments to woman ever made'—a thought that must often occur to the American archaeologist who, finding it broken up into thousands of pieces, and used as ballast inside another ancient temple, is currently trying to piece it together again with the aid of a computer; perhaps the largest jigsaw puzzle in the world.

Pregnancies were not allowed to interfere with her responsibilities as inspiration and model to the painters and sculptors of her husband's new school of advanced art, which was so progressive that the artists drew from life instead of using death masks and copying ancient statues as old-fashioned Egyptian artists were doing. This made Nefertiti extremely important as a model. In fact, her eldest daughter, Merytaton, had just begun to toddle, her second, Meketaton, had recently been weaned and the third (the one who was to marry Tutankhamen and not become well-known for another three thousand years) was on the way, when the Chief of Police put in an important order for his tomb-picture. He, naturally, thought it would be nice to have one that would boost his professional prestige so he chose as his subject Nefertiti riding with the King through the streets of el Amarna to show how well he, as Chief of Police, kept law and order in the Capital.

Even though she was six months pregnant, Nefertiti had to hop up onto one of her husband's two-wheeled tip-up chariots and stand there,

Nefertiti

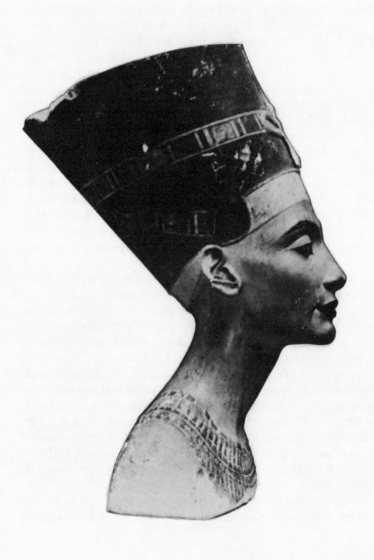

precariously balanced, while the artist did the preliminary sketches. As no Egyptian Queen had been required to pose for artists at all, let alone on chariots, this was an innovation which interests modern experts on Egyptian art. Jean Capart, for instance, says, 'The artist revolution is now generally recognized. In this el Amarna art, we are confronted with apparently unexpected bursts of new tendencies.' Professor Breasted comments, 'The monuments of Egypt bore what they had never borne before, a Pharaoh (and his Queen) not frozen in the conventional posture demanded by the traditions of Court propriety.'

Kissing and cuddling in public was not in the traditions of Court propriety, but when Ay, the Fan Bearer, ordered his tomb picture, one of the most advanced artists had the daring idea of showing Nefertiti as the loving wife and mother, with her family grouped affectionately around her, all in the nude except for their crowns. Whatever Nefertiti's private opinions of public demonstrations of affection, as loyal wife to her advanced-art-loving husband and conscientious model to the new art school, she dutifully took up the mother-love pose, keeping a sharp eye on the king in case of a fit.

Another of her problems was that Akhnaton was such an 'Egyptian Mummy's boy'. A few months after they moved into their new palace at Tel el Amarna, her glamorous mother-in-law, Queen Tyi, moved in with them. She had a most peculiar influence over Akhnaton and, with his family history, anything might have happened in the way of additional small sisters-in-law or brothers-in-law. Mother and son would spend hours reclining together discussing obscure aesthetic principles while Nefertiti would be sent off to Thutmose's studio to pose for the lid of a canopic jar—the decorated urn in which were stored all the entrails except the heart.

Leading the kind of life comparable to that of a twentieth-century career woman with a family, Nefertiti pioneered easy-to-wear clothes which were more practical than the traditional Egyptian shoulder-length woollen wig and masses of costume jewellery. She took to wearing simple gauze tunics, 'so transparent that one could see her form with almost the distinction of nudity, a red sash around her waist with the two ends falling to the ground', a plain off-the-face crown and little jewellery except pottery rings that she had specially made for her with her name on. With such simple clothes, make-up was all the more important so, however busy she might be, she always took time to have her eyes heavily made up and always carried around a fashionable eye-make-up container so that she could touch up her eye-lids if they became smudged.

Benevolent family picture

In spite of mother-in-law problems and her husband's fits and the news being gloomy, for messengers were coming in daily to report the break-up of yet another bit of the Empire (the King was a pacifist, too, and refused to let the army fight), Nefertiti carried on with royal dedication. The worse the news, the harder she posed for happy family pictures, because it was good for public relations and excellent propaganda for the King's Aton-is-Love principles.

When her second daughter died, there was no time for any private mourning. She had to be down at the studio straight away to pose for the child's funeral pictures while the embalmers were busy at their part of the business. This particular modelling job, for her own daughter's tomb, gives Nefertiti the distinction of being the first woman known to weep in a painting. When this picture was discovered only fifty or so years ago, Arthur Weigall, one of the first to see it after over three thousand years, was so moved by it that he wrote, 'Queen Nefertiti is seen holding in her arms her lately born seventh daughter, while the five other little girls weep with their parents beside the bier of their dead sister. It is a pathetic picture and one which stirs our sympathy.'

Pressure of work had not impaired Nefertiti's good looks; it was about this time that she sat for Thutmose's marvellous portrait bust which was found by the Germans in Thutmose's studio over sixty years ago and which spent the years of 1939–1945 safely at the bottom of a coal mine. It is now restored to the Berlin museum. This, however, marked the end of Nefertiti's modelling career. Soon afterwards Akhnaton died and all the people who had been critical of the new life-like art, saying, 'I may be old fashioned, but I don't like statues that look like real people', got together and, encouraged by the jealous priests of Amon, reduced the new art school to rubble. It was lucky that so many of Nefertiti's jobs had been tomb-pictures and the world owes a great deal to Thutmose, Auta, Bek and the undertakers of Ancient Egypt.

26. KIKI
The Venus of
Montparnasse

Kiki of Montparnasse is the last of the celebrated models, the final link in the chain that started with Nefertiti and Phryne of the ancient world. Phryne and Kiki have much in common, even to the extent that Montparnasse derives its name from Mount Parnassus, refuge of the Muses of ancient Greece; but just as the Paris suburb of Montparnasse reflected little of the 'glory that was Greece', so is the Kiki story acted out on a far less elevated plane than that of the legendary Phryne. Kiki was known as the Venus of Montparnasse, while Phryne has been immortalized as the most beautiful Aphrodite ever sculptured, and both had their troubles with the law; but while Phryne figured in that dramatic midnight trial, threatened with death for inspiring lust instead of worship, Kiki was hauled before the police court for assaulting a gendarme.

Both girls started life in the traditional artist's model way. In 1924 Kiki, then known as Marie Prin, was, like Phryne, only sixteen when she left home; leaving her widowed mother on the farm she went to Paris, intending to live with relatives who would get her a job in the local shoe factory. But instead of getting out of the train at St. Denis, she went on to the Gare Montparnasse, and once there she was too fascinated by the strange characters milling around the cafés to go back. So she stayed. It happened to be a Monday, the day when any of the artists requiring the services of a model came to the Dome or Rotonde, where they would find available models waiting for work. By chance, Marie Prin in her country clothes had chosen a table amidst a group of the most popular models, those up in the twenty francs an hour stratum. On her right the voluptuous Tatjana chatted to dusky-skinned Black Aicha, and on her left

Farouche Kheera, the Arab, sat alone. Soon the artists sauntered along, some already famous, some struggling to be recognized. Foujita, with his short black fringe and clever Japanese eyes, and Kisling and his friends, and Georges Braque, Utrillo and Soutine. But none of them wanted to paint Kiki.

Kisling was the first to notice her and not too flatteringly. He asked of a girl who had said a few words to her across the table: 'Who is that awful provincial-looking little tart over there?' And when he heard she was only sixteen and just arrived in Paris, observing her country bumpkin clothes and noisy manners, he, a kindly man at heart, offered to engage her for a few sittings on trial. He wanted to paint her as he had seen her at the Café, the boisterous little peasant come to town. But as soon as she got into the studio she went silent and none of his wittiest stories could evoke the faintest gleam of amusement.

In disgust he made a rude farting noise, at which she rocked with laughter. 'That's the thing that always makes me roar laughing,' she told him and from then on competing with each other became their main amusement. Despite such fun and games they must have worked steadily, since he painted her in over a hundred pictures. Kisling set young Marie Prin on the way to becoming 'Kiki, darling of poets and painters'. *Life* Magazine described her thus in a whole section devoted to Kiki as seen by the leading artists working in Paris between the wars. In each she shows an entirely different personality. That was Kiki's secret of success; she was never the same, avoiding therefore any risk of monotony. She could be the flapper of the twenties with Cupid's-bow lips and kiss curls, or the tough little apache lurking in disreputable alleys, or the sexy vedette of the night spots, or the lost gamine of the sewers . . . or the hilarious peasant girl from Brittany. And then in a flash she was transformed into Eve or into the Goddess of Love. It was this last, a rather pensive Kiki pictured as a twentieth-century Aphrodite, which made her known throughout the art colony as the Venus of Montparnasse and, moreover, established her internationally as the foremost model of modern art. Not that she was always easily recognized since this was the period of surrealism. Stunel painted her with a pineapple instead of a head; another painted her back to front and with a dead fish in place of a stomach. One of Kiki's favourite stories tells how she posed for Utrillo for three days, he constantly swilling down rough red wine and refusing to let her see the canvas. When eventually she managed to get around to the other side of the easel she saw the masterpiece—it was a landscape.

Another day she was off to keep an appointment with Soutine, but

Kiki

even she could not face the stench from the rotting meat on a dish which he had been working on for a still life during the past two weeks.

Now Kiki started to become as popular in the Montparnasse cafés and night-clubs as she was in the studios. She was a born show-girl with a husky sexy voice and suggestive gestures. Perched on the piano in the tiny dark club, singing her bawdy songs in her uninhibited way, she packed them in, and the tourists craned their necks from the doorways at this glimpse of what goes on in naughty Paris. Kiki told them.

Then she met the already successful American painter-photographer-writer Man Ray, who did more than anyone to publicize Kiki. His back view of her adorned by a musical score was seen everywhere. He writes about the six years during which he and Kiki were lovers and how it all started off. He says that it was only with the greatest difficulty that he persuaded her to pose in front of a camera. She dreaded photography; it was too revealing, nothing could be disguised, and she had a secret to conceal. She had what she referred to as a 'physical defect' about which she was tormentingly self-conscious. She grew no pubic hair. 'I have tried every kind of pomade, all the lotions and massage and nothing works,' she told him hopelessly, for this was no light matter for a French woman, although most American girls were beginning to shave their bodies, and as far as artists were concerned, they had to pander to the censors, who disapproved of anything more than a shadow. But Kiki could not be comforted. 'She undressed behind the screen that shielded the washbasin in the corner, and came out holding her hands in front of her. Her body would have inspired any painter,' recounts Man Ray.

As models do, she soon moved in and for a while seems to have made a great effort at domesticity. She cooked the delicious dishes of her native Burgundy and, having a bathroom with running hot water for the first time in her life, she spent so long soaking in the hot tub that she may have risked becoming as obsessed as poor Marthe Bonnard who was scrubbing away only a few kilometres distant.

And like Marthe and like Fernande and several other artists' models (including the famous Suzanne Valadon, who was the only one to become successful), Kiki, in her turn, took to Art. She did childish farm scenes in unlikely colours, with cows of curious shapes and odd-looking trees, which her friends likened to Chagall. The local gallery put on an exhibition of Kiki's paintings with every character on the Left Bank at the opening. Surprisingly they bought the pictures, though critics did not know what to make of the paper cut-outs, which may have been the first intimation of Pop Art collage, which came in after Kiki's lifetime. Probably Kiki never discussed matters of art as she was not a

conversationalist, preferring to sing her bad ballads and to jest and wisecrack with her comrades. The incessant talk young intellectuals indulged in in those days before television, bored Kiki to such an extent that she would insist that her escort leave the party and take her back to Montparnasse. Consequently she may have been considered a bit dumb; for according to Man Ray if anyone asked him whether Kiki was intelligent he would answer: 'I have enough intelligence for the two of us.' Apparently he did not question her morals.

Another starry-eyed American admirer is equally gallant when relating the story of Kiki's abortive trip in search of stardom on Broadway, a popular mecca for every ambitious girl of the period. Like many poor but sexy Frenchwomen, she always hoped for a rich boy-friend to take her to the United States. Instead she found a nice, kindly couple who invited her to return with them to America, where they would launch her as a show-biz star. But on the ship going over, the husband paid too much attention to Kiki and he would not leave her alone. The jealous wife stormed and their rows reached such a point that, on arrival in New York, the couple parted. Nothing materialized for Kiki's debut on the American scene except an introduction to a Paramount film executive. She got her audition but—typically Kiki—she never arrived. Having got as far as the studio, she wandered about, but could not find his office. No one she asked seemed to understand her English so, furious, despondent and homesick, Kiki cabled her friends for the money to pay the fare back to Paris. Stardom, she decided, was not for her.

The artists of Montparnasse welcomed her home and once again she was acclaimed as the leading model of the Latin Quarter by painters who were then penniless but are now great names. Chaim Soutine, Kisling, Jean Cocteau, Toulouse-Lautrec, Foujita, as well as scores of unknowns. Everyone knew Kiki. Isadora Duncan holding court with Raymond, her poet brother, wandering about in his toga, James Joyce with failing sight writing away at his table in a café on the Boulevard Raspail; or the young Hemingway showing off to the foreigners from the Middle West who took 'brunch' at the Dome on Sunday morning. All greeted Kiki as she swung along, usually followed by her cortège of current protégés. For it was not the dollar-padded Americans who knew the real Kiki of the cheap back-street cafés and the unheated studios, the girl who more often than not refused her model-fee if the artist was poor, or, if she did get paid, passed it on to some hungry young genius or a sick comrade. Why did she sit up all night till dawn when every table at the Dome had emptied? Because she had lent her bed to a down-and-out with 'flu who had nowhere to go. And her string bag

was always full of food and worn clothes she had collected for her needy friends. Naturally, she was taken advantage of, sponged on and exploited, and when she had no more to give, Kiki had to sing for her supper and earn more sous to give away.

She was as hot-tempered as she was generous and uninhibited and this resulted in some awful brawls. There was the incident in which she snatched the camera from a tourist to crack across the head of a drunken Russian poet who was annoying her; the time when she swiped her American beau across the face because he was paying too much attention to the two pretty daughters of a famous general, at whom she bawled furious insults in argot, which luckily they could not understand.

Then there is the story as told by her idealistic American admirer about the fracas she kicked up when holidaying in the south of France at the port of Villefranche. The townswomen were jealous, he affirms, because Kiki was acclaimed as the friend and mascot of the American sailors. But others infer that the local tarts got at her for impinging on their trade. At all events, when she threw a bottle of brandy in the face of a favourite prostitute, the whole place turned against Kiki, and the café owner appealed to the police to have her thrown out of town. Instead of leaving quietly, she made matters worse by cracking the policeman across the head with her handbag. 'He called her an ugly name,' was the excuse given by her American protector, who rushed to her rescue armed with a doctor's certificate that Kiki was being treated for mental aberration, but he had to cool his heels for weeks while Kiki was kept in jail to await the trial. He tells how, eventually, she faced the Court. 'Kiki was brought in. Without make up she looked like a frightened country girl. She smiled weakly.' The magistrate sentenced her to six months in jail . . . then let her off on parole, because, he said, he was sorry for her friend who had been put to so much trouble. The French pandered to the Americans in those days. They needed the dollars. Kiki went home to recuperate from this episode in Burgundy, where she spent her time drawing pictures of American sailors standing at bars or sitting around cafés with girls. Then she started her memoirs, which she brought back to show to Man Ray. 'It was not literature—it was a self-portrait of Kiki, true to life, shockingly but delicately frank at times.'

They found a publisher, none other than the strange Broca, who by that time is described as having 'gone Bohemian, a drinker and drug addict and subject to hallucinations'. Nevertheless, while teaching Kiki to proof-read, Broca persuaded her to move in with him. Despite (or because of) his vices, they enjoyed themselves until he tried to kill her and had to be taken to a hospital where he quickly died.

Kiki's next lover was the handsome young accordion player who accompanied her when she sang at night-clubs. They had cars, a luxury flat, and plenty of clothes. They seemed likely to become a successful team; bookings for acts in the Revues, promising her name in lights on the boulevards, contracts for recordings and radio programmes, all loomed up in the rosy future for Kiki the artist's model. But again none of it materialized, Kiki was not destined for stardom, and soon she was on her own again. What was left of the money she had made went into the pockets of the spongers who surrounded her, always following her around, living in her apartment, battening on her easy-going, here-today-gone-tomorrow outlook.

Then came the war and the war killed Montparnasse. Like homing pigeons *les étrangers* were on the wing, back to Seattle and Sydney, Nottingham and Oslo, and there were no more dollars in Montparnasse.

After it was all over the tourists returned . . . but different, careworn types who spent much more but laughed much less and talked about Zen and Existentialism. The inhabitants followed Sartre up to St. Germaine while the avant-garde poets and painters sat around the Deux Magots and pale girls with long, lank locks, wearing macabre black sweaters and tight, black trousers, shuffled around in the underground gloom of the 'Cave Rose' and other cellar night spots.

Not only did artists paint in a new way but their models had finished with Art for Art's sake. They demanded their rights; for one thing, the postwar fuel shortage made posing in the nude an altogether too chillsome ordeal and they threatened to go on strike unless something was done. Consequently in December of 1946 announcements appeared in the Paris press headed 'Gooseflesh Bonus' and went on: 'Models for the figure demand gooseflesh bonus of thirty-six francs an hour. As soon as a model shows goose pimples as proof of suffering from cold, owing to the strict fuel rationing in the studios, she is entitled to extra pay.' It was also reported that in London the models were banding together to form their own trade union to enforce regular rest periods every twenty minutes, heated studios, adequate dressing rooms and a standardized rate of pay.

None of this made sense to Kiki; she could find no place amongst the postwar youth. She suffered from dropsy and was fat and ill with a swollen stomach, and in dull suburban new Montparnasse no one recognized her poking in the gutter for cigarettes and papers. None of the artists wanted to paint her.

In the spring of 1953, at the age of fifty-one Kiki signed off in true artist-model tradition with an empty bottle of absinthe and the dregs of

Violin d'Ingres

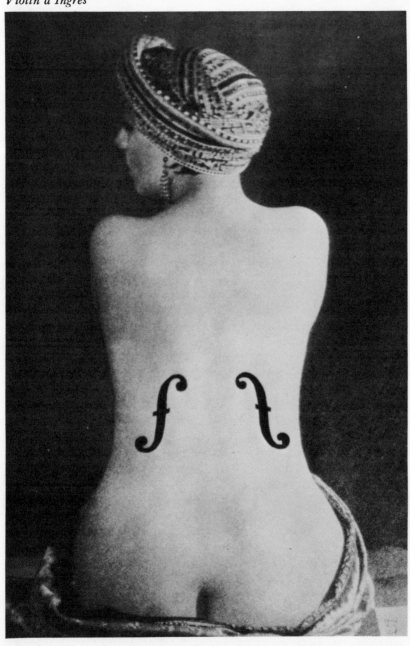

cocaine beside her in an icy attic. Under the bug-infested mattress were twenty-eight charcoal drawings and twenty paintings dated between 1925–1927 and 1929; all were of Kiki and all bore signatures worth a fortune in any language. The older artists mourned her, too late, and gave her a huge funeral; Kiki's picture was in every evening paper all around the world. Big bouncing Kiki with the black sloe eyes, pointed nose and abounding spirits was the last of the artists' models before a bicycle ridden across the canvas became True Art, followed by abstracts that would have broken even Phryne's intrepid spirit.